U0106606

NEON

霓 虹 艷 色

餐飲招牌手稿視覺記錄

The Visual Documentation of
Restaurant Neon Artworks

郭斯恆　著
Brian Kwok Sze-hang

HUES

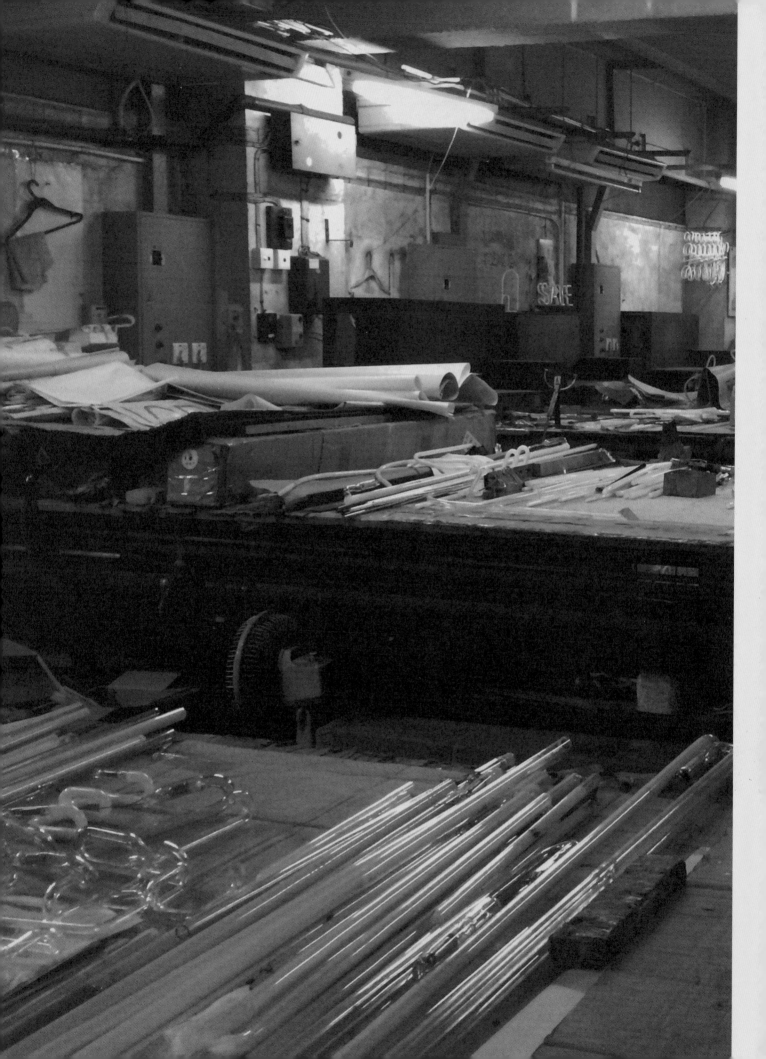

目錄 Contents

引言　FOREWORD

自二〇一〇年屋宇署實施「招牌清拆令」的十多年以來，香港各區有大量霓虹招牌陸續被拆卸，霓虹招牌已在我們的日常街道中無聲無息地消失，現今的街道再難重現昔日的生命力和色彩。在這不能逆轉的格局下，為了趕及記錄僅存的霓虹招牌，研究團隊早於二〇一五年開始，花了多於一年半時間走訪各區的大街小巷，趁霓虹招牌還未拆卸之前，用文字和照片將它們記錄下來，以免這些香港特有的街景在我們的記憶中消失。到了二〇一八年，我們將霓虹招牌的記錄成果出版成《霓虹黯色──香港街道視覺文化記錄》一書，此書引起了不同媒體、文化團體和市民大眾對霓虹招牌和街道獨有文化的關注。

為了加深認識香港街道視覺文化和傳統霓虹工藝，團隊有幸採訪了不同的霓虹燈師傅和文化學者，更幸運的是團隊可於二〇一五年，走進成立於一九五三年的南華霓虹燈電器廠有限公司（下稱「南華」）採訪。南華是香港最早的霓虹燈製造公司之一，至今已有六十多年歷史，始創人譚華正博士昔日曾被譽為「霓虹燈鉅子」，他早於六十年代已到日本考察及交流技術。當時日本的霓虹燈製造技術相當成熟，不論在設計、技術及科技上，都是處於世界的領導地位，相信譚華正也是希望從一些先進的城市和國家中，學習最先進的霓虹燈招牌科技。除了日本外，他也曾飛往曼谷、新加坡、馬來西亞各地考察及交換意見，藉以推廣香港霓虹燈生意，可見他的眼光不只著眼於香港市場，更放眼於亞洲地區。在過去眾多的南華霓虹招牌製作中，較為人熟悉的作品有七十年代位於佐敦的「樂聲牌」大型戶外霓虹招牌。這個樓高超過二十層的招牌，更打破了當年「最大戶外霓虹招牌」的健力士世界紀錄。但由於近年霓虹工業日漸式微，加上不少霓虹燈師傅年事已高，在青黃不接下，南華於二〇一七年後也逐漸淡出霓虹工業。之後，霓虹燈工廠也謝絕外人進入和採訪。

雖然這樣，慶幸我們過去多次到訪南華，也記錄了珍貴的霓虹招牌製作過程。其中一次，我們看見南華霓虹招牌製作工廠的一角，有一個不顯眼的儲物櫃，好奇打開，意外發現櫃內存放了多張碩果僅存人手繪製的霓虹招牌手稿與及相關的製作文件，當中的手稿年份橫跨五十至七十年代。這個發現使研究團隊十分雀躍，因為這些手稿相當重要，它可以讓我們認識香港霓虹招牌的發展歷史，亦有助我們了解昔日的香港視覺文化。

當細閱這些霓虹招牌手稿時，才了解到它在整個製作流程中扮演著重要的角色：它不只呈現出霓虹招牌預期的視覺效果，而且更是製作團隊與顧客互相溝通的平

台。在電腦還未出現之前，招牌畫師或「畫佬」會先將客戶的想法和概念，以人手繪畫出來。為求力盡逼真和完美，畫師會用圭筆描繪出招牌的各項細節，例如圖案、字體、顏色及形狀等。因此，每一張手稿都反映出畫師的藝術修養，以及精湛的繪畫技巧，這可說是美學與功能結合的藝術作品。當看見這些有五、六十年歷史的手稿時，更倍感珍貴。故此我們大膽向南華提出把這些手稿帶回學校作研究之用，怎料南華一口答應，願意把大部份手稿捐贈給香港理工大學設計學院用作視覺文化研究和教學用途；另外，也將部份手稿捐贈到不同文化機構作保存和研究。為此，我們十分感謝南華的慷慨捐贈。

經收集後，團隊初步點算大約有七百多張手稿，部份是完整無缺，但也有不少手稿因為年代已久，而有不同程度的破爛、破損和褪色。當務之急是必須立即進行修復，並作詳細記錄與分析，好使手稿上的原有狀態和色彩得以完整保存，讓市民大眾有機會再次欣賞這些珍貴的霓虹招牌手稿。

在手稿復修計劃和記錄工作展開之初，最花時間的是清潔和按時序整理這些手稿。由於我們並不是專業的收藏家或歷史研究人員，換句話說，我們是從零知識去開始整理這些手稿。我們在外國歷史博物館網站了解收藏和清潔藝術品的方法，並在網上訂購了一些專用海綿，以確保能清走霓虹手稿上積聚了四、五十年的塵埃，並使過程不會令手稿表面破損。經過清潔後，我們將每一幅手稿用專用保護膠套包起，以免紙張長期接觸空氣而受損，然後便開始為手稿拍攝和做記錄，例如每張手稿的字體、顏色、圖案、形狀、尺寸及年份等資料都會記錄在電腦中。雖然七百多張手稿算不上很多，但也花了不少時間。

這七百多張手稿，可按主題歸納成八大類別，例如食肆、服飾、百貨及服務等，但礙於時間及篇幅所限，本書主要集中展現和分析佔最多的食肆手稿。在七百多張手稿中，食肆招牌約有二百多張，佔整體數目約三分一。我們希望透過整理二百多張食肆的霓虹招牌手稿，從側面探討香港五十至七十年代的飲食文化，以至不同年代的社會、民生和經濟狀況。

本書是《霓虹黯色 —— 香港街道視覺文化記錄》的延續，重新編寫部份內容，同時補充更多資料：第一章，補充了不少有關香港霓虹招牌的歷史；第二章，特別整理了香港餐飲業的轉變，例如從茶樓發展到酒樓、西餐廳及冰室的特色，以至今天成行成市的茶餐廳等；第三章，主要分析霓虹招牌手稿的視覺美學，包括招牌的外形、字體、顏色及圖案等；第四章，集中展示霓虹招牌的手稿，讓讀者能近距離欣賞。

最後，我們希望藉著此書，為喜愛街道文化和霓虹招牌美學的讀者，提供更多閱讀我城的面向。

During the more than 10 years after the Buildings Department implemented the "Signboard Removal Order" in 2010, a vast amount of neon light signboards have been taken down across Hong Kong. Without a fanfare, neon light signboards have disappeared from our day-to-day lives, leaving the streets drained of its former colour and vitality. In response to this irreversible situation, our research team started to document the extant neon signboards in 2015. We spent over eighteen months visiting streets and alleys in different districts to take records of signboards not yet removed through words and photography, hopefully to prevent the neon light streetscape unique to Hong Kong from fading from our memory. In 2018, we published our research in the book *Fading of Hong Kong Neon Lights - The Archive of Hong Kong Visual Culture* (written in Chinese) (Kwok, 2018), which has raised concerns from the media, cultural bodies and general public regarding neon light signboards and the unique street culture.

The team was fortunate to have the opportunities to interview neon light craftsmen and scholars who shared their expertise on Hong Kong street visual culture and traditional neon light craftsmanship. An even greater stroke of luck was the team's receiving an invitation in 2015 to visit Nam Wah Neonlight and Electrical Mfy, Ltd. (Nam Wah), which was established in 1953 as one of Hong Kong's earliest neon signboard manufacturers. Nam Wah has been in operation for over sixty years, and its founder Dr. Tam Wah-ching is widely known as "the neon tycoon". Early on in the 1960s, he visited Japan for technology inspection and exchange. At that time, Japan's neon light manufacturing was very well-developed, leading the world in terms of design, technique and technology. Dr Tam was eager to learn state-of-the-art technologies from advanced cities and countries. His vision extended beyond Hong Kong to cover other parts of Asia. He travelled to Bangkok, Singapore and Malaysia for inspection and exchange to promote Hong Kong's neon light business. Among the numerous neon signboards produced by Nam Wah, National's giant outdoor signboard installed in Jordan during the 1970s is among the most memorable ones. The 20–storey tall signboard broke the Guinness World Records as "the largest outdoor neon signboard" then. In recent years, along with the decline of the neon light industry and the aging of neon light masters without the entry of new blood, Nam Wah began to gradually step away from the business in 2017 and refused visits of their premise and interviews since then.

Despite this, we had been fortunate to have gathered valuable documentation of neon light manufacturing process during the multiple visits we made with Nam Wah. During one of our visits, we happened to notice an unassuming cabinet in a corner of the factory and opened it out of curiosity. To our surprise, there were many extremely rare hand-drawn sketches of neon light signboards spanning from the 1950s to the 1970s and related manufacturing documents. The research team was overjoyed by this discovery, as these important sketches allowed us to learn about the development history of neon signboards in Hong Kong and helped us understand the visual culture of the city in the past.

By closely examining the neon light sketches, we learnt that they played an important role throughout the entire production process: besides portraying the planned visual effects of the neon lights, they also served as a platform for the production team to communicate with the clients. Before computers were invented, neon light signboard illustrators or "painter guys" visualized clients' ideas and concepts by hand drafting. For realistic and perfect representations, the painters used a sable brush to illustrate every detail of the signboard, including patterns, characters, colours and shapes. Therefore, each sketch was a presentation of the painters' artistic sentiments and refined painting skills as an artwork perfectly combining aesthetics and functionality. Considering that these drafts had fifty to sixty years of history, we treasured them very much. Therefore, we boldly asked Nam Wah for letting us take the sketches back to our university for research purposes, and the answer was surprisingly yes. As a result, most of their neon light sketches were donated to the School of Design of Hong Kong Polytechnic University for visual culture research and education, while some were donated to other cultural organizations for preservation and studies. We were truly grateful for Nam Wah's generous donation.

According to initial counting, the team collected some 700 sketches, of which some remained completely intact, while others, due to ageing, showed decays, damages or faded colours. They urgently required restoration as well as detailed documentation and analysis, to fully preserve their original conditions and colours so that the general public could appreciate these precious sketches again.

During the initial period of restoration and documentation, the most time-consuming tasks were cleaning and arranging the sketches in chronological order. Since none of us were professional collectors or historians, we started to handle the sketches from scratch. The team learned about methods of preserving and cleaning artworks from the websites of foreign history museums and bought specialty sponges online to clean the dust accumulated on the sketches for 40 to 50 years, making sure they would not be damaged during the process. After cleaning, the sketches were wrapped individually in specialty plastic bags to prevent them from damages due to prolonged contact with the air. Then, each of them was photographed and recorded in detail on the computer, including information on their typography, colours, patterns, shapes, measurements and production years. The whole process took quite some time though there were not really many sketches.

The over 700 sketches were divided into eight categories by industry, such as restaurant, clothing, department store and services. Given limitations in time and space, this book focuses on the exhibition and analysis of restaurant sketches. Out of the over 700 sketches, over 200 were restaurant signboards, accounting for about one-third of the total. Through the organization of the over 200 restaurant signboards sketches, we hoped to understand from another angle of Hong Kong's food culture between the 1950s and the 1970s as well as the social, livelihood and

economic conditions of different times.

This book is based on *Fading of Hong Kong Neon Lights - The Archive of Hong Kong Visual Culture*, with some parts rewritten and supplemented with additional information. The first chapter talks about the history of Hong Kong's neon light signboards, while the second chapter describes the transformation of Hong Kong's food and beverage industry, covering its development from tea houses to Chinese restaurants, Western restaurants, local cafes and the popular Cha Chaan Tengs nowadays. Chapter three discusses the visual aesthetics of neon light signboards, including their shapes, typography, colours and patterns. Chapter four focuses on displaying the sketches for readers' close appreciation.

Lastly, we hope this book will provide our readers who love street culture and the aesthetics of neon lights with more angles to understand our city of Hong Kong.

香港霓虹燈的
興衰簡史

1 The
Rise and Fall of
Hong Kong's
Neon Signboards

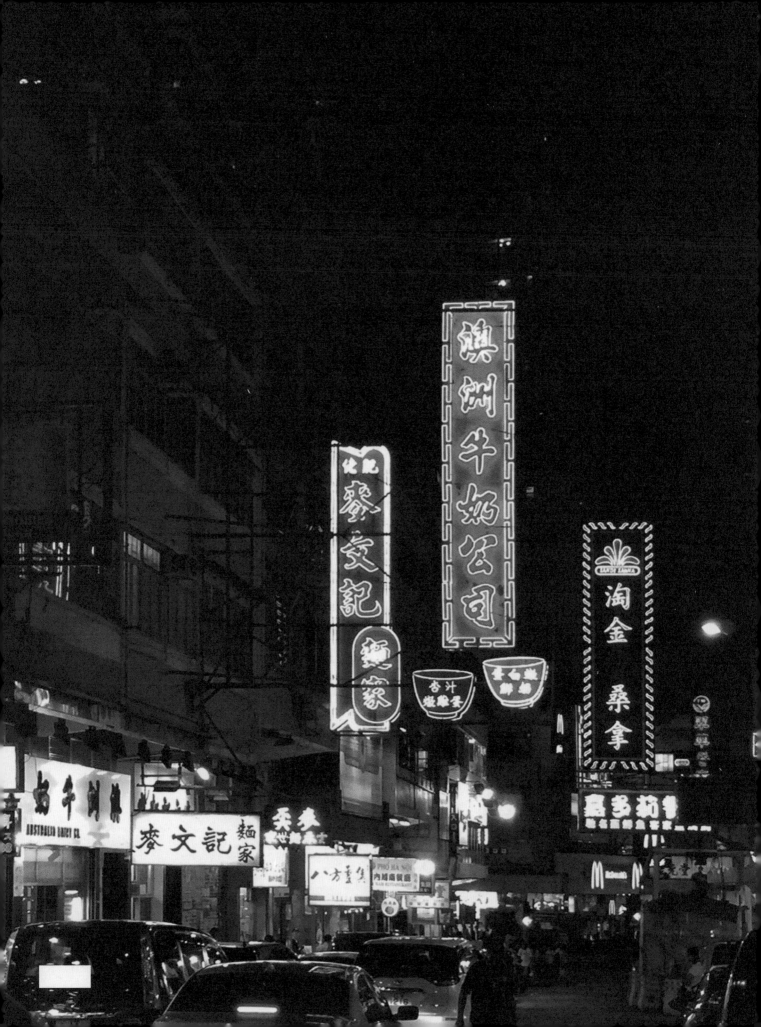

霓虹燈的誕生
The Birth of Neon Lights

1.1

霓虹燈的誕生

霓虹燈的誕生

一八九八年，英國倫敦兩個科學家 Sir William Ramsay 和 Morris W. Travers，在實驗裡發現在真空管注入氖氣（Neon，即霓虹），會發出迷人的紅光。其後，法國化學家與企業家 Georges Claude 把這個發明改良，以氖氣和電極的「明克勞德管（Claude Tube）」代替原本以二氧化碳和氮氣為主的「摩爾管（Moore Tube）」，使霓虹燈的光芒更持久。

Claude 的改良，為霓虹燈的商業化及普及化，正式揭開序幕。一九一〇年，霓虹燈首次公開亮相，Claude 在巴黎大皇宮舉行的車展上，展示兩個大型霓虹燈裝置，奪目哄動。當時的霓虹燈，只能發放有限的顏色，直至一九二〇年代末，經過科學家努力不懈反覆試驗，霓虹燈技術才有重大突破，真正做到五光十色、大放異彩。一九六〇年代，霓虹燈有二十四種顏色；二〇〇五年，霓虹燈顏色已發展至有近一百種。

The Birth Of Neon

In 1898, two scientists in London, the United Kingdom namely Sir William Ramsay and Morris W. Travers discovered in the laboratory that vacuum tubes filled with neon would emit mesmerizing crimson glows. The innovation was modified by French chemist and entrepreneur Georges Claude, by replacing Moore Tubes, mainly comprising carbon dioxide and nitrogen, with Claude Tubes made of neon gas and electrodes, to make neon glows more long-lasting.

Claude's improved design gave rise to the commercialization and popularity of neon lights, which stunned the audience during their first public showcase when two neon displays were displayed at a motor show held in Grand Palais in 1910. Neon lights at that time had only limited colours. Thanks to scientists' unremitting efforts and repeated experimentations, breakthroughs in the technology enabled neon lights to emit various kinds of colours, up to 24 in the 1960s and almost 100 in 2005.

上海南京路上百貨公司的霓虹燈，遠在江灣和浦東都可望見。（資料來源：《天光報》，一九三五年六月十四日。）

The signboards of department stores along Nanjing Road in Shanghai were visible from as far as Jiangwan and Pudong. (Information source: *Tin Gwong Po*, 14th June 1935)

二戰前已遍及全球

霓虹燈的出現震撼歐洲後，不久它就傳到美國。一九二三年，洛杉磯的市民第一次在城裡看到「PACKARD」車行的霓虹廣告牌。自此，霓虹燈熱潮席捲美國，單在一九三三年，曼克頓和布魯克林已安裝逾一萬六千多個戶外霓虹招牌；一九四〇年代，全美國有達二千間霓虹招牌公司；紐約時代廣場後來更成為了有名的霓虹燈展示場，多年來有不少大型廣告燈牌在此爭妍鬥麗。

緊隨美國之後，一九二六年，日本東京率先在亞洲安裝第一個霓虹廣告牌；同年，上海南京東路的伊文思圖書公司也安裝中國第一個霓虹廣告牌。當時的上海人稱霓虹燈為「年紅燈」，一來與「Neon」譯音相近，二來取「年年分紅」的吉利寓意。一九二七年，上海遠東化學廠開始生產霓虹燈；至一九三〇年代，在上海已滿目皆是霓虹燈。當時香港的《天光報》就曾形容，南京路上百貨公司的霓虹燈，遠在江灣和浦東都可望見。二戰期間，日軍佔領上海租界，並實行燈火管制，禁止亮起霓虹燈，導致大量霓虹工廠關閉。不過，戰爭無法阻擋霓虹燈的熱潮，戰後工廠陸續復業，在短短幾年間上海霓虹業的發展迅速達至高峰。

Neon Lights Brightened the Whole World before WWII

Shortly after its debut in Europe, neon lights were brought to the United States. In 1923, Los Angeles people saw the city's first neon signboard hung over car dealership PACKARD. Since then, the trend went viral throughout the country. In 1933 alone, over 16,000 outdoor neon signboards were erected in Manhattan and Brooklyn and by the 1940s, there were around 2,000 neon signboard companies across the country. Later, New York's Times Square became famous for being a neon signboard showroom where many large neon advertisements competed with one another for people's attention over the years.

In 1926, a little while after neon lights reached the United States, the first neon signboard in Asia was unveiled in Tokyo, Japan. In the same year, China welcomed its first neon signboard when Evans' Bookstore put up one on East Nanjing Road, Shanghai. Back then, Shanghainese called neon lights "nianhong" as the Chinese pronunciation sounded similar to "neon" in English, also because it referred to the auspicious phrase of "annual bonus" in Chinese. In 1927, Shanghai Far East Chemistry Company started to produce neon lights. By the 1930s, neon signboards were everywhere in Shanghai. Hong Kong newspaper *Tin Gwong Po* described the signboards of department stores along Nanjing Road as being visible from as far as Shanghai's Jiangwan and Pudong. During World War II when Shanghai's Concession was occupied by the Japanese army, light control was enforced and neon lights were forbidden to be turned on, causing many neon light companies to shut down. However, the war did not erode the popularity of neon lights. After it, neon factories resumed operation and the industry grew to its peak in Shanghai in just a few years.

香港首個霓虹燈

翻查文獻及報章，香港最早於一九二九年已有霓虹燈，當時的英文報章 *The Hong Kong Telegraph* 有一篇報導，指霓虹燈已在全球繁忙街道流行，終於來到香港這城市。雖然，比起東京遲了三年起步，但霓虹燈其後卻在香港發揚光大，甚至成為香港的文化符號，不論在電影或旅遊宣傳中，掛滿霓虹招牌的亞洲城市就是香港了。

當時的報導並沒有提及掛上霓虹燈的街道或區域，但卻詳盡介紹了這種在歐美國家流行的新技術，包括它是在真空玻璃管中加入稀有氣體「氖氣（Neon）」所製，能散發顏色燈光，也是當時唯一在霧中亦能看見的燈光。可以想像，霓虹燈在當時的香港而言是非常新奇的事物。

Hong Kong's First Neon Signboard

Neon lights were seen in Hong Kong as early as in 1929 according to literature and newspapers. Local English paper *The Hong Kong Telegraph* reported that neon lights finally reached Hong Kong after becoming common on all busy streets across the globe. Though they emerged in Hong Kong three years later than Tokyo, their development was brought to great height in the city. They have become a cultural symbol of Hong Kong, an Asian city widely recognizable in tourism promotions and movies by its abundance of neon signboards.

Reports on neon lights at that time did not mention the streets or districts where the signboards were installed. Instead, they focused on introducing this novel innovation prevailing in Europe and the United States, including its production by filling vacuum glass tubes with the rare gas of "neon" to create colourful lights, the only kind of light that could shine through the mist. As one can imagine, neon lights were very novel in Hong Kong at that time.

早期的本地霓虹業發展

位於士丹利街的「利華光管公司」，是最早的華資霓虹燈公司之一。從它在一九四七年的廣告標題〈十餘年老號 利華光管公司 為遠東放一異彩〉估計，利華光管在一九三〇年代初已成立。廣告中描述利華的霓虹燈：

> 本號新由美國運到各種顏色螢光粉管，怡情養眼，勝於燈光，艷麗柔和，足以照達，並各種光管原料，為本號獨家經理，但因發明伊始，在遠東尚屬創見，所以極得各界愛好，除裝設招牌及牆壁外，並多裝設戶內，以替代電燈，各界新裝或修理舊招牌申請等及裝較各種電器工程，請電下列地址，同業賜顧，一律歡迎。

"NEON" LIGHT.

AN EXPLANATION OF ITS NATURE.

An invention new to China, but one which has been attractively illuminating the busiest streets of the leading cities of the world for the last 14 years, has now reached Hongkong. It is known as "Neon"—a rare constituent of the air discovered decades ago, but now confined under glass in partial vacuum. A spectra of bright orange colour is brought to life by an electric discharge in vacua between two electrodes. Then we have Helium, a yellow gas, and Argonne, a purple, each named after the discoverers. These, with other gases, form a notable group which have great commercial use.

十餘年老號
利華光管公司
為遠東放一異彩

◀│霓虹燈於一九二九年在香港初現。
（資料來源：*The Hong Kong Telegraph*，
一九二九年十二月十六日。）
Neon signboards reached Hong Kong
in 1929. (Information source: *The Hong
Kong Telegraph*, 16th December 1929)

➡│根據這篇報導的年份推斷，利華
光管是最早的香港華資霓虹燈公司
之一。（資料來源：《工商晚報》，
一九四七年二月十五日。）
Estimated from the year of this
report, Lee Wah Neonlight was one
of the earliest Chinese-funded neon
light companies. (Information source:
The Kung Sheung Evening News, 15th
February 1947)

至於本地的首間外資霓虹燈工廠，則是在全球各地如上海等皆有分店的「克勞德霓虹公司」（Claude Neon Lights Fed., Inc.）。據 *Hong Kong Daily Press*（1932）報導，上海工廠擁有約四百名經驗豐富的霓虹燈師傅，霓虹燈的原材料都是由歐美進口。在港未設廠前，這品牌所出的香港霓虹燈都是由上海工廠專門製造，以滿足香港霓虹招牌市場的需求。但由於不同形式的霓虹燈廣告牌越出越多，有見及此，香港政府於一九三三年刊登憲報向公眾闡述規管霓虹燈廣告條例（香港政府憲報，1933）。

Early Development of Local Neon Industry

One of the earliest Chinese neon light companies established in Hong Kong was Lee Wah Neonlight located on Stanley Street. Based on the company's advertisement in 1947 titled "Lee Wah Neonlight: a decade-old established business shining over the Far East", the company should be founded in the early 1930s. The advertisement read:

> A range of coloured neon tubes imported from the United States are now available at our company. Neon makes a better lighting option with its glow bright enough for illumination, yet its softness brings comfort to the eye. Our company is the exclusive distributor of various tube materials. The new invention is novel and very popular among different industries in the Far East. Besides on signboards and walls, neon lights can be used indoor to replace light bulbs. For the production of new signboards and repair of old ones as well as various electronic works, please contact us at the following address. Industry peers are welcome for knowledge exchange as well.

NEON LIGHT FACTORY FOR HONG KONG.

TO EMULATE SHANGHAI'S 6,000 SIGNS.

The establishment of a subsidiary factory in Hong Kong for the production of Claude Neon Lights was foreshadowed the other day by Mr. W. Krause, special representative of the Claude Neon Lights Fed., Inc., U.S.A., who passed through the Colony on the P. & O. s.s. Ranpura. Mr. Krause is on his way to Bangkok to supervise the erection of a huge sign to be installed at His Majesty's Theatre in that city. The sign is not only one of the largest in the world, but also one of the most distinctive. Its blazing colours will send out its message for miles. Claude Neon offices all over the world have telegraphed requests for photographs after installation for use in their own advertising programmes.

Hong Kong's numerous Claude Neon signs are now manufactured at the Shanghai factory, in which city alone there are over 6,000 signs. At this factory there are some 400 well-trained and experienced workmen and only the highest-grade materials from Europe and the United States are used as, for instance, British wiring, General Electric transformers, Pyro glass tubing and the original Claude Neon gas.

早期的香港「克勞德」霓虹招牌都是由上海「克勞德霓虹公司」專門製造。（資料來源：*Hong Kong Daily Press*，一九三二年九月二日。）

Claude's Hong Kong neon signboards were all manufactured by its Shanghai factory during the early stage. (Information source: *Hong Kong Daily Press*, 2nd September 1932)

The first foreign neon light company established in Hong Kong was Claude Neon Lights Fed. Inc., which had branches all over the world including Shanghai. According to *Hong Kong Daily Press* (1932), its Shanghai factory hired about 400 experienced neon masters, with all raw materials imported from Europe and the United States. Before opening of the Hong Kong factory, all neon lights the company made for Hong Kong were produced by the Shanghai factory to fulfil demand from Hong Kong's neon signboard market. As the number of various neon billboards grew rapidly, the Hong Kong Government gazetted and explained to the public neon billboard regulatory measures in 1933 (*The Hong Kong Government Gazette*).

霓虹招牌的黃金年代

二戰後，香港經濟及工業發展在一九五〇年代重新起步，商品推銷需求龐大，讓霓虹廣告招牌迅速發展，霓虹燈製造公司也越來越多。一九六〇年代，百業興旺，酒樓、酒吧、夜總會、百貨公司、家庭電器、香煙及手錶名牌等尤其喜愛以繽紛搶眼的霓虹招牌吸引目光，香港街頭的霓虹招牌多不勝數，可謂本地霓虹的黃金時期。一九六六年，在一篇《華僑日報》報導中提到香港霓虹招牌可視為美術品來欣賞，當中的招牌色彩和圖案含有豐富的藝術性；當時香港製造的霓虹招牌設計和製作，吸引了一些外國商人下訂單，使香港的霓虹招牌與設計輸出到東南亞以至非洲各地。

將霓虹招牌輸出到東南亞的，包括南華霓虹燈電器廠有限公司。一九六五年六月五日，《華僑日報》報導譚華正飛往日本東京、大阪等地進行霓虹燈業務考察；翌年，《華僑日報》再報導譚華正飛往日本考察一星期，是因為當時日本正流行活動霓虹燈圖案，他跟專家會面並進行技術交流。報章除了講述日本考察外，亦提及譚氏曾到曼谷、新加坡和馬來西亞等地與霓虹燈製造公司高層或夥伴商討擴展海外業務。

一九五〇年代入行，在南華從學徒做到霓虹燈師傅的劉穩（穩師傅）在訪問中談到，當日譚華正親身飛到日本，正是為了客戶「樂聲牌」對科技和技術的要求。「『樂聲牌』要我們到日本看看他們供應的各種物料，例如電極及霓虹燈的顏色效果等。譚華正必須親身前往，以了解一切技術上的問題。由此得知，譚華正對這宗生意十分看重。」穩師傅解釋，譚華正因為與代理「樂聲牌」的蒙民偉有來往，所以南華能接下這個日本電器巨頭的生意。「是蒙民偉將『樂聲牌』這個客戶交給譚華正的。但一切關於『樂聲牌』的品牌和設計都必須向日本總公司負責，若做得不好就不會有下一次，所以譚華正當然十分著緊。」其後多年，南華為樂聲牌在香港打造了大大小小的霓虹招牌。

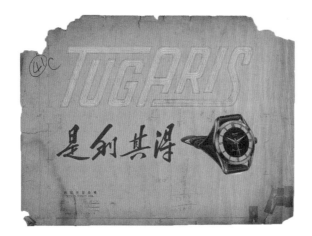

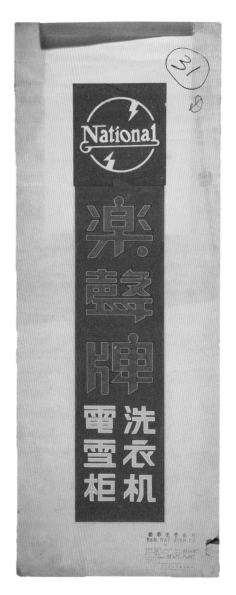

↑ |「得其利是」是六十年代的手錶品牌，這張手稿是由利國光管公司製作。

An artwork for Tugaris, a watch brand from the 1960s, created by Neco Neon Company.

➜ | 自六十年代起，香港經濟和民生逐步改善，洗衣機和雪櫃是昔日必備的家庭電器。

Along with gradual improvements in Hong Kong's economy and livelihood since the 1960s, washing machines and refrigerators became must-have household items.

The Heyday of Neon

After World War II, Hong Kong's economy and industrial development picked up again in the 1950s. With huge demand for consumer product promotions, the neon industry grew rapidly with an increasing number of neon light manufacturers. During the 1960s, various industries boomed and an array of businesses like Chinese restaurants, bars, night clubs, department stores, home appliance shops as well as cigarettes and watches brands all loved to draw people's attention with colourful and eye-catching neon lights. Streets were packed with uncountable numbers of neon lights and this period can be considered the golden era of the local neon industry. A news article from *Overseas Chinese Daily News* in 1966 reported that neon signboards could be appreciated as artistic works, with the colours and images carrying high

artistic values. The design and production of Hong Kong's neon signboards caught the attention of foreign companies, with the signboards and design starting to be exported to various countries in Southeast Asia and Africa.

Nam Wah Neonlight & Electrical Mfy, Ltd., founded locally in 1953, was one of the leading local neon companies which exported neon signboards to Southeast Asian. Its founder Dr. Tam Wah-ching was later known as Hong Kong's "Neon Tycoon". Its most famous signboard is the big outdoor one for the National brand in Jordan. The 20-storey-tall signboard broke Guinness World Records as the largest outdoor neon signboard back then. A news article from *Overseas Chinese Daily News* dated 5th June 1965 reported Tam's business inspection trips to Tokyo, Osaka and other cities. The following year, the same paper again reported Tam's one-week visit to Japan to meet experts and conduct technological exchange on animated neon light patterns popular in Japan at that time. Aside from Japan, the report also mentioned that Tam visited Bangkok, Singapore, Malaysia and other places to meet the senior management of local neon companies and business partners for the discussion of overseas business expansion.

Tam visited Japan in person due to National's stringent requirements for the production of their signboards regarding the technology and techniques employed, as recalled in an interview by neon light master Lau Wan, who entered the industry as an apprentice at Nam Wah in the 1950s. "National required us to fly to Japan to understand all the materials they supplied, such as electrodes, and the effects of different neon light colours. Dr. Tam insisted visiting the Japanese company himself to better understand the technology. It's evident that he valued this client a lot." Lau said Tam was a friend of National's distributor William Mong Man-wai, who connected Tam to the Japanese electronics conglomerate. "Mong introduced Tam to National. Everything related to National's branding and design had to be reported to its Japan headquarters. If the result had not been satisfactory, we would have lost the client. That's why Tam paid close attention to the production." Since then, Nam Wah has produced many neon signboards of various sizes for National in Hong Kong over the years.

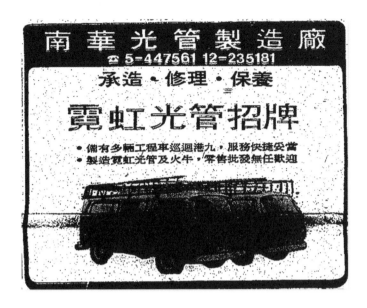

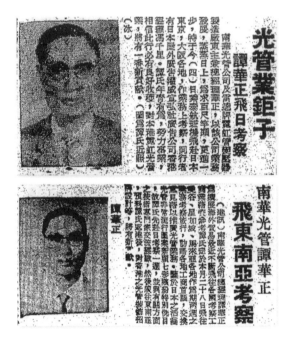

↑ | 昔日南華光管製造廠有限公司的廣告。
An old advertisement of Nam Wah Neonlight & Electrical Mfy, Ltd.

↗ | 六十年代譚華正經常到東京或新加坡考察，以擴展霓虹燈業務和進行技術交流。(資料來源：《華僑日報》，一九六五年六月五日 [上]；《華僑日報》，一九六六年七月二十七日 [下]。)
During the 1960s, Tam Wah-ching paid frequent business visits to Asian cities such as Tokyo and Singapore for neon light business expansion and technological exchange. (Information source: *Overseas Chinese Daily News*, 5th June 1965 (top) and 27th July 1966 (bottom))

香港特色：打風要熄霓虹燈

在香港，因為颱風而造成的霓虹招牌險象，也算為霓虹史添上獨特的一頁。香港位處南中國近岸地帶，常受颱風吹襲，戶外霓虹招牌在烈風中擺動搖晃、搖搖欲墜的景象，觸目驚心。霓虹招牌比一般招牌更危險，在於塌下會傷及途人之餘，燈牌的電線甚至可引致火警。早在一九三九年，政府已加例規定在天文台發出五號或以上風球時，光管招牌須熄燈（《大公報》，一九三九年七月三十日）。在一九六○年六月颱風襲港後，《華僑日報》有這樣的一段描述：「由於颱風襲港，而致本港酒店與街頭宣傳廣告之霓虹光管招牌等，毀壞不堪，時有墜下之可能，對路人等，實屬危險」，當中尤其灣仔的莊士頓道、高士打道及軒尼詩道為多。

但颱風過後，因為大量霓虹招牌需要搶修，反而成為霓虹燈公司的旺季。一九六四年《華僑日報》曾經記錄，當時搭棚工人的維修工程太多，即使日薪倍升、高達百元，仍是應接不暇。穩師傅記得一九六二年溫黛襲港後的情況：「對於一般做生意的人來說，打風並不好受，因為它對生意造成不同程度上的破壞和損失；但對做霓虹招牌生意的人來說，打風是一個很好的機遇或增加做生意的機會，因為很多霓虹招牌會因打風而損毀，很多店主會要求霓虹燈公司進行修補或更換，最終會為霓虹燈公司帶來豐厚的收入。」

Hong Kong Only: Neon Lights off During Typhoons

In Hong Kong, the dangerous situations typhoons created with neon signboards can also be regarded a unique issue in the history of neon lights. As Hong Kong is situated on the coastal shore of Southern China, it was frightening to see neon signboards swinging and shaking violently on the verge of collapse in strong winds. Neon signboards were more dangerous than regular signboards because other than the danger of falling and hurting pedestrians, the electric wires could start fires. The Hong Kong Government introduced a regulation in 1939, requiring all neon signboards to be turned off when typhoon signal no. 5 or above was hoisted (*Tai Kung Pao*, 30th July 1939). According to a news article published on *Overseas Chinese Daily News* in June 1960 after a typhoon, "the typhoon has caused severe damages to many hotel neon signboards and outdoor neon advertisements in Hong Kong, with some being on the verge of collapse, putting pedestrians' lives in great danger". Most damaged signboards were found on Johnston Road, Gloucester Road and Hennessy Road in Wan Chai.

However, typhoons brought good business to neon light companies since many damaged signboards urgently needed repair afterwards. A news article published in *Overseas Chinese Daily News* in 1964 recorded that due to a surge in repair orders, the daily pay of scaffolding workers doubled to a hundred Hong Kong dollars, but they were still overwhelmed with works. Lau recalled the situation after typhoon Wanda hit Hong Kong in 1962 and said "business owners hated typhoons because of the damages and losses caused to their businesses, but

typhoons brought business opportunities to neon makers as many business owners would request for repair or replacement, bringing good money to neon companies."

全球石油危機　霓虹要關燈

至一九七〇年代，香港的霓虹廣告招牌越設越多，據一九七三年的統計數字指出，當時全香港有達一萬八千個霓虹廣告招牌，它們所發出的光芒令鬧市街道每晚也燈火通明，但耗電量也十分驚人，佔全港總用電量三分之一。

在全球爆發石油危機時，香港的霓虹廣告招牌運作也大受影響，需「熄燈」以節省電力。一九七三年十二月十日，香港實施霓虹燈開放管制，規定商舖霓虹招牌只准每晚由六至十時亮燈，違者罰款（《大公報》，一九七三年十二月十日）。為回應燈火管制，一些商家率先響應節省能源呼籲，例如「樂聲牌」率先關掉九龍彌敦道上全遠東最大的霓虹招牌，為期兩周（《工商晚報》，一九七三年十二月三日）。

燈火管制不止令港九各街道在晚上十時後黯然失色，它亦帶來日常生活上的影響，例如市民索性早點回家，商舖因此生意驟減，也令黑夜中的劫案增加。當年的《工商日報》曾報導，為打擊熄燈後可能帶來的罪案上升，警察會增加晚上巡邏次數（《工商日報》，一九七三年十二月十日）。

在石油危機過後，香港經濟迅即復甦，霓虹招牌數目更在一年多急增四倍，據一九七五年所做的統計，當時全港共有八萬多個霓虹廣告招牌，香港區有二萬六千個，九龍區則有五萬四千個（《華僑日報》，一九七五年二月二十二日）。

踏入八十年代，香港逐漸成為國際金融中心，霓虹燈在香港的發展更上一層樓，國際企業爭相在香港豎立招牌，裝設的位置由面向街道上的行人，發展至面向維港，甚至更遠的地方。例如日本品牌「星辰錶」於一九八二年在銅鑼灣伊利沙伯大廈天台頂，建造當時最大的霓虹廣告招牌，據說這巨型招牌用了三英里長霓虹光管製造（《華僑日報》，一九八二年十月三十一日）；另一日本電器品牌「NEC」亦於一九九一年在五十層高的遠東金融中心頂樓豎立巨型霓虹招牌，其高度達三十二呎，公司的執行董事表示豎立大型霓虹招牌是對繼續在香港作長遠投資的承諾，並且對本港前途充滿信心（《華僑日報》，一九九一年六月三日）。由此可見，在香港維港兩岸豎立霓虹招牌不單純是建立國際品牌形象，也是對香港前途投以信心的實則舉動。

Neon Lights off During Oil Crisis

The number of neon billboards continued to rise in the 1970s, reaching 18,000 across Hong Kong in 1973 according to statistics. Their brightness lit up the busy streets of the city every night, but the electricity consumption was huge, accounting for up to one-third of the total electricity usage in Hong Kong.

Therefore, when the world was suffering from the oil crisis, the operation of Hong Kong's neon signboards was greatly affected as they were required to be turned off for energy saving. Amid the implementation of neon light control on 10th December 1973 in Hong Kong, businesses were only allowed to light up their signboards from 6 to 10 pm or they would be fined (*Tai Kung Pao*, 10th December 1973). Some businesses took the lead in responding to the call for energy saving. For example, National switched off for two weeks its giant neon signboard on Nathan Road in Kowloon, the biggest in Far East (*The Kung Sheung Evening News*, 3rd December 1973).

This lighting regulation not only threw the city into total darkness after 10 pm, but also resulted in shops' losing business as people got home earlier. More robberies were reported in the dark city so that the police had to increase night patrols to prevent crimes, as reported by *The Kung Sheung Daily News* (10th December 1973).

After the oil crisis, the Hong Kong economy rapidly revived, with the number of neon signboards rocketing by four folds within just over one year. According to 1975's data, there were a total of over 80,000 neon billboards territory-wide, including 26,000 on Hong Kong Island and 54,000 in Kowloon (*Overseas Chinese Daily News*, 22nd February 1975).

Entering the 1980s, Hong Kong gradually rose to become a global financial centre and the development of Hong Kong's neon industry also took a bigger leap. International brands competed to erect neon signboards in Hong Kong, of which the orientation went from facing street pedestrians to Victoria Harbour and beyond. For example, Japanese watch company Citizen put up the largest neon signboard at the time on the roof of Elizabeth House in Causeway Bay in 1982, using neon tubes spanning three miles as reported (*Overseas Chinese Daily News*, 31st October 1982). Another Japanese electronics brand NEC also installed a huge neon signboard on the top of the 50-storey Far East Finance Centre in 1991. The CEO said the 32-feet-tall neon signboard represented the company's confidence in the future of Hong Kong and its continual commitment of long-term investment in the city (*Overseas Chinese Daily News*, 3rd June 1991). It was evident that the erection of large neon signboards on both sides of Victoria Harbour was not only about international brand-building but also a tangible action showing their confidence in Hong Kong's future.

衰落

二〇〇〇年後，霓虹招牌行業在香港開始走下坡——原因包括霓虹光管工廠自九十年代為減省成本陸續北移；及後，屋宇署在二〇一〇年推行小型工程監管制度，銳意將不合規格、日久失修的霓虹招牌清拆，大規模的招牌清拆令昔日光輝不再。如今，香港的霓虹廣告招牌拆一個少一個，轉而換上更慳電、維修更容易的 LED 招牌，甚至是大型戶外屏幕，霓虹廣告招牌已逐漸變成歷史舊物。

Decline

The local neon signboard industry began to decline after 2000, with one of the reasons being the relocation of local factories to Mainland China since the 1990s for cost saving. With the launch of The Minor Works Control System by the Buildings Department in 2010, damaged neon signboards failing to comply with requirements were removed on a large scale, which also rapidly dimmed the vibrant neon cityscape of the past.

Today, Hong Kong's neon signboards continue to disappear one by one, replaced by energy-saving and low-maintenance LED signboards and massive outdoor display screens. Neon signboards are gradually becoming a part of history.

如今香港霓虹招牌拆一個少一個，自此光輝不再。
Hong Kong's neon signboards are disappearing one by one, rapidly dimming the distinctive and vibrant neon cityscape.

霓虹招牌考現學
The Modernology of Neon Signboards

1.2

昔日香港鬧市街道滿佈錯落交疊的霓虹燈，是構成香港城市景觀的重要視覺元素之一。每一塊招牌也以吸引消費者目光為首要重任。若以更宏觀的角度看，從字體種類、顏色配搭、大小、形狀、安裝的位置，可反映出這個城市的生活模式、行業盛況，甚至是社會結構等，因此多年來也吸引不少以街頭觀察城市的學者的注意。

所謂街頭觀察，早在一九二〇至一九三〇年代已在日本東京出現，當中的佼佼者為本身是建築師及民俗學家的今和次郎。一九二三年關東大地震後，今和次郎在城市裡觀察災後的人們生活與城市空間的變化，透過觀察、筆記、速寫、照片等方法採集數據並進行分類和統計分析，以客觀性的觀察來記錄當前的城市。他把這種結合人類學和民族學、研究當下城市的方法，稱為「考現學」，以對比「考古學」研究過去的分別。

「考現學」的出現，也影響了不少後來研究香港城市的日本學者——最先在香港觀察街道招牌的，是一班旅居香港的日本城市研究者。一九八九年，香港社會學家呂大樂與日本城市社會學家大橋健一，編著了《城市接觸——香港街頭文化觀察》，集合一群本地學者與日本學者的文章，當中包括由來自日本山口文憲的一篇〈出街——談招牌〉，是最早以街頭觀察研究香港招牌的文章。他當時是如此形容八十年代的香港街道空間：

> 香港街道的風景中，是沒有半點兒空白的，簡直像一個患上空間恐懼症的精神分裂病人所描繪的圖畫般，街道的上空，掩埋著一片驚人的招牌森林。

山口文憲細緻地描寫了街道招牌的疏密，進程猶如人的成長過程，由幼年期、青年期，再發展到壯年期。他形容，在街道上伸展出來的招牌，壯年期的狀況已變得「亂七八糟」。「倘若你了解到招牌為什麼是那樣子的話，你自然也會明白到香港為什麼會是那樣子的。」而大橋健一在同一本書裡，也寫了一篇〈日語招牌生態學〉，嘗試梳理在尖沙咀出現的日本語招牌的象徵意義，從而了解招牌跟當地的旅遊活動有著密切的關係。

因為招牌的任務就是要搶奪行人的目光，它們總要在已有的招牌之間搶佔未用的空間，務求在眾多招牌中亮相，所以在同一街道上，招牌總是高低不一、有橫有直，建構出來的街道景觀就更複雜且多層次。

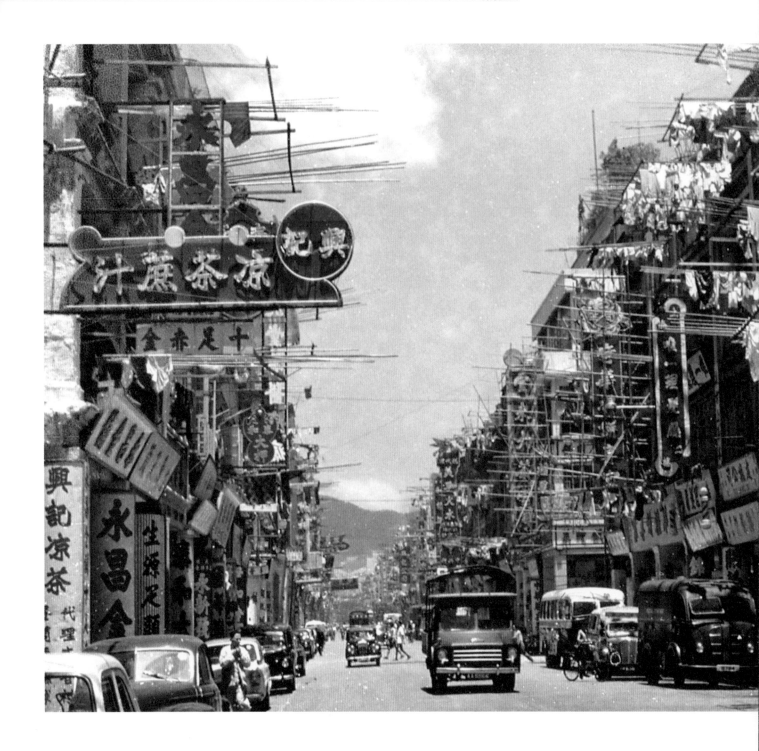

昔日香港街道滿佈縱橫交錯的霓虹招牌，建構出獨有的城市景觀。（照片由高添強提供）
Overhanging neon signboards above the bustling streets weaved Hong Kong's unique cityscape. (Photo courtesy of Ko Tim-keung)

The countless neon signboards overlapping each other like colourful bolts of cloth over the busy streets of old Hong Kong formed one of the key visual components of the cityscape. Considering from a macro perspective, the typography, colour palettes, sizes, shapes and locations of signboards actually reflect Hong Kong's lifestyles, industry development and even societal structure. Over the years, many scholars have been drawn to learn about Hong Kong through the study of neon signboards by street observation.

The term "street observation" first appeared in Tokyo, Japan as early as in the 1920s and 1930s. After the Great Kanto earthquake in 1923, Japanese architect and ethnographer Wajiro Kon was the most prominent scholar who studied the changes in the lives of Japanese people and urban space by collecting data through observing, note taking, quick sketching and photo taking. He then classified and analyzed the data to create objective records of the city at that time. He named this methodology for contemporary city study combining anthropology and ethnography as "modernology", in contrast to "archaeology" which refers to the study of the past.

The emergence of "modernology" had later influenced many Japanese scholars studying the city of Hong Kong. Those who conducted the earliest studies of Hong Kong signboards were a group of Japanese city researchers who travelled and lived in the city. In 1989, Hong Kong sociologist Lui Tai-lok and Japanese urban sociologist Kenichi Ohashi co-wrote the book *City Touch – An Observation of Hong Kong Street Culture*, which is a collection of writings by local and Japanese scholars. One of the articles, "Going Out – Signboard Talks" by Japanese Fuminori Yamaguchi, is the earliest essay recording the study of Hong Kong signboards through street observation. He describes space on Hong Kong streets in the 1980s this way:

> *There is not a single inch of blank space in Hong Kong's streetscape. It is like a drawing by a schizophrenic patient suffering from kenophobia — sprawling beneath the empty sky is an astonishing forest of signboards.*

Yamaguchi describes in detail the density of signboards on the streets of Hong Kong by comparing their development to the growth of humans from childhood through adolescence to adulthood. He mentions that the signboards extended from buildings became messy in their adulthood. "If you understand signboards, you understand Hong Kong," said Yamaguchi. In the same book there is another essay by Ohashi titled "*The Ecology of Japanese Signboards*". By categorizing the symbolic meanings of Japanese characters on signboards found in Tsim Sha Tsui, he attempts to understand the close relationship between signboards and local tourism.

Since signboards are intended to grab the attention of pedestrians, they must compete for unoccupied space among existing signboards to stand out from the cluttered crowd. That is why neon signboards are always hung at different heights horizontally and vertically, together weaving a complex and multi-level neon streetscape for Hong Kong.

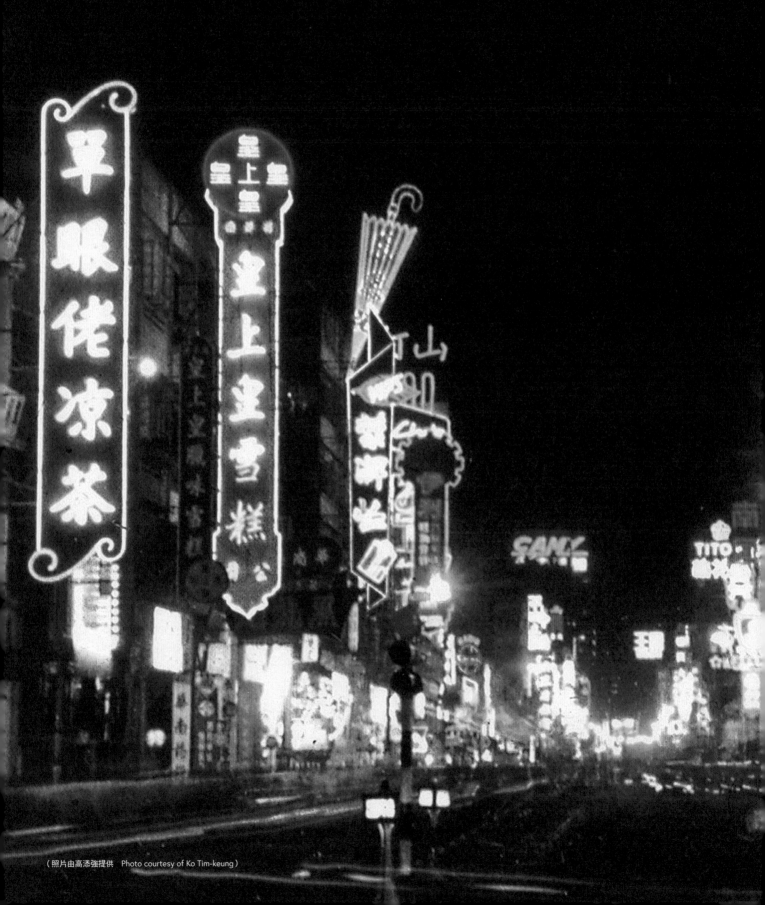

（照片由高添強提供　Photo courtesy of Ko Tim-keung）

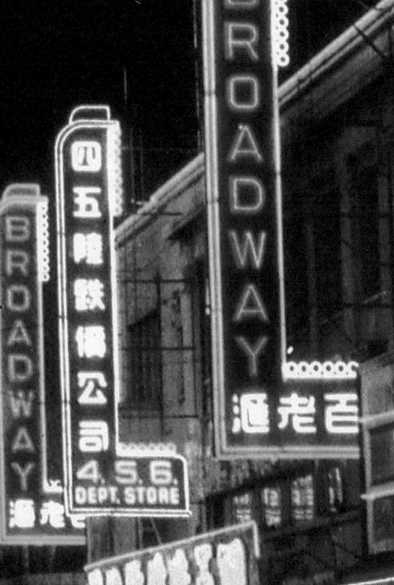

淺談香港
飲食文化與歷史

2

A
Brief Introduction
of
Hong Kong's Food
Culture and
History

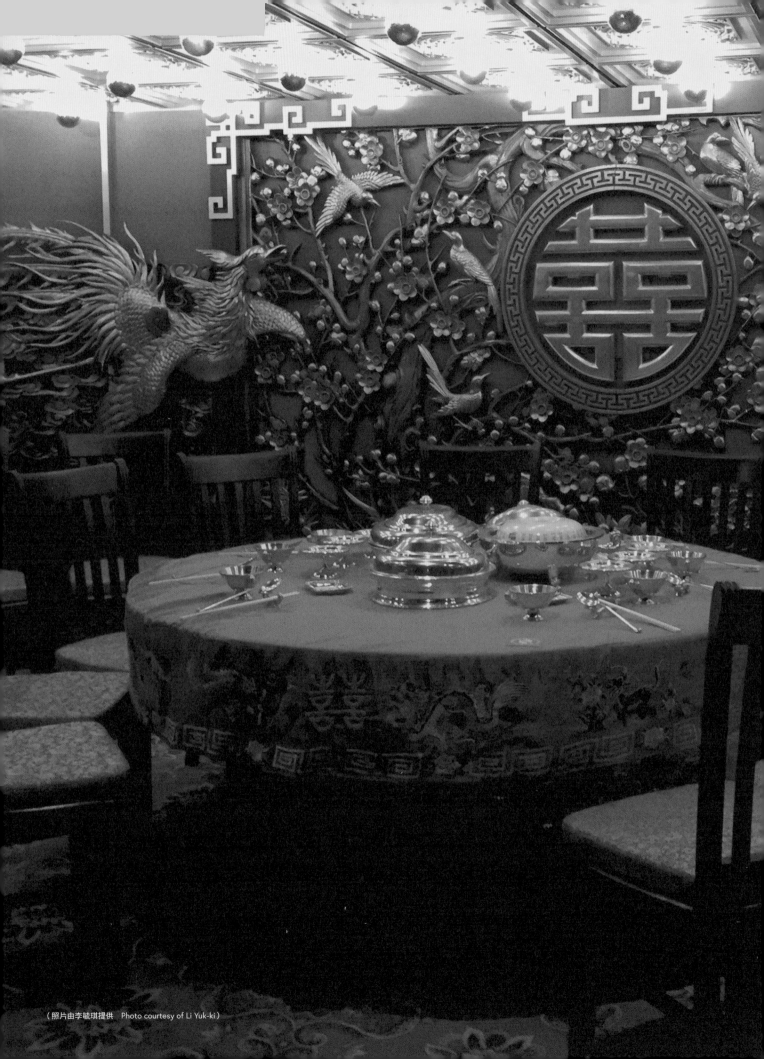

（照片由李毓琪提供　Photo courtesy of Li Yuk-ki）

香港飲茶文化
Hong Kong Tea Culture

2.1

記得兒時，我曾在家樓下的一家小酒家做短期暑期工，主要負責做一些廚房裡的雜務。這酒家雖然細小，但五臟俱全：早市有為晨運客提供的一盅兩件；午市則有燒味部提供各式燒味飯，令一眾勞苦大眾大飽口福；晚市更是人頭湧湧，酒家門前設置舊式大魚缸，供客人挑選生猛海鮮。踏入冬天，酒家門外更有供應各式熱騰騰的煲仔飯和時令羊腩煲，門外一排排火力十足的炭爐，十分有氣勢。由於價錢相宜，長期深受街坊愛戴，食客大多是街坊鄰里，每圍枱都是相熟的老街坊，或是在當區工作的上班族，食客之間打成一片，就像一個社區中心。所以這酒家每晚都十分熱鬧，食客的快樂笑聲此起彼落，不亦樂乎。

酒樓在香港人的飲食文化中一直佔有很重要的位置，去酒樓飲茶食飯，不單是為了果腹，也是一種習慣，例如我們經常聽到「得閒去飲茶」這句口頭禪；酒樓除了是屋企以外一家人經常聚首的地方，人生各種大事例如解穢酒、婚宴、謝師宴、滿月酒及和頭酒等，都會在餐枱上解決。飲茶食飯背後蘊藏的飲食文化，其實載有本地人的生活模式、價值觀，甚至是跟社會結構、發展歷程等相關。在這一章節，我們將從食肆的霓虹招牌手稿中，淺談中西飲食文化影響下的香港飲食文化發展。

香港的多元文化及由其衍生的各式美食，使香港有「美食天堂」的美譽。香港的飲食文化受鄰近廣州一帶所影響（吳昊，2001），正所謂「食在廣州」，昔日的香港飲食習慣都以廣州飲食文化為主，其後廣州人品茗的習慣在香港也隨之興起。因此，廣州不少酒樓例如蓮香樓紛紛來香港開分店，讓茶樓和茶室一時間遍佈香港，廣州的茗茶文化也逐漸受香港人歡迎。

據香港典故專家鄭寶鴻（2003）在《香江知味：香港的早期飲食場所》所寫，本港第一間茶樓是一八四六年在威靈頓街與鴨巴甸街交界開業的杏花樓。後來由於中區逐漸發展成商業區，妓院和酒樓只好陸續遷出，搬往石塘咀一帶，附近是「太平山娼院區」及「水坑口風月區」。稱得上「風月區」，因為這裡處處是尋花問柳的場所，不過，這一帶也有不少食肆及酒家，例如杏花樓，正是為富有嫖客提供飲花酒而開設的場所。由於生意興旺，妓院和酒家越開越多，後來開設的有陶園、萬國、金陵等。

香港開埠初期，茶樓數目不算太多，這是因為香港一直實行宵禁令，限制居民晚間活動，直至一八九七年宵禁令解除後，茶樓就如雨後春筍，茶居、茶社、茶館和茶座等也陸續出現，它們集中在中上環一帶；同時，茗茶文化也在香港各處遍地開花。

When I was young, I got a summer job at a small Cantonese restaurant near my home doing chores in the kitchen. Despite its scale, it offered a complete menu, including breakfast deals in the morning for early birds and packed roasted meat (siu mei) rice boxes for hardworking citizens to feast on at lunchtime. Diners swarmed the restaurant in the evening, picking fresh seafood

from the old-fashioned fish tank in front of it. During winter time, the restaurant offered all kinds of piping hot clay pot rice and seasonal lamb stews on a row of blazing charcoal stoves lined up outside its door. Considered a neighbourhood treasure due to its affordability, the restaurant served familiar customers who were either neighbours or office workers in the area. Everyone got along well with each other, transforming the restaurant into a community centre. Night after night, the entire restaurant was filled with the joyful laughter of diners.

Cantonese restaurants have always played an important part in Hong Kong's food culture. We don't have tea or meals there just out of hunger but it is a habit, as described by the common saying "let's go have tea sometime". Apart from being a place where families get together outside home, Cantonese restaurants are the venues for commemorating many important milestones in life, such as funeral repasts, wedding banquets, teacher appreciation banquets, baby showers, reconciliation banquets and more. Behind the eating and drinking lies a wealth of dining culture, carrying local lifestyles and values as well as social structure and developmental history. In this chapter, we will briefly talk about the development of Hong Kong's food culture under Chinese and Western influences using neon light signboard sketches as a roadmap.

The diverse culture of Hong Kong and the countless delicacies it has inspired has earned the city its appellation "Food Paradise". Culinary culture in Hong Kong was greatly influenced by Guangzhou, which was also renowned for its food (Ng, 2001). The culinary habits of old Hong Kong revolved around Guangzhou's food culture and the tea drinking habits of Guangzhou were adopted in Hong Kong quite naturally. One by one, many tea houses from Guangzhou, such as Lin Heung Lau, came to open branches in Hong Kong. All of a sudden, tea houses and tea rooms became prevalent on streets, with more and more Hongkongers embracing Guangzhou's tea drinking culture.

According to *Early Hong Kong Eateries* by folk expert Cheng Po-hung (2003), the first tea house in Hong Kong was Heng Fa Lau established at the junction of Wellington Street and Aberdeen Street in 1846. As Central gradually developed into a business centre, brothels and tea houses moved to Shek Tong Tsui, neighbouring the Tai Ping Shan and Shui Hang Hau red-light zones. Concentrated with brothels, the areas also had many restaurants and tea houses. Heng Fa Lau, for example, was opened expressly to target wealthy brothel visitors, offering them a place to drink wine and fool around. As the industry boomed, brothels and tea houses grew in number, including Tao Yuen, Man Kwok and Kam Ling which later entered the picture.

In the early days of Hong Kong's opening up as a port city, there were not many tea houses due to a curfew policy that restricted residents' evening activities. After its abolition in 1897, tea houses sprang up like mushrooms after the rain. Tea cafes, tea clubs, tea stands and tea stalls also began to pop up mainly in Central and Sheung Wan. At the same time, the tea drinking culture blossomed everywhere in Hong Kong.

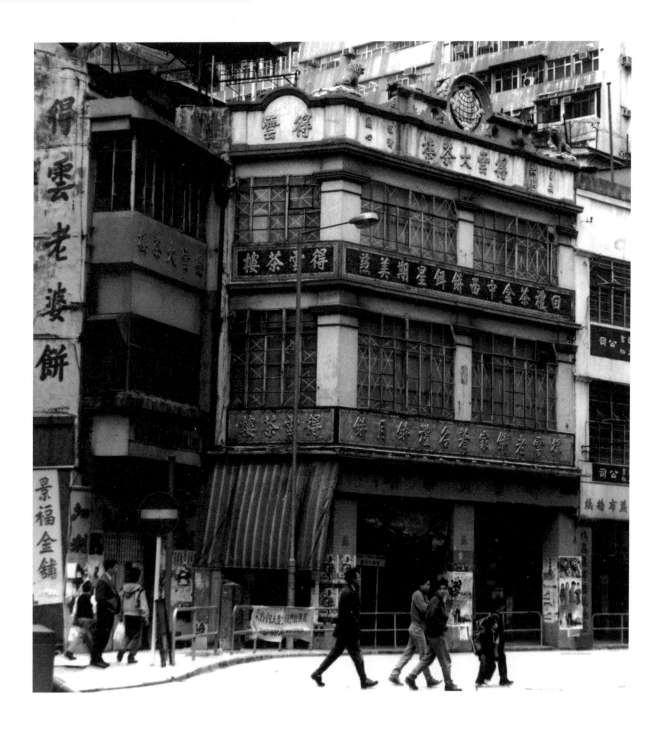

得雲茶樓早於十九世紀末開業，早期叫「德雲茶居」，後改為「得雲大茶樓」，於九十年代初結業。（照片由高添強提供）

Opened in the late 19th century, Tak Wan Tea House had served the neighbourhood for a century until it was closed down in the early 1990s. Its Chinese name was changed from "Tak Wan Tea Room" to "Tak Wan Tea House". (Photo courtesy of Ko Tim-keung)

茶樓與酒樓酒家
Tea Houses and Cantonese Restaurants

2.2

二十世紀初，茶樓和酒樓在經營時間上截然不同。昔日的酒樓或酒家只做晚宴，營業時間大致上是下午五時至凌晨二時。而由於港人早已秉承廣州飲茶文化，早上喜愛上茶樓歎茶、吃一盅兩件，早期的茶樓多只做早午市，於清晨四、五點開市，這可能是配合往時「日出而作、日入而息」的簡樸生活節奏，茶客在享用茶和包點後，便開始一天的工作。

根據吳昊在《飲食香江》（2001）裡提到，舊日的茶樓有不同種類，設有兩層樓或以上的，稱為「大茶樓」；規模較小或只有地舖的，則稱「茶居」、「茶室」、「地檔」或「二里館」。昔日的大茶樓一般是三層高，樓層越高，茶錢收費也越貴，上層稱為「樓上雅座」，因為樓上窗戶通風，亦可眺望遠處風景，可讓茶客閒坐，慢慢品茗，茶價自然也貴一點。據悉當時樓上雅座特別受愛捧雀籠的茶客歡迎，因此茶樓的座位較高位置常有掛鉤，茶客可以寫意地一邊品茗，一邊賞雀。

至於地舖茶樓，則稱為「地踎」茶樓，皆因地舖佈置較雜亂簡陋。「地踎」茶樓的客人，多數是勞動階層或普羅大眾，不少茶價只收兩厘，所以又稱為「二里館」。相比「二里館」，「茶居」的空間佈置會略為舒適，可以吸引一批有閒階層光顧。從昔日的茶樓收費高低，可了解當時華人的不同社會階級和生活方式。

另外，昔日有不少茶樓選址在碼頭附近，因工人會在上船前與大夥兒品茶。昔日在深水埗碼頭附近可以找到信興酒樓；而早期的得如酒樓，也靠近昔日的旺角碼頭和佐敦碼頭。

In the early 20th century, tea houses and Chinese restaurants had distinctively different opening hours. Chinese restaurants only served dinner and typically opened from 5 pm to 2 am. Since Hongkongers had completely adapted to Guangzhou's tea drinking culture and liked having tea and dim sum in the morning, most tea houses only served breakfast and lunch, opening at around 4 or 5 am to match the simple lifestyle of "early to bed, early to rise", so that diners could begin the day's work after having tea and breakfast.

According to *Dining in Hong Kong* by Ng Ho (2001), there used to be different types of tea houses. Those that occupied two or more floors were known as "grand tea houses", while smaller establishments or those on the ground floor were called "tea cafes", "tea rooms", "tea stalls" or "Yi Lei Kwun". Most grand tea houses had 3 storeys. The higher the storey, the more expensive the tea. The top floor was often called a "lounge", where charges were higher with better window ventilation and farer views, so customers could relax and enjoy their tea in peace. At the time, lounges were particularly popular among customers with pet birds in cages, so tea houses installed hooks on upper storeys for bird cage hanging, so that customers could appreciate the birds while sipping tea.

Tea houses that only occupied ground floors were called "Tei Mau" (literally

low-priced tea rooms) because of their messy and crude interiors. Most customers were grassroots workers or the general public. Many of these tea rooms only charged two Chinese copper coins for tea, which was why they were also called "Yi Lei Kwun" (literally house charging two copper coins). Compared with a "Yi Lei Kwun", a "tea room" was more comfortable and thus attracted relatively well-off patrons. The various pricing reflected the different social classes and lifestyles in Chinese society at the time.

Meanwhile, many tea houses in the past were located near the piers, so members of the working class could gather and have tea before boarding ships. Some examples of early tea houses included Shun Hing Restaurant near the then Sham Shui Po Ferry Pier and Tak Yu Restaurant near the then Mong Kok and Jordan Ferry Piers during its early years.

酒樓酒家

戰後，香港經濟逐漸復甦，食肆在局勢穩定後漸入佳景，市民外出消費的意欲也恢復高漲，新的茶樓或酒樓在各區也成行成市。除了粵菜外，來自北京、上海、湖南、福建等的餐館，亦紛紛在香港提供京菜、杭州菜、川菜和滬菜等，使香港的食肆百花齊放。從一九四九年的報紙廣告中的食肆分類得知（《大公報》，一九四九年四月七日），當時香港的食肆已有供應不同的中國傳統菜式如粵菜、川菜、天津菜、京滬菜、福建菜、雲南菜等，已漸見「美食天堂」的雛形。

六十年代，香港人口不斷增加，除了因為中國內地內戰逃難來港的難民外，還有戰後第一代在香港出世的嬰兒潮。內地的技術、資金和人口，為日後香港帶來新的經濟動力。香港從昔日的轉口港，逐漸轉型至輕工業，並成為勞工密集的製造業城市。大量塑膠、玩具、電子、紡織製造工廠出現，吸納了大量勞動人口，亦為大眾帶來相對穩定的收入。所謂「為口奔馳」、「搵餐飯食」，市民的生活得以改善，無疑帶旺飲食行業，特別是酒樓，不論婚禮、升遷、壽宴和滿月等喜慶，人們都不吝嗇在酒樓設宴。無怪乎，在我們的霓虹招牌手稿中，可見中式酒樓或茶樓的手稿數目佔最多。

茶樓和酒樓酒家均陸續延長營業時間，自此茶樓與酒樓的界線開始變得模糊。《華僑日報》曾指出，一九五九至一九六二年間是茶樓酒家的黃金時期（《華僑日報》，一九六五年一月五日）。不過，時移世易，食肆的經營手法也趨向以集團式經營。食客不再追求一盅兩件的質素，只求滿足果腹需要；同時，也提出新的期望，例如酒樓的裝潢氣派、服務態度等。所以新式酒樓的設計佈局推陳出新，空間更為寬敞，裝潢設計也流行富麗堂皇、金碧輝煌，大廳牆身背景會擺上立體的龍鳳裝飾雕塑。

到了七十年代，酒樓行業就如經濟寒暑表。七十年代初，股市暢旺，社會一片歌舞昇平，市民大吃大喝，大灑金錢，更曾出現「魚翅撈飯」的奢華日子，酒樓酒家生意蒸蒸日上，業務快速增長。直至一九七三年股災，經濟重創，市民對前景悲觀，消費力大減，酒樓的生意亦一落千丈，更有不少缺乏資金的酒樓酒家在無法經營下而不得不結業。

Cantonese Restaurant

Hong Kong's economy gradually recovered after World War II and the restaurant industry began to thrive after the political climate stabilized. As people's consumption desire returned to a high level, new tea houses and restaurants sprang up in various districts. Apart from Cantonese cuisine, restaurants from Beijing, Shanghai, Hunan and Fujian started to offer Beijingese, Hangzhouese, Sichuanese and Shanghainese cuisines, resulting in a booming restaurant scene in Hong Kong. A restaurant listing found in a newspaper advertisement published on *Tai Kung Pao* (on 7th April 1949) showed that a remarkable variety of traditional Chinese cuisines were available at the time, namely Cantonese, Sichuanese, Tianjinese, Beijingese, Shanghainese, Fujianese, Yunnanese and more. It was clear that Hong Kong was already well on its way to becoming a "Food Paradise".

In the 1960s, Hong Kong's population grew continuously with the arrival of refugees fleeing from the Chinese Civil War and the first post-war baby boom. Technology, funds and manpower from the Mainland invigorated the Hong Kong economy with new drivers, transforming Hong Kong from an entrepôt into a labour-intensive light industry city later. Numerous plastic, toy, electronics and textile manufacturing factories emerged and employed a significant number of labours, providing the general public with relatively stable income. As suggested by popular sayings such as "earn one's daily bread" and "bring home the bacon", improved general living standards gave rise to a flourishing food and beverage industry, particularly benefitting banquet halls since celebratory events such as wedding, promotion, birthday or baby shower were lavishly celebrated at banquet halls. No wonder that most neon sketches belonged to Chinese restaurants and tea houses in our artwork archive.

As tea houses and restaurants extended their opening hours one after another, the distinction between them started to blur. As suggested by an article published in *Overseas Chinese Daily News* (on 5th January 1965), the period between 1959 and 1962 was the golden age of tea houses and banquet halls. However, as things evolved with time, restaurants shifted towards commercialization and chain operation. Diners no longer pursued tea and dim sum quality but simply desired to fill their stomachs. Instead, they developed new expectations, including decors and services. In response, new restaurants boasted spacious rooms, grand interior designs and glamorous decorations such as life-like dragon and phoenix sculptures on the walls of their main halls.

In the 1970s, the business of the restaurant industry went up and down

following the economy trend. In the early 1970s, the stock market boomed and the society was flourishing. People indulged themselves in extravagant food and drinks, living luxury lifestyles and even served rice with braised shark fin. Many restaurants thrived and expanded their business. However, the 1973 stock market crash devastated the economy. Citizens became pessimistic about the future and restaurants' business took a nosedive with consumption plummeted. Many restaurants had to close down due to a lack of funds.

星期美點

陸羽茶室星期美點紙
Luk Yu Tea House still maintains the tradition of weekly special offering.

在霓虹廣告手稿中，會見到茶樓招牌上寫上「星期美點」作賣點。昔日不論是茶樓、茶居或二里館，售賣的點心款式單調有限，主要是包點、蝦餃和燒賣三種，當中包點分為鹹包和甜包，鹹包所指的就是到了今天仍然售賣的叉燒包和生肉包。如果想吃多款式的點心，則要到茶室，相比茶樓，茶室雖然空間略小，但環境清幽，點心款式多樣化。

當行業的競爭越來越激烈，茶樓也不得不推陳出新以作招徠，例如推出「星期美點」，每逢星期六及日推出新穎點心，每周推出六至八款精美點心以吸引茶客光顧。茶樓除了登報紙做宣傳外，茶樓酒家的霓虹招牌亦經常寫上「星期美點」作賣點。

時至今日，不論是茶樓或茶室，已逐漸被新興的酒樓或酒家所取替；加上在城市發展下，舊式唐樓陸續拆卸，這些茶樓或茶室也慢慢地消失。現在，茶樓只剩下寥寥數間，例如陸羽茶室和蓮香居等，但只有陸羽茶室仍保留這種「星期美點」的傳統。

Weekly Specials

From the neon sketches, we can see that many tea houses put "weekly specials" on their signboards as a selling point. In the past, the availability of dim sum was very limited at tea houses, tea cafes and "Yi Lei Kwuns", which primarily offered buns, prawn dumpling and siu mai. There were savory and sweet buns, with savory buns referring to barbecue pork bun and minced pork bun still available today. For more varieties of dim sum, one had to visit tea rooms, which were generally smaller than tea houses but offered a more pleasant environment and more dim sum choices.

As competition grew more intense, tea houses were forced to attract customers with new offers such as "weekly specials", providing six to eight new dim sum delicacies every Saturday and Sunday to boost business. Apart from publishing ads in newspapers, tea houses also promoted this by putting the words "weekly specials" on their neon signboards.

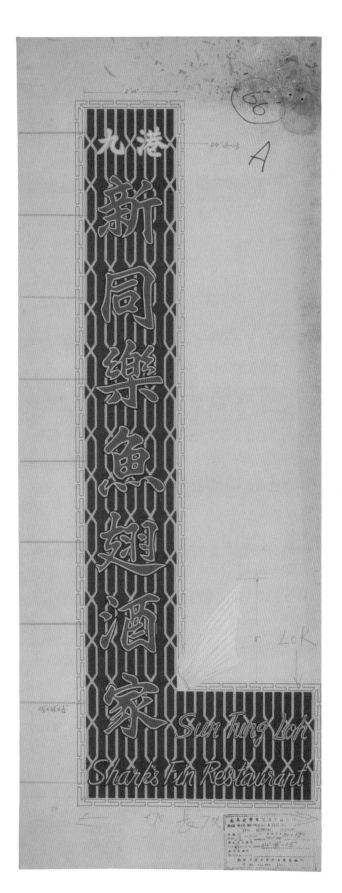

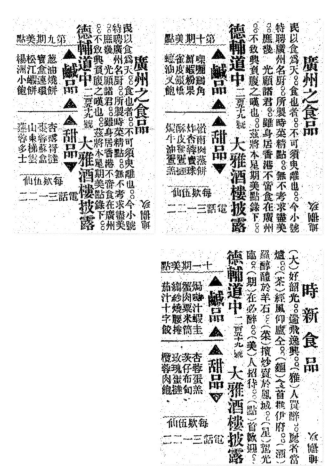

↑｜從以上三則報紙廣告中，可見這間大雅酒樓於一九二六年四月內一連推出三期「星期美點」，每期有八道小食或點心，鹹點、甜點各四款。（資料來源：《香港工商日報》，一九二六年四月十三日［左］，一九二六年四月二十日［右］，一九二六年四月二十六日［下］。）

The three newspaper clippings above depict three sets of weekly specials offered by Tai Nga Cantonese Restaurant in April 1926. Each set comprised eight snacks or dim sum, four of them were savory and four were sweet. (Information source: *The Kung Sheung Daily News*, 13th April 1926 (left), 20th April 1926 (right) and 26th April 1926 (bottom))

←｜新同樂魚翅酒家的招牌令人想起七十年代「魚翅撈飯」的奢華日子。

The neon signboard of Sun Tung Lok Sharks Fin Restaurant is reminiscent of the luxurious days of "serving rice with braised shark fin" during the 1970s.

Nowadays, tea houses and tea rooms have gradually been replaced by modern restaurants and Cantonese restaurants. Along with urban development, old Chinese buildings were demolished one by one, leading to the gradual disappearance of tea houses and tea rooms. Only a few tea houses remain in business now, such as Luk Yu Tea House and Lin Heung Kui, but only Luk Yu Tea House has kept the tradition of weekly special offering.

「茶花」和「茶博士」

茶室廣告中提及「女招呼」。(《香港工商日報》,一九二六年四月二十六日。)

A tea house ad mentioning "female attendants". (*The Kung Sheung Daily News*, 26th April 1926)

以往因為傳統的社會觀念,女人不可以拋頭露面,上茶樓光顧的客人都是以男茶客為主。他們到茶樓聊天、捉棋和玩雀等來消磨一天的時間,在茶樓工作的也只有男侍應,亦稱「茶博士」。顧名思義,他們熟悉不同茶的種類,也熟悉茶客的口味,平日多為茶客沖水,亦會與熟絡的茶客聊天。若茶客與茶博士打好關係,會獲得茶博士的優待,例如預留座位,毋須排隊等候(梁廣福,2018)。

直至一九二五年省港大罷工才打破只有男侍應的生態,因為沒有男侍應上班,酒樓主管唯有聘用女工頂替,當時這個破天荒的做法,不單成為解決人手短缺的及時雨,甚至成為在男尊女卑社會文化下的噱頭,吸引了一批帶著奇異眼光的顧客光顧,使到因大罷工而瀕臨結業的酒樓因而起死回生(吳昊,2001;鄭寶鴻,2003)。昔日的女侍應稱為「茶花」或「女招呼」,在一九二六年的茶室廣告中,也有提及「女招呼」。同年,另一則有關茶樓的評論,文中亦特別形容在場的女侍應「如紫燕穿梭,輪流沖水,皆淡定溫雅」。時至今日,在茶樓酒家工作的女侍應已十分普遍,顧客們沒有年齡或性別限制,茶樓酒家更成為家庭聚會的最佳飲食場所。

Tea Ladies and Tea Masters

Conservative societal values of the past dictated that women should avoid going out and appearing in public, thus most tea house customers were men who spend their leisure time there chatting, playing chess and playing with their pet birds. Moreover, only men were allowed to work at tea houses as waiters, known as "tea masters". As the name suggests, they were knowledgeable about different types of teas and familiar with patrons' preferences. They refilled teapots and chatted with the regulars. Customers who got along well with tea masters would receive preferential treatment, such as table reservation so they could bypass the queue up process (Leung, 2018).

The Canton-Hong Kong strike in 1925 put an end to the custom of male waiter hiring. As waiters were on strike, tea house owners were forced to employ female workers as replacements. This groundbreaking move not only alleviated the labour shortage in time, but also became something of a publicity stunt in a male-dominated society, attracting curious customers who wished

to observe such an oddity in action and saving tea houses on the brink of closure due to the strike (Ng, 2001; Cheng, 2003). These waitresses were known as "tea ladies" or "female attendants", with the latter used in a tea room ad in 1926. A tea house review published in the same year described waitresses in tea houses as "graceful as swallows, taking turns pouring tea with poise and composure". Nowadays, waitresses are very common without age or sex discrimination, while tea houses and Cantonese restaurants have also become the best venues for family gatherings.

月餅會

昔日酒樓除了做食肆外，售賣月餅也是一椿有利可圖的生意，難怪在酒樓的招牌手稿中，很容易找到售賣月餅的宣傳字句。
Mooncake selling made a good business for Chinese restaurants. Mooncake promotion messages were often seen on neon signboard artworks.

酒樓酒家除了做食肆生意外，售賣月餅也是一宗有利可圖的大生意。鄭寶鴻曾寫道，昔日單是售賣半個月月餅已佔了茶樓一年的大部份收入（鄭寶鴻，2016），所以這也是各大酒家酒樓的「必爭之地」。當年為了迎接中秋佳節，酒樓會提早一個月前開始為室內佈置；更有大型傳統酒樓不惜工本，在酒樓外牆掛上大型廣告，例如八仙過海、嫦娥奔月等應節宣傳；又例如六十年代末，美國太空人首次登陸月球，當時在大型廣告牌上會有太空人與嫦娥在月球表面一起漫步，意念非常前衛，且吸晴。

除此之外，以往月餅包裝並不受重視，普遍都是將月餅放在紙圓筒內，但在市場競爭激烈的情況下，酒樓商家各出奇謀，重新包裝設計禮盒，從此月餅盒大行其道，到了七十年代，月餅盒發展成用鐵盒包裝，看上去更有體面（吳昊，2001）。香港製造的月餅，不單在本港暢銷，也曾出口至日本、新加坡、泰國、英國、美國及加拿大等國家（《華僑日報》，一九六五年七月二十九日）。

月餅大賣特賣，皆因華人社會重視人情，而中秋節贈送禮品和月餅是一件表達心意和維繫關係的重要事情。每逢中秋佳節，酒樓門外可見來購買中秋月餅的人潮。但在生活水平不高的年代，月餅價格高昂，一般大眾無法一筆過的支付，為此酒樓提了供「月餅會」的方式，就是以月供的方法預購月餅，會員只需每月供款數元，一年後中秋節時便可提取若干月餅。一九六五年報章上報導，當時會員每月供款三元，每位完成供款的顧客可於中秋節前提取十多盒不同款式的月餅（《華僑日報》，一九六五年八月二十一日）。當時以月供方式來訂購月餅是十分流行的，這正是看準了香港人的精明消費之道。

Mooncake Club

Apart from dine-in service offering, mooncake selling was also a lucrative business for Cantonese restaurants. Cheng Po-hung wrote that in the past, the sales revenue of mooncakes of just half a month would take up the majority of what a restaurant would make in a year (Cheng, 2016: 126), making mooncake selling the battleground all restaurants hoped to conquer. Restaurants put up interior decorations a month in advance to welcome the Mid-Autumn Festival. Some large traditional Cantonese restaurants spared no expense in installing massive billboards on their outer walls, featuring festive illustrations such as "The Eight Immortals Crossing the Sea" and "Chang'e Flying to the Moon". In the late 1960s, American astronauts landed on the moon for the first time in human history. Innovative and eye-catching billboards were then seen, featuring astronauts and Chang'e taking a stroll on the moon's surface together.

Restaurants used not to pay attention to mooncake packaging, with mooncakes mostly packed in paper cylinders. As competition grew increasingly fierce, restaurant owners had to pull out all the stops and transformed the simple packages into gift boxes, a trend that has gained popularity ever since. In the 1970s, restaurants began to pack mooncakes in tin boxes that looked more elegant (Ng, 2001). Mooncakes made in Hong Kong were not only sold locally but exported to countries such as Japan, Singapore, Thailand, the United Kingdom, the United States and Canada (*Overseas Chinese Daily News*, 29th July 1965).

Mooncakes were well received because the Chinese society highly valued relationships. It was important to present each other with gifts and mooncakes during the Mid-Autumn Festival to show your care. Whenever the Mid-Autumn Festival approached, people would queue outside tea houses to purchase mooncakes. However, at the time when living standards were relatively low, mooncakes were considered expensive that the general public couldn't afford the large sum in an one-off payment, thus tea houses created "Mooncake Clubs". The system allowed members to pre-order mooncakes by paying a monthly instalment of a few dollars and pick up the mooncakes by the time of the Mid-Autumn Festival a year later. According to a newspaper article published in 1965, members paid three dollars per month and those who had paid in full could pick more than ten boxes of different mooncakes before the festival (*Overseas Chinese Daily News*, 21st August 1965). Purchasing mooncakes by paying monthly instalments was very common back then, a solution perfectly suited the smart consumption habit of Hongkongers.

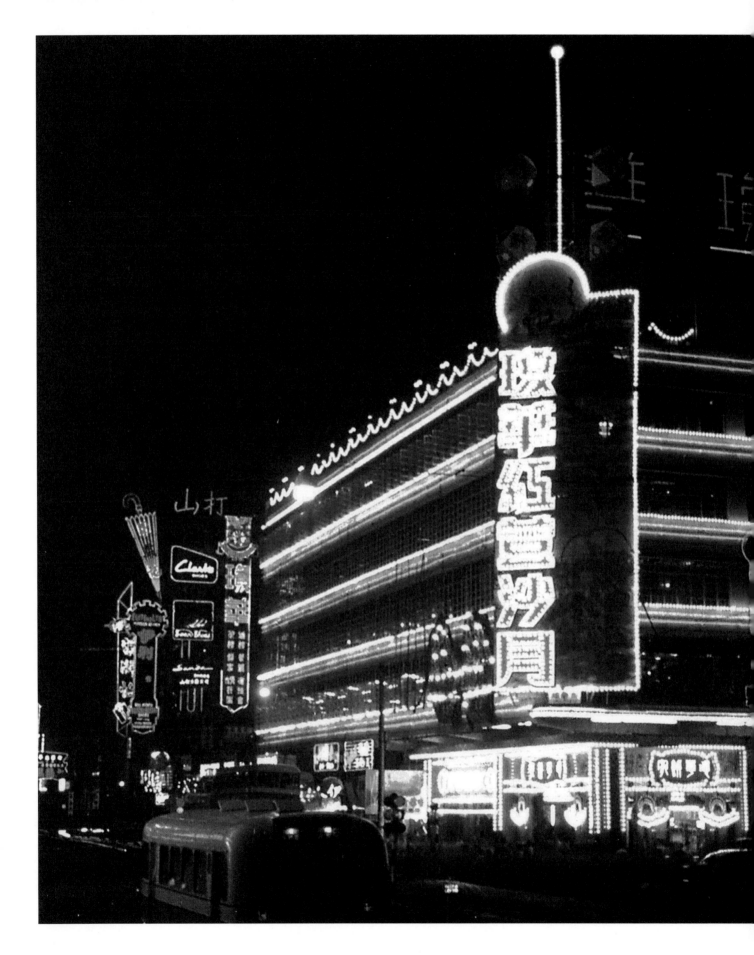

每逢中秋佳節，瓊華大酒樓定必推出大型月餅宣傳廣告攻勢。（照片由高添強提供）
King Wah Restaurant launched a huge mooncake signboard for the Mid-Autumn
Festival. (Photo courtesy of Ko Tim-keung)

信興酒樓

SHUN HING RESTAURANT

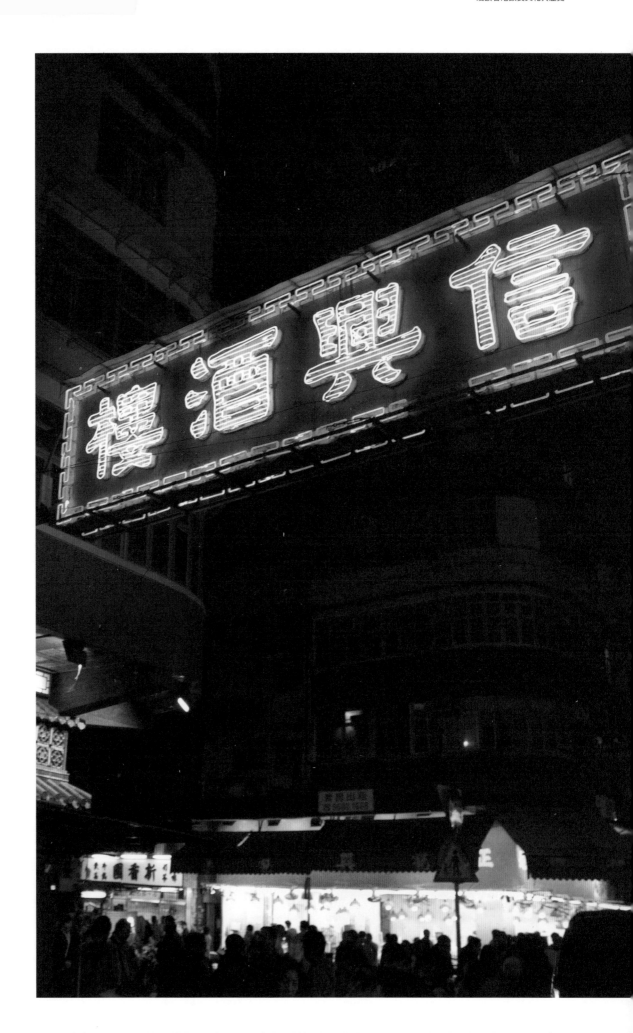

信興酒樓於一九三六年開業,至二〇一六年十二月二十九日光榮結業,屹立深水埗八十載,經歷了四代人,只在抗戰期間停業了三天。據說,信興酒樓於深水埗開業,乃與於一九二四年建成的深水埗碼頭有關。因為昔日碼頭都是人流貨流的集散地,大批苦力在碼頭附近工作,而前來找工作的工人,會常聚在酒樓碰運氣,所以酒樓選擇開設在碼頭附近,生意必旺。這也是信興酒樓第一代羅如璋先生選址桂林街開業的理由。而酒樓門前的帆船標誌,乃寄寓出海工作的人和信興酒樓也都一帆風順、事事順景。而這個帆船標誌是由酒樓其中一位創辦人的女兒羅慧敏設計的。

Opened in 1936, Shun Hing Restaurant had served Sham Shui Po for 80 years until its "glorious closing" on 29th December 2016. The family business was passed down through four generations and remained in business except for three days during the Japanese occupation. Supposedly, the eatery's being located in Sham Shui Po was related to Sham Shui Po Ferry Pier established in 1924, a busy point of people and cargoes. Back in the day, coolies (wharf labourers) usually gathered in Chinese restaurants near piers to look for job opportunities, so restaurants located around piers could make good business. That was why Law Yu-cheung, Shun Hing's first-generation owner, chose to open the restaurant on Kweilin Street. The sign of junks on the shop's outer wall was intended to bless both the labourers going out to sea and the restaurant for favourable winds. The sign was designed by Law Wai-wan, the daughter of one of the restaurant's co-founders.

五十年代,小本經營的信興酒樓原本叫「信興茶室」,七十年代易名為「信興樓」,到了八十年代再改名為「信興酒樓」,往後一直沿用至光榮結業。

信興酒樓內部保留了六十年代的裝修,有舊式木桌椅和茶餐廳常見的卡位。老街坊們去飲茶都不需要等位,他們會自己找座位,也懂得走到大廳旁的茶檔動手沖茶,看似沒有秩序,但這都是老街坊們長久以來建立的默契。

The restaurant was originally named "Shun Hing Tea House" in the 1950s when it was operated as a small business, and then renamed as "Shun Hing Lau" in the 1970s. Its name was changed again in the 1980s to "Shun Hing Restaurant", which was used until its closure. The restaurant retained its 1960s interior, with old-styled wooden tables and chairs as well as booth seating. Diners did not wait for guidance but found tables and made tea themselves at the tea stall beside the big hall. These seeming disorders were actually familiar rituals long adopted by regular patrons.

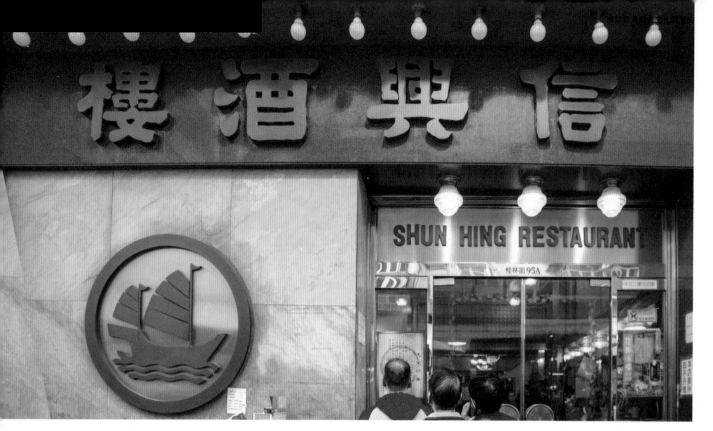

信興酒樓門前的帆船標誌，寄寓出海工作的人一帆風順。

The sign of junks at Shun Hing Restaurant's shop front represented blessings of favourable winds to its mariner patrons.

信興酒樓與其他酒樓有別之處，在於它擁有一個位於二樓的茶倉來陳化茶葉。信興的茶葉搜羅自雲南、四川和越南等地，茶倉由一九六〇年已加入酒樓的馬德輝師傅專人主理。馬師傅憑多年經驗來親自調茶，秘訣是將新舊茶葉按比例混合而成，這可令茶質濃郁且香醇。在眾多款茶葉裡，陳年普洱是鎮店之寶，也是一眾老街坊和熟客到來飲茶的不二之選。

除此之外，信興的懷舊點心，例如豬肚燒賣、雞球大包、臘腸卷、節瓜釀肉丸等，都是師傅親手製作，尤其是豬肚燒賣，一出爐便瞬間賣清。如今一般新興酒樓，都沒有豬肚燒賣，相信已成絕響了。另外，信興酒樓也有為客人食魚翅而特別訂做了魚翅碗，這亦已成為歷史文物，現已捐贈給歷史博物館收藏。

What made Shun Hing distinctive was its tea storage on the second storey used for tea leave aging. The tea leaves were bought from Yunnan, Sichuan, Vietnam and other places. The storage was managed by tea master Ma Tak-fai who joined Shun Hing in 1960. Master Ma blended new and aged tea leaves in optimal ratios determined with his many years of experience to get the rich and mellow tastes. Out of the many options available, the restaurant's signature aged pu'er tea was always the number one choice of neighbourhood folks and regular patrons.

信興酒樓的陳年普洱是鎮店之寶。
Aged pu'er tea was Shun Hing
Restaurant's signature tea.

Another signature of Shun Hing was its traditional dim sum, including pork belly siu mai, jumbo chicken bun, dried sausage roll, stuffed hairy gourd and more, freshly made by the masters. Pork belly siu mai, in particular, was snatched up by diners as soon as it left the kitchen. New restaurants nowadays do not offer pork belly siu mai, which is believed to have become extinct.

Shun Hing served shark fin soups in bowls specially made for patrons. The bowls have been donated to the Hong Kong Museum of History for collection as historical relics.

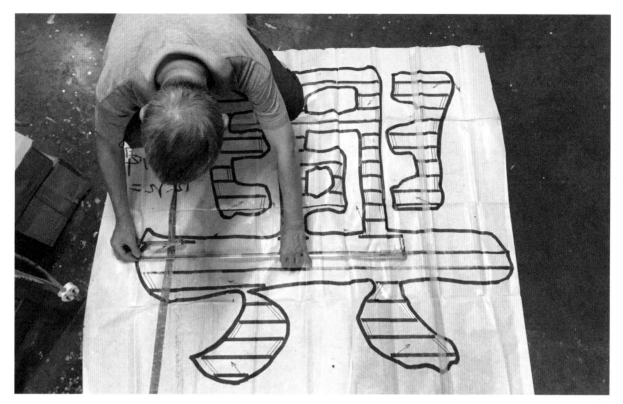

圖為信興酒樓的霓虹招牌製作。
The making of the Shun Hing's neon light signboard.

信興酒樓的霓虹招牌以隸書書寫，是多年來深水埗的地標之一。根據第四代傳人羅梓洋指出，這個招牌高掛在桂林街已有五十八年，招牌雖然歷史悠久，但酒樓每年都有定期保養維修和更換損壞零件，一直也保存得十分好，只是後來因為屋宇署下令清拆，才不能再掛。慶幸 M+ 博物館能夠保育其中一塊大型的霓虹招牌，不用丟到垃圾堆填區。

Shun Hing's neon light signboard, written in Lishu, had been an iconic landmark of Sham Shui Po for many years. It had been hung high over Kweilin Street for 58 years, according to Law Tsz-yeung, the fourth generation of the family-owned business. Law said the signboard, which had been well-maintained and regularly repaired with new parts, was only removed due to the Buildings Department's order. Fortunately, one of the big signboards was saved from being destined for the landfill by M+ Museum and is now under its care.

醉瓊樓

TSUI KING LAU

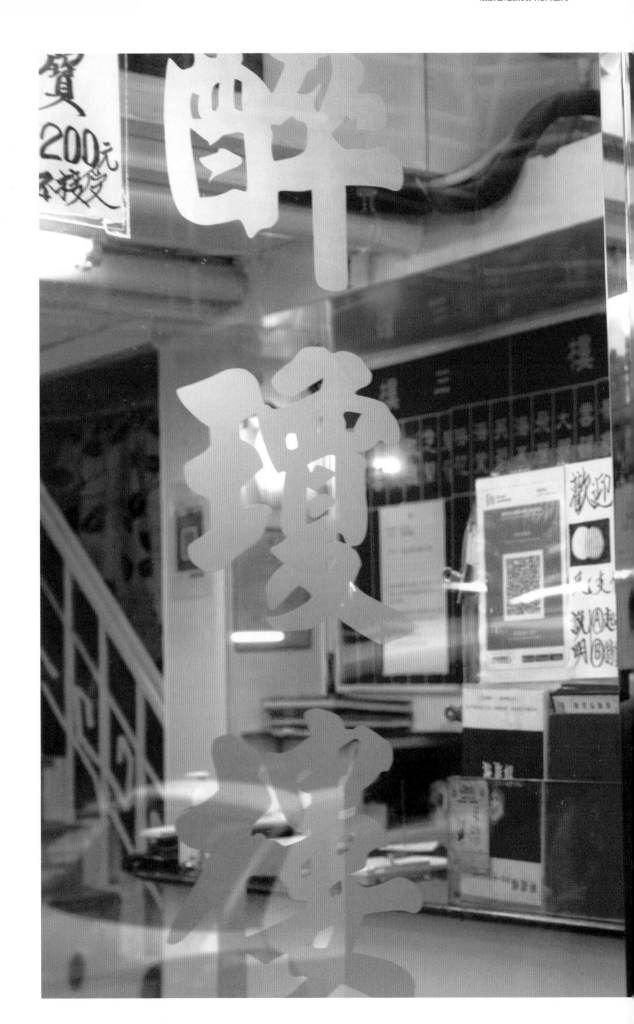

六、七十年代，客家菜在香港十分盛行，泉章居、醉瓊樓、梅江飯店都是響噹噹的名字，經常高朋滿座。全盛時期，單是醉瓊樓已有四、五十家之多。不過，由於當時公司註冊並不普及，只要在門外掛上醉瓊樓招牌便可營業，所以雖然醉瓊樓遍佈港九，但它們之間互不從屬，不同醉瓊樓也有不同的老闆。那時為了識別，每間店舖會加上地區名稱，例如佐敦的醉瓊樓名為「九龍醉瓊樓」。但隨著新式海鮮酒樓的出現和行業間的激烈競爭，現在只剩下數間醉瓊樓，當中灣仔和佐敦的最為人熟悉。

現時位於佐敦西貢街的醉瓊樓已有六十多年歷史，姚劍成是這家醉瓊樓的第三任老闆。七十年代姚老先生從內地來港，一家八口住在板間房，後來因姚老先生是客家人，對客家菜有一份情意結，遂在九十年代末頂手佐敦的醉瓊樓。

醉瓊樓佔地兩層，外牆有中式傳統裝飾，遠看十分搶眼。地舖面積較大，可放幾張大圓枱，收銀處旁有樓梯，食客可上樓上雅座，但樓上的樓底不算太高，座位佈局多以卡位為主，可容納二、三十位食客。醉瓊樓內部裝潢仍保留傳統客家餐館低調樸實的風格，牆上掛著用毛筆手寫的菜牌。醉瓊樓的侍應皆上了年紀，一身中式打扮，男夥計穿著傳統白色恤衫襯上黑色西褲，女侍應穿上類似小鳳仙裝的制服。

Hakka cuisine was very popular in Hong Kong during the 1960s and 1970s. Chuen Cheung Kui, Tsui King Lau and Mui Kong Restaurant that usually drew full houses were among the most popular Hakka restaurants. During the heyday, there were forty to fifty Tsui King Laus territory-wide, but they in fact had different owners. Business registration was not common back then, so the same business name could be used by anyone starting a business. Even though there seemed a lot of Tsui King Laus across Hong Kong, they were actually completely unrelated. To differentiate the restaurants from one another, each Tsui King Lau had its location written on its signboard. For example, the one in Jordan was named "Kowloon Tsui King Lau". However, due to the emergence of new Chinese seafood restaurants and heightened competition within the industry, only a few of them are left in the city now, among which the Wan Chai and Jordan ones are the most well-known.

The Jordan Tsui King Lau has been operating on Saigon Street for more than 60 years. Yiu Kim-shing, its third owner, came to Hong Kong from Mainland China in the 1970s and lived in a partitioned flat with his family of eight. Being a Hakka person with a strong connection to Hakka cuisine, Yiu decided to take over the Jordan Tsui King Lau at end-1990s.

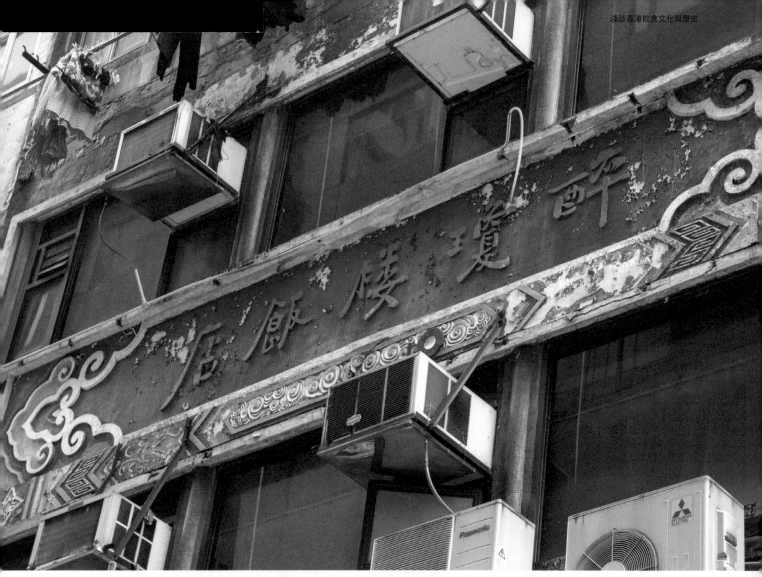

佔地兩層的醉瓊樓，外牆有中式傳統裝飾，遠看十分搶眼。
The two-storey Tsui King Lau features traditional Chinese decorations on its outer wall, which look captivating from a distance.

The restaurant occupies two storeys with traditional Chinese ornaments on the shop's outer wall which looks eye-catching from a distance. The ground floor has a larger area, with enough space for several big round tables. Next to the cashier is the staircase leading to the second floor lounge. This floor, with a lower ceiling, has booth seating that can host 20 to 30 patrons. The interior remains minimally furnished to echo the down-to-earth style of traditional Hakka restaurants. The menus on the walls are written in Chinese calligraphy. The waiters, of a certain age, are outfitted in traditional Chinese uniforms, with waiters in white shirts and black trousers as well as waitresses in cheongsams.

⬆｜鹽焗雞是醉瓊樓的招牌菜，特別受食客歡迎。
Salt-baked chicken is one of the most popular signature dishes of Tsui King Lau.

⬇｜醉瓊樓保留舊式酒家的風味，夥計遞上舊式鐵製茶壺與洗杯盆，讓客人沖洗碗筷。
The restaurant still maintains the traditions of old restaurant, such as serving tea in iron teapots and providing small pots for patrons to wash dishes and chopsticks.

據說客家人經常勞動耕種且易出汗，所以菜式偏多油多鹽，認為菜鹹可補充身體因勞動而失去的鹽分；而肥膩一點的菜式可讓人有飽感。這可解釋為什麼客家人喜愛食梅菜扣肉和鹽焗雞等重口味的菜式。

醉瓊樓最為人熟悉的招牌菜為鹽焗雞、梅菜扣肉、東江豆腐煲、梅菜蒸鯇魚等傳統客家菜。當中以鹽焗雞最為著名，其雞肉鹹香、肉質嫩滑、雞味濃郁，蘸上沙薑醬吃，份外美味。昔日的客家菜講求實而不華，多以豬雞等平實食材為主，賣點是「大件夾抵食」，加上客家菜價錢大眾化，以往特別受基層和勞動階層歡迎。

It is said that Hakka cuisines are oily and salty because Hakka people need to replenish the salt their bodies have lost after a day of sweaty hard work on the farm, while fatty food gives a stronger sense of fullness. This may explain why Hakka people enjoy heavy dishes like braised pork belly with preserved vegetables and salt-baked chicken.

The signature Hakka dishes of Tsui King Lau include salt-baked chicken, braised pork belly with preserved vegetables, Dongjiang tofu casserole and steamed grass carp with preserved vegetable. Salt-baked chicken is the most popular for its savory aroma, tender meat and strong chicken flavour, with enhanced tastes when it goes with the "sand ginger" sauce. Hakka cuisine of the past was known for being practical rather than glamorous. Made from affordable ingredients like pork and chicken, it was considered good value for its large portions and affordable price, which made it particularly popular among the grassroots and the working class.

雖然飲食業近年不景氣，但醉瓊樓仍然有很多捧場客，光顧的人，大多是上了年紀的食客。至今，酒樓仍保留了充滿懷舊風味的舊式酒家傳統，例如當客人進來時，老夥計隨即遞上舊式鐵製茶壺與洗杯盆，讓客人沖洗碗筷。相信來這裡光顧的食客，除了欣賞這裡的招牌鹽焗雞和梅菜扣肉外，也喜歡這裡沿用多年的招待方式，能找到一份親切感。

Although the recent economic downturn has dealt a great impact to restaurants, Tsui King Lau has not been affected much because most of their customers are regular patrons and elderly folks. The restaurant preserves the traditions of old-styled restaurants like serving tea in iron teapots and providing a washing pot for patrons to wash their cutlery. Apart from delighting in the signature dishes, regular Tsui King Lau customers enjoy the warmth and nostalgia they feel when dining there.

長康酒樓　CHEUNG HONG RESTAURANT

青衣長康邨在七十年代末興建，是青衣以南首個大型公共屋邨；而長康酒樓就在一九八一年開業，是這屋邨的唯一一間酒樓，服務長青及長康兩個屋邨共二十一座的街坊。翻看舊報導，長康酒樓開業當天掛上八號風球；經營至二〇一七年，由於領展收回，被迫結業。

長康酒樓雖然於舊社區開業，並以服務老街坊為主，但其裝潢相比其他新式大酒樓也絕不遜色。酒樓入口樓高兩層，牆上高掛著一幅由八組中式屏風組合而成的「大觀園」，另一邊則掛上「八仙過海」，氣勢磅礴。此外，酒樓亦保留了不少舊式酒樓手寫字的傳統，大堂側牆以白油手寫上「今日菜單」和訂座貴賓廳的貴賓名字；而在其他當眼處，亦有寫上「超值海鮮晚飯，鵲局喜慶宴會」。

Cheung Hong Estate was the first large-scale public estate built in Tsing Yi South during the late 1970s, while Cheung Hong Restaurant was opened in 1981. It was the only Cantonese restaurant serving residents living in the 21 blocks of Cheung Hong Estate and the neighbouring Cheung Ching Estate. The restaurant was opened when Hong Kong was hit by a signal no. 8 typhoon, according to newspaper clippings. It was forced to close in 2017 as the premise was reclaimed by Link.

Despite its location in an old neighbourhood and its dedication to serving only locals, Cheung Hong Restaurant had a grand interior design comparable to that of modern large Cantonese restaurants. It had a two-storey high entrance, with the spectacular picture of "Grand View Garden" composed of eight Chinese screens hung on one side and "The Eight Immortals Crossing the Sea" on the other. The restaurant also preserved the hand-writing tradition of old restaurants, such as "today's menu" and the list of guests reserving the VIP rooms handwritten in white paint on the side wall in the main hall. In other prominent places, there was more calligraphy promoting the restaurant's seafood dinner and banquet services.

長康酒樓老闆區先生指出，過去逾三十年的裝潢貫徹如一，只曾作輕微修補和更換地氈，目的是希望保存懷舊的味道。甫踏進大堂，映入眼簾的是一對大龍鳳。這對大龍鳳體積龐大，比成年人還要高，龍鳳頂處差不多貼近酒樓的天花。據區老闆所說，由於這對龍鳳雕刻巨型，根本沒辦法進入酒樓大門，酒樓唯有從廣州邀請一位專做木雕的師傅親臨現場製作。區老闆記得，這對龍鳳雕刻分別用上一整塊原木，以人手雕刻而成，當中完全沒有任何接合位置，而為了使龍鳳造型維肖維妙，師傅刻意將雕刻向外展翅翻騰，讓龍鳳顯得更為生猛，所以雕刻佔用的空間也比一般的為大，要求的工藝技巧也很高，在酒樓裝修期間，師傅用上多個月才能完成。區老闆說，由於這對大龍鳳甚有氣勢，曾吸引香港電影在這裡取景拍攝。

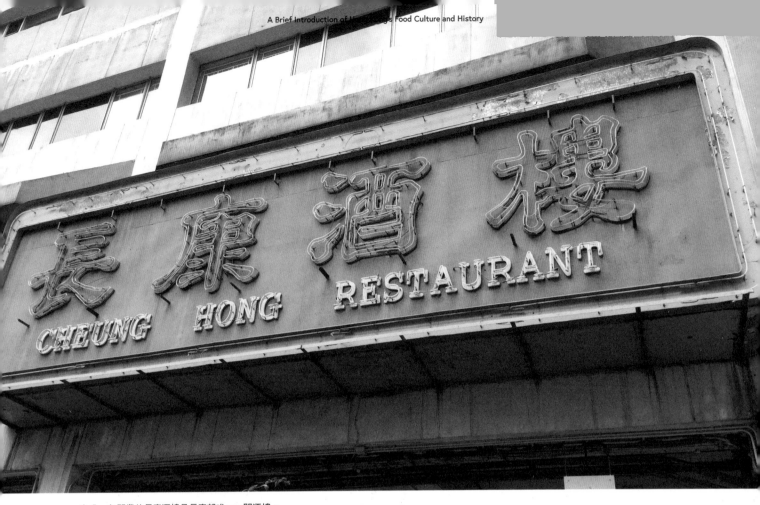

一九八一年開業的長康酒樓是長康邨唯一一間酒樓。

Cheung Hong Restaurant was opened in 1981 as the only Cantonese restaurant in Cheung Hong Estate.

The restaurant's owner Mr. Au said that the interior had not changed in the past 30 years in order to maintain a nostalgic ambience. Only minor repairs had been done and only the carpet had been replaced. Entering the main hall, one could not help but noticed the large dragon and phoenix sculptures taller than an average adult almost reaching the ceiling. Au said the sculptures were too big to go through the entrance, so they were carved on site by an experienced wood-carving craftsman invited from Guangzhou. Au recalled that the pair of sculptures were made by hand from two single big wood logs without any joints. The dragon and phoenix were in flying gestures with spread-out wings to create a striking visual impact and a sense of liveliness, so they occupied extra space and required a high level of skills, taking several months to be completed along with the refurbishment. Au said the awe-inspiring sculptures had attracted Hong Kong filmmakers to shoot movie scenes at the restaurant.

圖為「八仙過海」。

"The Eight Immortals Crossing the Sea".

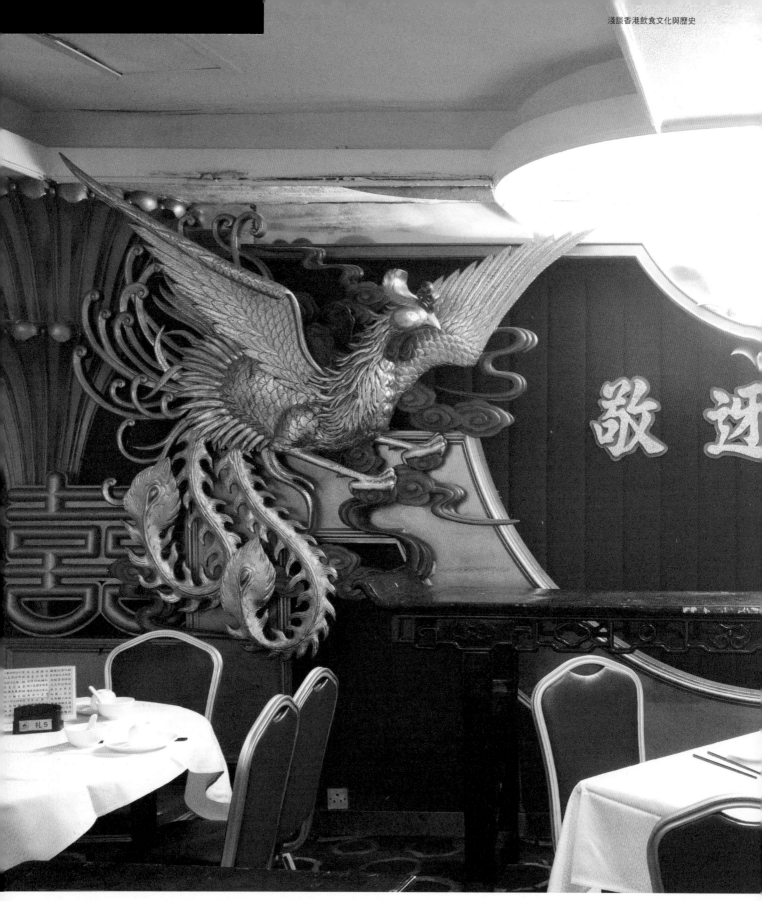

這對大龍鳳是特別邀請廣州木雕師傅親臨現場製作。
The dragon and phoenix sculptures were crafted by a Guangzhou wood-carving craftsman on site.

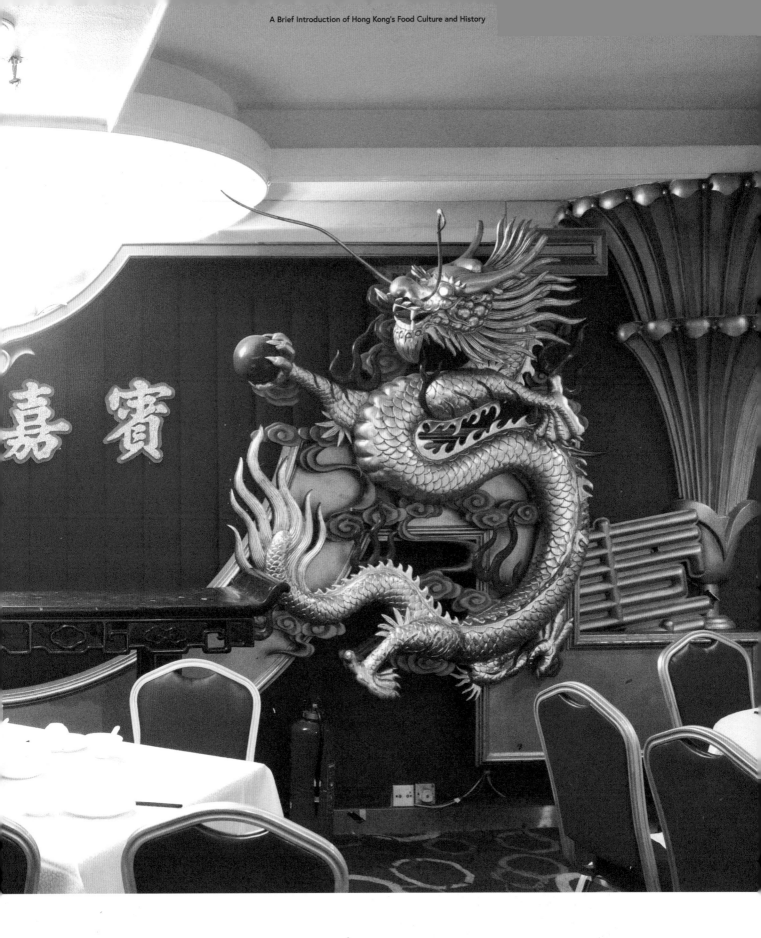

長康酒樓的裝潢不比其他新式大酒樓遜色。

The grand interior of Cheung Hong Restaurant was no inferior to modern Cantonese restaurants.

由於這間酒樓坐落在青衣長康邨的一個商場內，大部份食客都是來自本區的老街坊和熟客，他們光顧了幾十年，有些甚至曾在這裡擺酒結婚。這裡每天也有一班固定的熟客會坐上好幾小時，與朋友結伴一邊吃點心一邊談天說地，相比其他大集團的新式酒樓，長康酒樓更貼近社區的需要。這裡的經理、夥計和食客都能打成一片。

只是，街坊酒樓終不敵集團管理。二〇一七年，長康酒樓不被續約，舖位被領展收回。開業三十六年後，長康酒樓在此畫上句號。營業的最後一天，酒樓在店前寫上臨別字句：「衷心感謝街坊好友三十六年來鼎力支持。依依惜別，無言感激！」

The restaurant was situated inside the Cheung Hong Estate shopping arcade, Tsing Yi. Most patrons were from the local community. They had visited the restaurant for several decades and even had their wedding banquets there. The same familiar group of people used to meet there every day for dim sum and casual talks, spending hours at a time. Compared to modern group restaurants, Cheung Hong Restaurant better catered to the needs of the community. There, the managers, waiters and patrons got along like friends.

However, the neighbourhood restaurant finally failed the fight with group operation. Cheung Hong Restaurant was rejected for lease renewal by Link and the premise was reclaimed in 2017, putting an end to the 36-year-old restaurant. On its last business day, a thank you note was stuck on the shop front, reading: "Neighbours and friends, please accept our heartfelt thanks for your support over the past 36 years. We are sad to go and words cannot express our gratefulness to you all."

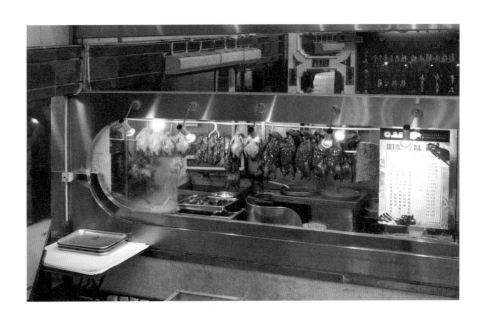

高級西餐廳
Western Restaurants

2.3

香港的飲食文化，大部份源自中國傳統，同時也受西方的飲食文化所影響。香港開埠初期，中上環一帶已經有西餐館、餐廳和餐室開設。早期西餐廳的主要服務對象是外籍人士，並集中開設在酒店或私人會所之內，一頓西餐動輒大約三至五元（吳昊，2001），非常昂貴。一九二〇年代受僱於華人家庭的傭人年薪由七十二至四百四十四元不等（Hong Kong Blue Book, 1928），即是月入只有約六至三十七元。此外，大酒店規定客人必須穿著正規禮服，否則謝絕進內。

後來西餐廳逐漸普及，一些本地華人開始接觸並營辦西餐廳，但仍屬小部份人可享用，對一般普羅大眾來說，根本無法負擔。直至二十世紀初，平民化的西餐廳出現，吸引本地普羅大眾，一九〇五年開業的「華樂園」，是首間華資西餐廳（吳昊，2001），它降低價格並調整菜式，以滿足華人對西式餐廳的嚮往。此後，本地西餐廳跟高級西餐廳越走越遠，更趨向大眾化，以及貼近本地華人的飲食習慣，往後也逐漸發展出港式的茶餐廳飲食文化。

戰後，不同的華資西餐廳應運而生，包括以豉油西餐馳名的「太平館餐廳」。據說太平館的創始人徐老高曾於廣州「旗昌洋行」做廚房雜工，後來成為廚師，由於洋行內多外籍員工，所以便學懂了如何烹調西式菜式；後來徐老高嘗試以中式醬汁調味配以西式煮法，創造出街知巷聞的瑞士雞翼。另外，還有「愛皮西ABC飯店」、廟街的「美都餐廳」、一九五五年開業的「瓊華酒家」西餐廳、一九五七年開業的俄國菜館車厘哥夫餐廳，還有一間俄國菜館「雄雞大飯店」。當時西餐廳的聖誕晚餐約每人四元（The China Mail，一九二九年十二月二十三日），而一席六人的中菜則約十四元（《香港工商日報》，一九二六年六月五日）。

Food culture in Hong Kong, though mostly originates from China, has also been heavily influenced by the West. The first Western restaurants in Hong Kong were opened in Central and Sheung Wan as early as when the city was first opened as a port. These establishments were founded to cater to the needs of foreigners. Most of them were opened in hotels or private clubhouses, with a meal costing an astronomical cost of three to five dollars (Ng, 2001). In the 1920s, the annual salary of domestic servants employed by Chinese households ranged from 72 to 444 dollars (Hong Kong Blue Book, 1928), representing a monthly income of a measly 6 to 37 dollars. Moreover, guests had to dress in formal attire to enter the hotels.

As Western restaurants became more common, some local Chinese began to operate their own, but dining in those places remained a privilege as they were prohibitively expensive to the general public, until the early 20th century when affordable Western restaurants targeting the masses began to emerge. Opened in 1905, Wah Lok Yuen was the first Chinese-funded Western restaurant in Hong Kong (Ng, 2001). It charged lower prices with adjusted menus, catering to the Chinese craving for Western cuisine. Since then, local Western restaurants had further deviated from

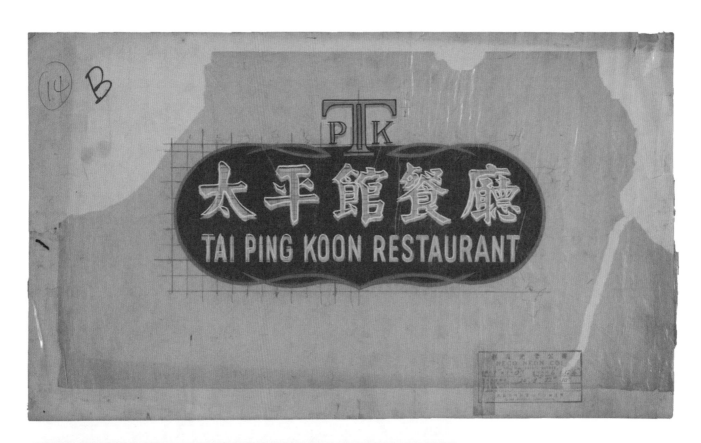

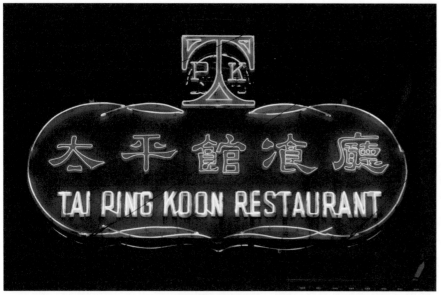

昔日的霓虹招牌手稿設計與今天的太平館餐廳招牌大致一樣。

This old hand-painted sketch of the restaurant's neon light signboard is no different from the signboard being used today.

their high-end counterparts and evolved to give birth to Hong Kong's "Cha Chaan Teng" dining culture.

After the war, different Chinese-funded Western restaurants started to pop up, including Tai Ping Koon Restaurant famous for its soy sauce Western food. It is known that Chui Lo-ko, the restaurant's founder, worked as a kitchen porter at Russell & Co. in Guangzhou before becoming a chef and learned to cook Western food for foreign workers of the company. Chui later experimented combining Chinese sauces and condiments with Western cooking techniques, creating the renowned dish of Swiss chicken wings. Other prominent restaurants included ABC Restaurant, Mido Cafe on Temple Street, a Western diner opened by King Wah Restaurant in 1955, Russian diner Cherikoff Restaurant opened in 1957 and Chantecler Restaurant & Bakery which also served Russian food. At the time, Christmas dinner served at Western restaurants cost about four dollars per person (*The China Mail*, 23rd December 1929). In comparison, a dinner set for six at a Chinese restaurant cost about 14 dollars (*The Kung Sheung Daily News*, 5th June 1926).

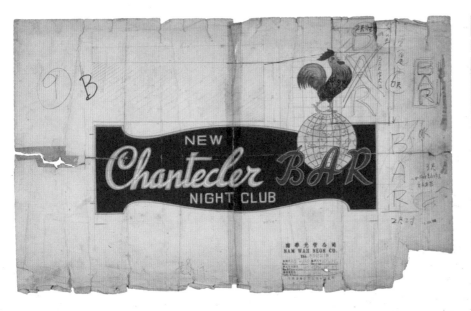
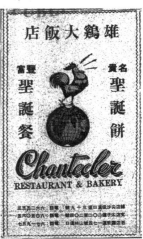

雄雞夜總會霓虹招牌手稿（左）；聖誕大餐是西餐廳的一大賣點，臨近聖誕節雄雞大飯店推出聖誕大餐廣告（右）。（《華僑日報》，一九六六年十二月二十一日。）

The hand-painted art for New Chantecler Bar Night Club's neon light signboard (left). An ad of Chantecler Restaurant & Bakery posted in 1966 before Christmas to promote its Christmas feast, a major selling point of Western restaurants (right) (*Overseas Chinese Daily News*, 21st December 1966).

太平館餐廳　TAI PING KOON RESTAURANT

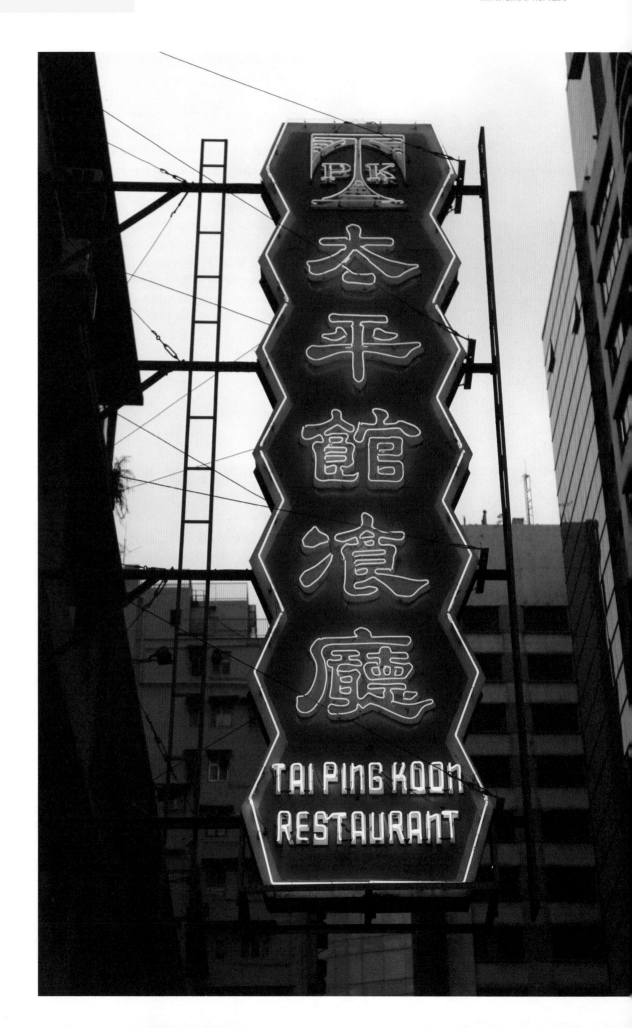

百年老店太平館餐廳（下稱「太平館」）是香港極少數有過百年歷史的華人西餐廳，時至今日仍然屹立不倒。想當年，太平館創辦人徐老高仍是一名二十歲的廣州年輕小伙子，他有幸在一間美資公司「旗昌洋行」的自設西餐食堂做廚房雜務，逐漸學會西式烹調技巧。其後，他於一八六〇年在廣州最繁華的地段——太平沙大巷開設西餐館，取名「太平館」，被視為最早開設西餐館的中國人。太平館的菜式將中式烹調方式加入西餐中，中西合璧，可謂是最早期的「Fusion 菜」。餐廳最為人熟悉的莫過於「豉油牛扒」，徐老高以中式豉油調味，但沿用西式方法處理牛扒，這結合中西的烹調方法，非常適合華人的口味，這些創新的「本土化」西餐，更為太平館打響名堂。

太平館開業至今已有一百六十四年歷史，經歷了五代人。它的悠久歷史足以見證過去百年中國社會的急劇轉變。經歷了多場內戰的洗禮後，為了逃避戰火，太平館創辦人決定舉家撤離廣州，並於一九三八年在香港上環開設第一間西餐館，及後陸續開設了四間分店。太平館的招牌菜如燒乳鴿、焗葡國雞、煙鯧魚、瑞士雞翼等，吸引不少城中名人慕名而來。

Tai Ping Koon Restaurant is one of the very few Hong Kong-style Western restaurants with over a hundred years' history still standing to this day. It all began with the restaurant's founder Chui Lo-ko, a then 20-year-old young chap from Guangzhou who had the opportunity to do kitchen chores in the Western canteen of American company Russell & Company. He gradually picked up Western cooking techniques and later opened a Western restaurant in 1860 named "Tai Ping Koon" on Taipingsha Main Lane （太平沙大巷）, the most prosperous area in the city. Chui is considered the first Chinese to open a Western restaurant. The dishes of Tai Ping Koon, incorporating both Chinese and Western cooking techniques, can be considered an early form of "fusion cuisine". "Soy sauce steak", the restaurant's most well-known dish, is seasoned with Chinese soy sauce and prepared in Western ways. Combining Chinese and Western elements, it delights local taste buds. The innovative "localized" Western cuisine soon built a reputation for Tai Ping Koon.

With 164 years of history, Tai Ping Koon has been passed down to five generations and witnessed the drastic transformation of the Chinese society during the past century. After going through a series of civil battles, Chui decided to leave Guangzhou with his family to escape the flames of war. In 1938, he opened the first Tai Ping Koon Western restaurant in Sheung Wan, Hong Kong and added four more branches later. The restaurant's signature dishes, such as roasted baby pigeon, Portuguese-style baked chicken, smoked pomfret and Swiss chicken wings, have attracted many celebrities in town to dine there.

位於佐敦的分店共有兩個霓虹招牌，一個外形像薯條形，另一個是線條比較簡單的長方形。

There are two neon signboards at the Jordan branch of the restaurant – one has a frame in the shape of a French fry, while the other has a more simple rectangular design.

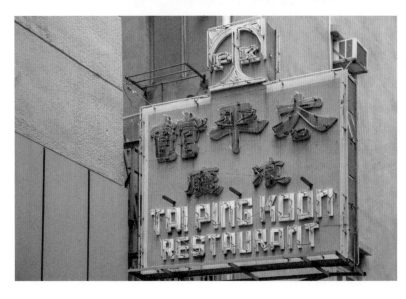

說到太平館招牌菜，不能不提瑞士雞翼。事緣在四十年代，有一位外國食客到太平館用膳，吃完豉油雞翼後豎起拇指稱讚其十分甜美（Sweet），但由於侍應不懂英語，誤以為食客讚賞雞翼的烹調方式充滿瑞士（Swiss）風味，便將之轉告當時的太平館老闆徐漢初。他喜聞食客如此好評，便索性將「豉油雞翼」改為「瑞士雞翼」，想不到這道菜大賣，客人蜂擁而至。此後瑞士雞翼便成了太平館的招牌菜，多年來深受中外食客歡迎。這個美麗的誤會影響深遠，有趣的是很多人仍然相信瑞士雞翼源自瑞士，為此就連瑞士領事館也特意澄清瑞士雞翼並非瑞士菜式。

When it comes to the signature dishes of Tai Ping Koon, one has to bring up its Swiss sauce chicken wings. In the 1940s, a foreign diner gave the thumbs-up after eating soy sauce chicken wings, praising the taste as being very "sweet". The waiter, who did not speak English, thought that the diner was praising the dish's cooking method as being very "Swiss" and passed the news to Chui Hon-cho, the owner at the time. Delighted to hear such a great review, Chui decided to change the dish's name from "soy sauce chicken wings" to "Swiss chicken wings". The dish became an unexpected hit, attracting customers to flock to the restaurant. As Tai Ping Koon's signature dish, it has been very popular among Chinese and foreign diners ever since. Interestingly, this beautiful mistake has a far-reaching impact as many people now still think that "Swiss chicken wings" originate from Switzerland. Even the Swiss Consulate had to clarify that the dish was in fact not Swiss.

太平館招牌菜：焗梳乎厘及瑞士雞翼

The signature dishes of Tai Ping Koon: Baked Soufflé and Swiss chicken wings.

↑ | 室內懷舊的佈置。

Tai Ping Koon has retained its nostalgic interior décor.

↓ | 牆上掛著昔日太平館的舊照片。

On the walls there are old photos of the restaurant.

太平館餐廳除了美食外，其室內裝修也保留了懷舊風格。玻璃正門掛著白紗布，昏暗的吊燈襯托著胡桃木色的座椅和牆身，牆上掛著昔日太平館的舊照片。這種室內裝修風格既優雅又簡約，淡淡流露出百年老舖的餐館經營哲學——不嘩眾取寵，亦不隨波逐流，堅守傳統家族生意，以色香味俱全的菜式留住客人的胃和心。

位於加連威老道的太平館餐廳，其霓虹招牌已拆卸。幸好太平館餐廳老闆徐錫安先生願意為香港的霓虹燈文化盡一份綿力，將招牌捐贈予霓虹燈保育機構「霓虹交滙」（Tetra Neon Exchange）進行文化保育。最終，這個外形獨特的「薯條形」霓虹招牌找到了新的主人，逃過被活埋在堆填區的命運。這算是給招牌劃上了完美句號，也為香港的霓虹燈文化保留了一份珍貴的遺產。

Apart from its delicious food, Tai Ping Koon has retained its nostalgic interior decor. The glass front door is hung with a white gauze, while the walnut wood seats and walls are dimly lit by chandeliers, and on the walls there are old photos of the restaurant. The elegant and simple interior design echoes the operating philosophy of this century-old restaurant – never grandstand or follow the trend but hold fast to the traditional family business and retain guests with pleasing, fragrant and delicious dishes.

The neon signboard at Tai Ping Koon's Granville Road branch had been taken down. Fortunately, the restaurant owner Chui Shek-on was willing to contribute to Hong Kong's neon light culture and donated the signboard to neon light conservation organization Tetra Neon Exchange for cultural preservation. This distinctive neon signboard, in the shape of a "French fry", has found a new owner and escaped the fate of ending up at a landfill. This has not only given a happy ending to the signboard but also preserved a precious piece of heritage for Hong Kong's neon light culture.

太平館餐廳佐敦分店內的牆燈裝飾及門把，也是從已關閉的油麻地舊店中搬移到這裡來的。（照片由李毓琪提供）

The wall lamps and door handles in the Jordan branch of Tai Ping Koon were relocated from its Yau Ma Tei old branch which has been closed down. (Photo courtesy of Li Yuk-ki)

從冰室到茶餐廳
From Ice Chambers to
Cha Chaan Tengs

2.4

受西方飲食文化影響，香港除了發展出平民化西餐廳外，同時亦出現了適合小聚的冰室。二十世紀初，香港已有不少冰室，跟西餐廳一樣有消費高與低之分，以迎合不同消費群。早期的冰室主要定位為閒聊和短聚的地方，所以不單提供不同飲品，也有供應雪糕、多士、刨冰、牛奶麥皮、燉奶、通心粉⋯⋯以及包點如雞尾包、蛋撻和椰撻等，這些都帶有西方飲食文化的影子。後來冰室逐漸普及，不同階層的人也可感受西式餐飲的樂趣。

到了戰後，茶餐廳開始出現。初期的茶餐廳所供應的食物跟冰室近似，都是以飲品和餅食為主。但冰室和茶餐廳略有不同，例如價錢方面，早期的茶餐廳可視為廉價版的冰室，主要走親民價格兼大眾化路線，務求吸納低下階層人士（蕭欣浩，2019）。另一方面，初期的冰室通常以小食牌照經營，相比茶餐廳的普通食肆牌照，冰室不能售賣使用新鮮食材製作的食物。因此，面對茶餐廳及後來的快餐的競爭，冰室逐漸被取替，現在傳統的冰室已經所剩無幾。而茶餐廳則越趨多元化，發展出更多不同類型的菜式，並衍生出獨特的港式風味。今時今日，我們在茶餐廳既可品嚐西式扒餐和焗飯，亦可吃到中式小菜、粥粉麵飯等，還有咖啡奶茶，這種混雜和兼容度高的茶餐廳，最能反映出香港的多元飲食文化。

Under the influence of Western culinary culture, besides local affordable Western restaurants, ice chambers were also developed simultaneously in Hong Kong. There were many ice chambers in Hong Kong in the early 20th century. Like Western restaurants, prices varied among different ice chambers to cater to different target customers. Early ice chambers positioned themselves as venues for brief get-together and chatting. In addition to drinks, they served food like ice cream, toast, shaved ice, oatmeal with milk, steamed milk pudding and macaroni as well as baked goods such as cocktail bun, egg tart and coconut tart, all of which carried the traces of Western food culture. The increasing popularity of ice chambers allowed people of different social statuses to enjoy Western delicacies.

"Cha Chaan Tengs" started to emerge after the war. The menus of early Cha Chaan Tengs, which mainly included drinks and baked goods, were similar to those of ice chambers. However, there were some major differences that set the two apart. In terms of pricing, early Cha Chaan Tengs were more affordable than ice chambers to attract the working class (Siu, 2019). In fact, early ice chambers held light refreshment restaurant licences, while Cha Chaan Tengs held general restaurant licences, meaning that ice chambers were not allowed to sell food made from fresh ingredients. Amid intense competition from Cha Chaan Tengs and fast food restaurants, ice chambers have been gradually replaced, with only a few traditional ones remaining in business today. Cha Chaan Tengs, on the contrary, have become more diversified with the development of more food varieties, creating a new food culture unique to Hong Kong. Today at Cha Chaan Tengs, we can not only enjoy Western steak sets and baked rice but also Chinese dishes, congee, noodles and rice, not to mention coffee and milk tea. The intermixing and inclusiveness of Cha Chaan Tengs perfectly exemplifies Hong Kong's diverse food culture.

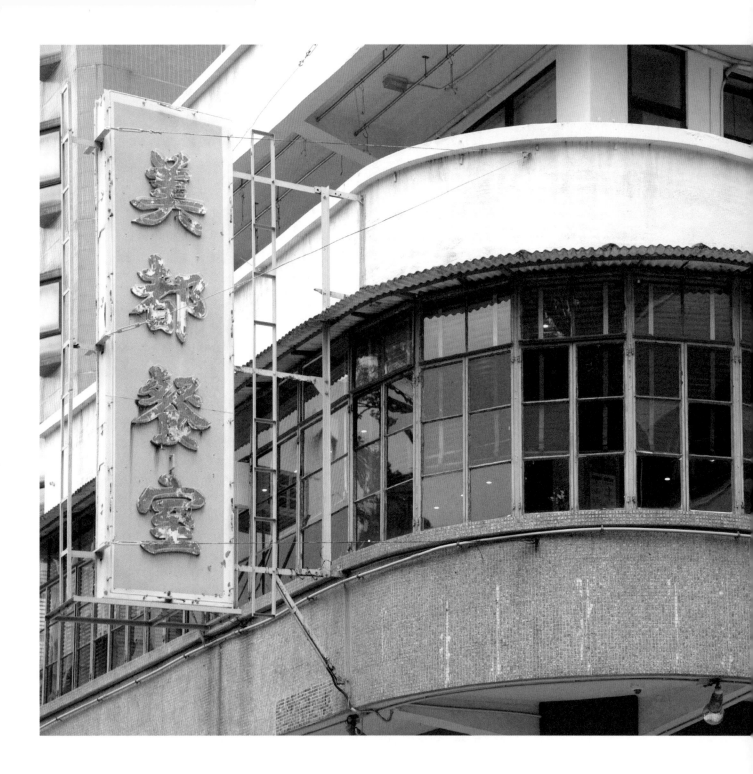

美都餐室的室內設計充滿懷舊氣息。
Mido Cafe's nostalgic interior design.

蘭芳園
LAN FONG YUEN

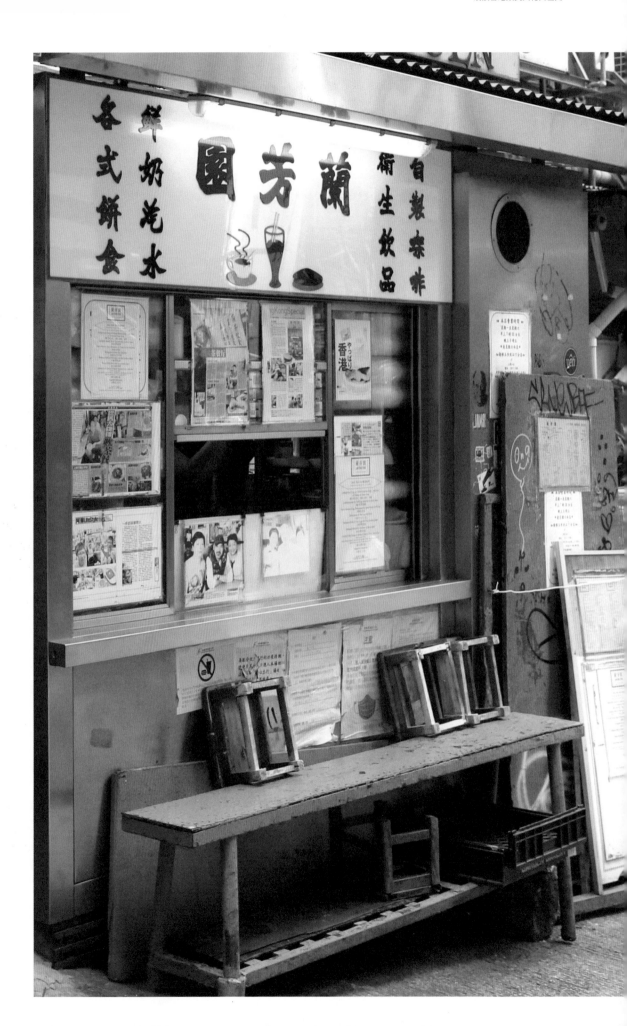

蘭芳園創辦人林木河，人稱「林伯」，一九五二年只有二十歲的他與鄉里在中環結志街經營茶水檔售賣咖啡奶茶，還有平民小食例如多士、光酥餅和雞仔餅等。及後，蘭芳園轉做大牌檔繼續經營，早年在結志街中間擺檔，七十年代搬到街口現址，後因牌檔地方不敷應用，所以買下後面鋪位擴充生意，直至今天。

蘭芳園由五十年代的街邊無牌茶水檔做到茶餐廳，七十多年來見證了茶餐廳的轉變。昔日光顧幫襯的都是在中環碼頭附近做苦力的工人及勞動階層，至六、七十年代客路轉變為白領，而到了今天，很多中產及遊客來到這間茶餐廳，為的是懷緬舊日的香港風味。

蘭芳園的舊式大牌檔仍然保留至今，食客可見昔日的面貌，例如綠色鐵皮結構和檔前的木凳，現在已經買少見少。據牌檔第二代傳人業哥（林俊業）憶述，當年每逢夏天在這檔裡煲茶都熱得叫苦連天，只有在這裡工作過的人才能體會箇中辛酸。

Lan Fong Yuen was founded in 1952 by Lam Muk-ho, also known as Uncle Lam. At the young age of 20, he and his hometown friends opened a mobile food stall on Gage Street in Central, selling coffee, milk tea and local snacks such as toast, Chinese shortbread and chicken biscuits. Later, it was transformed into a food hawker stall for continual operation. The business was relocated in the 1970s from the middle of Gage Street during its early days to the current address at the street corner, where Lan Fong Yuen still situates today. For more space, they subsequently bought the shop at the back to expand their business until today.

蘭芳園的綠色牌檔和檔前的木凳，早已成為香港人的集體回憶。
Lan Fong Yuen's green-painted iron sheet stall and wooden chairs have long been the collective memories of Hong Kong people.

Lan Fong Yuen developed from an unlicensed itinerant food stall in the 1950s to a renowned Cha Chaan Teng, witnessing the transformation of the industry during the past 70 years. In the olden days, most customers were pier coolies and working-class people near Central Pier. In the 1960s and 1970s, the regulars became white collar workers. Today, tourists and the local middle class come to experience the nostalgic vibe of old Hong Kong.

Lan Fong Yuen has kept its old stall, allowing diners to imagine what it looked like in the past. The green-painted iron sheet structure and wooden chairs in front of the stall are now hard to find elsewhere. According to second-generation owner Lam Chun-yip (also known as Yip Gor), when boiling tea in the stall during the summer in the old days, the intense discomfort caused by the heat was a feeling only those who worked there would understand.

蘭芳園最馳名的「絲襪奶茶」，其奶茶用上不同茶葉，包括錫蘭茶，再經手壺來回撞茶三次，令茶味均勻，茶質不帶苦澀，入口香滑自然。時至今日，奶茶每日仍然可賣出逾千杯。據悉，香港戰前仍流行喝南洋咖啡，到了五、六十年代香港人才開始愛喝奶茶，但由於昔日煲奶茶並不講究，茶味常帶苦澀。為此蘭芳園改

良方法，秘訣在於使用高密度的茶袋隔去茶渣，並去掉茶葉中的青澀味。由於過濾後的茶袋呈啡色，看似絲襪，因而稱為「絲襪」奶茶。到了今天「絲襪奶茶」已遠近馳名，也吸引不少中外飲食雜誌和報章特意到來訪問，可想而知蘭芳園如何受本地人及外國人歡迎，同時也成為香港本土茶餐廳之中的經典。

蘭芳園是現存香港最歷史悠久的茶餐廳之一，見證了茶餐廳的發展。蘭芳園在二〇〇五年被選為「十個最代表香港的設計」的第一位。另外，近年港式奶茶製作技藝被選為二〇一七「香港非物質文化遺產」的傳統手工藝，實至名歸。

現時蘭芳園已由第二代接棒，絲襪奶茶這種夾雜英式與港式的飲品，至今仍保持一貫高水準，城中不少名人影星都是長期捧場客。今時今日，雖然飲食行業受經濟下滑所困擾，但蘭芳園的食客仍然絡繹不絕。

Lan Fong Yuen's signature "silk stocking milk tea" is made from a mixture of different tea leaves, including Ceylon. It is filtered by hand thrice to well mix the aromas and flavours of the teas while eliminating the bitterness, and creating a smooth and natural texture. Up to now, Lan Fong Yuen still sells over a thousand cups of milk tea each day. Back in the old days before World War II, local people used to drink Nanyang coffee, the traditional Malaysian style coffee. It wasn't until the 1950s and 1960s that people started to enjoy milk tea. However, there wasn't much consideration to the making at the time, so the tea was often bitter. Lan Fong Yuen works on improving the tea by filtering it with a very fine cotton bag to remove the tea dust and thus the bitterness in it. It is named "silk stocking milk tea" because the cotton bag resembles a stocking after being dyed brown by tea leaves. Now the famous silk stocking milk tea has attracted many coverages by local and foreign food magazines and newspapers, resulting in a wide recognition of Lan Fong Yuen as an iconic local Cha Chaan Teng popular among locals and foreigners alike.

As one of the most long-standing Cha Chaan Tengs in Hong Kong, Lan Fong Yuen has witnessed the development of the industry. In 2005, it was ranked at the top for the list of ten designs best represent Hong Kong.

Now run by the second generation of the founding family, Lan Fong Yuen strives to maintain the high quality of its signature silk stocking milk tea as a hybrid of English and Hong Kong flavours. Many celebrities are their long-time patrons.

蘭芳園的「絲襪奶茶」，夾雜英式與港式飲食文化，盡顯中西匯聚的本土特色。

Lan Fong Yuen's "silk stocking milk tea" is a hybrid of English and Hong Kong tea cultures, demonstrating the local characteristic of Chinese and Western integration.

涼茶舖
Herbal Tea Shops

2.5

在霓虹招牌手稿中，除了有酒樓、茶樓、西餐廳、冰室外，還有數張涼茶舖手稿。涼茶在香港的歷史可以追溯到開埠時期，由於當時的醫療服務還未普及，一般華人遇有「頭暈身㷫」，都是飲涼茶解決，這在二戰時期尤其明顯，醫療設備短缺、經濟困難，涼茶是勞苦大眾備以不時之需的良方。

香港第一間涼茶舖「王老吉」於一八九七年註冊，為有需要的民眾提供藥飲。昔日的慈善機構，除了免費贈醫施藥，還會派涼茶，例如成立於一九一六年位於灣仔的黃大仙祠及其藥店，以免費或實惠的價錢派發涼茶給有需要的信眾治病調理（Evans & Tam, 1948）。涼茶舖在四十至六十年代也是百姓常聚集的地方，一杯涼茶只需一毫，除了可以閒坐聊天，舖內還常設當時還未普及的收音機、點唱機、電視機等。在五十年代平均日薪為 5.53 元（Census & Statistics Department, 1969）來說，是很划算的消磨時間方法，因此吸引了很多年輕人光顧及在店內消遣。除了是重要的舊香港文化，涼茶在香港歷史中也有其重要性，有文獻指出，黃大仙祠之所以廣受本地人認識和認同，很大程度歸功於這些免費涼茶（Lang & Ragvald, 1993）。

In our archive of hand-painted neon signboard artworks, other than those for Cantonese restaurants, tea houses, Western restaurants and ice chambers, there are several for herbal tea shops. The history of herbal tea in Hong Kong can be traced back to the time when the city was first opened. Back then, medical services were limited, so most Chinese people who felt unwell counted on herbal tea for relief. During World War II, in particular, when medical equipment was in short and the economy was struggling, herbal tea was the remedy readily available for the poor.

Wong Lo Kat, the first herbal tea shop in Hong Kong, was registered in 1897 to provide medical drinks to citizens in need. In the past, charitable organizations not only gave away free medical consultation and medicine but also distributed herbal tea. For example, Wong Tai Sin Temple and its pharmacy located in Wan Chai distributed herbal tea to followers for free or at a discounted price to cure their ailments or nurse their health (Evans & Tam, 1948). Between the 1940s and the 1960s, people often gathered at herbal tea shops to buy a cup of herbal tea for only ten cents and then sit around and chat as well as enjoy the radios, jukeboxes and televisions which were uncommon at the time. During the 1950s when the average daily wage was only 5.53 Hong Kong dollars (Census & Statistics Department, 1969), hanging out in herbal tea shops was a cost-effective pastime attracting many youngsters to patronize and spend time there. Apart from constituting an important culture of old Hong Kong, herbal tea plays an important role in the city's history, as some literature attributes Wong Tai Sin Temple's being widely known and recognized to the free herbal tea (Lang & Ragvald, 1993).

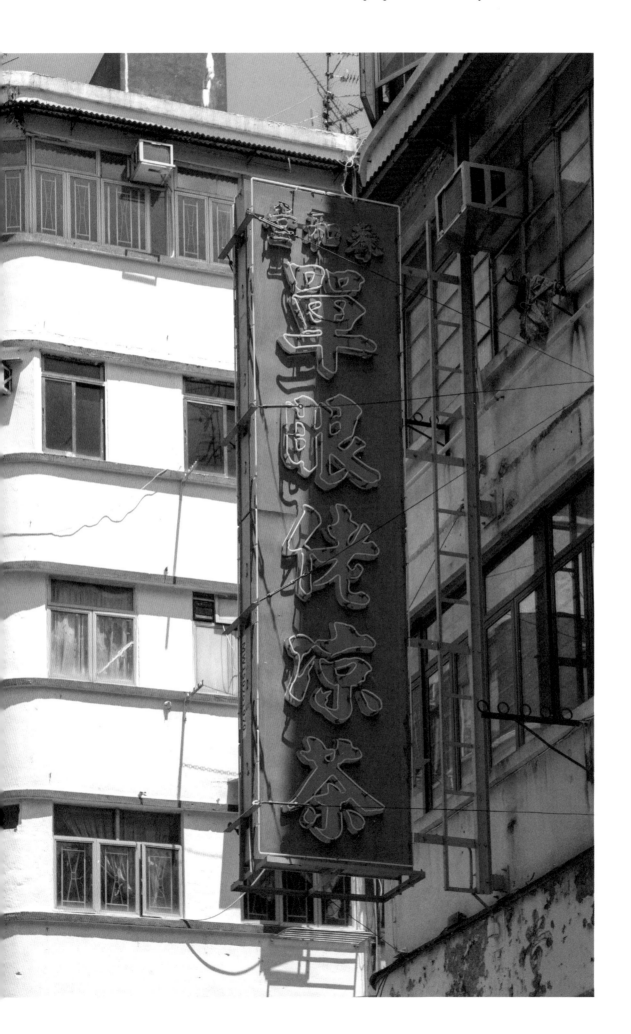

春和堂單眼佬涼茶　CHUN WO TONG DAN YAN LO HERBAL TEA

中國涼茶文化擁有悠久歷史，二〇〇六年，涼茶配製文化更成為國家級非物質文化遺產之一。在香港，涼茶早已融入市民大眾的生活。鄭寶鴻曾寫道，香港開埠以來第一間涼茶舖是在文武廟直街（荷李活道）開設，並於一八九七年正式將商標註冊為「王老吉」的涼茶店。

見證香港涼茶發展史的，除了百年老店王老吉外，也有佐敦的春和堂單眼佬涼茶。單眼佬涼茶創辦人李鏞昌，天生大細眼，加上斜視，街坊誤以為他的一隻眼睛有問題，所以稱他「單眼佬」。後來，李鏞昌索性以此為名賣涼茶，至今已經歷四代人。追本溯源，這間店舖原先以賣藥為主，後來才兼賣涼茶，所以原先店舖名稱叫「春和堂藥行」，後來賣涼茶生意越做越旺，最後改名為「春和堂單眼佬涼茶」。

Chinese herbal tea culture, with a long history in Hong Kong, was officially listed as one of the state-level intangible cultural heritage items in 2006. It had become part of Hong Kong people's lives long time ago. Wong Lo Kat is Hong Kong's first herbal tea shop after the port was opened, with its first shop opened on "Man Mo Temple Straight Street" (the unofficial name of Hollywood Road coined by the locals) and its trademark officially registered in 1897, according to Cheng Po-hung, a local renowned folk expert.

Besides Wong Lo Kat, Chun Wo Tong Dan Yan Lo Herbal Tea in Jordan is another witness of the historical development of herbal tea in the city. The shop's founder Lee Yung-cheung was born with asymmetrical eyes and a squint, so people thought he had problems with one of his eyes and gave him the nickname "Dan Yan Lo", meaning "single-eyed man", which Lee later adopted as its business name to sell herbal tea. Ever since, the family business has been passed down through four generations. The shop, originally named "Chun Wo Tong Chinese Medicine", began with selling medicines before it started to sell herbal tea too. As their herbal tea sold increasingly well, Lee renamed the shop to Chun Wo Tong Dan Yan Lo Herbal Tea.

開業超過半世紀，單眼佬涼茶是區內的老字號，它的霓虹招牌屹立在廟街多年，已成為當區的地標。店內保留了五、六十年代的格局，店內的兩層高樓底，中間掛上陳年吊扇，牆上掛著創辦人李鏞昌的肖像，也可看見舊式白底紅字的招牌廣告，寫著「春和堂單眼佬滴耳油琥珀膏」，另一邊也有覆蓋整幅牆身的陳年百子櫃，而地上則是已褪色的方形地磚，當然最重要的鎮店之寶，是放在門前的銅製大型涼茶壺。

Having been in business for over half a century, Dan Yan Lo has become a familiar name in the area. Its neon signboard has been hung over Temple Street for years as a local landmark. The shop keeps the same interior design as it had in the 1950s and 1960s. On the two-storey high ceiling hung a vintage fan in the middle. A picture of Lee Yung-cheung is on the wall. There is an old advertisement printed in red on white paper reading "Chun Wo Tong Dan Yan Lo Ear Drop Oil and Amber Ointment". A "hundred-drawer cabinet" covering the entire wall is on the other side. On the floor there are faded square ceramic tiles. Of course the most precious item of all in the shop — the giant copper herbal tea pot, is placed at the entrance.

上世紀五、六十年代，只有有錢人才能負擔得起看西醫，一般市民大眾若有頭暈身� ，都習慣到涼茶舖飲碗涼茶以除疾病，因此涼茶舖開遍成行成市。後來，涼茶舖也緊貼潮流，在舖內增設舊式唱片機，播放流行音樂以作招徠。當年顧客只要花一毫子買碗涼茶，便可坐上半天，聽「麗的呼聲」或歐西流行音樂。所以昔日的涼茶舖是年輕人聚會、男女約會的「蒲點」。

單眼佬涼茶憑藉其涼茶的獨特口感和堅實用料，逐漸贏得街坊口碑，當中最為人熟悉的是單眼佬涼茶（即廿四味）。涼茶秘方由創辦人李鏞昌獨家研發，秘方保持百年不變，涼茶呈深褐色，帶有草本清香，入口甘甜順喉，藥到病除。七、八十年代全盛時期，店舖每日賣近百碗涼茶，更有街坊拿漱口盅來買。曾在這裡工作多年的鄧叔指出，他每朝清晨一早在涼茶舖煲茶，涼茶是用火水爐慢火煲約四小時，煲的過程必須同時攪拌，煲完還要焗茶十小時才算完成。至於涼茶秘方和材料比例，則為祖傳秘方，只有老闆知道，絕不泄露。

During the 1950s and 1960s, only wealthy people could afford visiting Western doctors. Common folks used to drink herbal tea as a quick fix for minor health problems, so such shops could be found in every neighbourhood. Later on, herbal tea shops also caught up with the trend to equip themselves with radios playing pop music to attract customers. One spending only ten cents for a cup of herbal tea could stay in the shop for a whole afternoon listening to Rediffusion's radio programmes and Western pop songs. The shops provided places for hanging out and dating among young people at that time.

The unique texture and rich ingredients of Dan Yan Lo's herbal tea have gradually earned people's recommendation. The most famous one, Dan Yan Lo herbal tea (i.e. "24-flavour tea"), was developed by founder Lee Yung-cheung. The formula has remained unchanged for a century. The deep brown tea, with a refreshing herbal aroma, a bittersweet flavour and a smooth texture, is effective in curing ailments. During its heyday in the 1970s and 1980s, it sold up to nearly a hundred bowls of herbal tea every day with customers buying with their own tooth mugs. Uncle Tang, who worked in the shop, said he prepared the tea early in the morning every day. The tea was boiled over a low fire on coal oil stoves for four hours with frequent stirring, followed by ten hours of steeping to be deemed finished. The tea formulae and ingredients were family secrets never disclosed and known only to the owners.

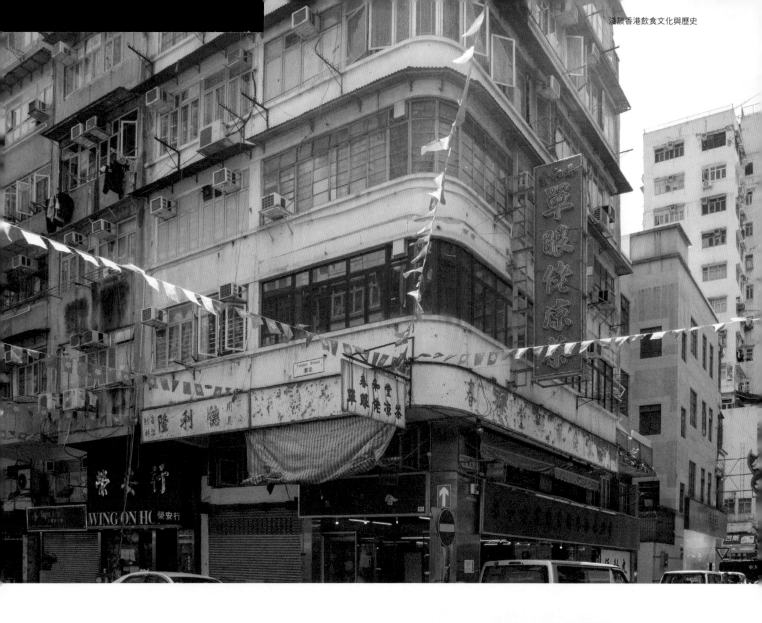

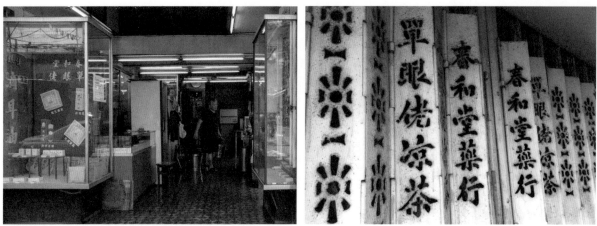

春和堂單眼佬涼茶是區內的老字號,它的霓虹招牌屹立在廟街多年,是當區的地標。

Chun Wo Tong Dan Yan Lo Herbal Tea had been long-standing in the area, with its neon signboard standing on Temple Street for years as a local landmark. The herbal tea shop was already closed down in 2018.

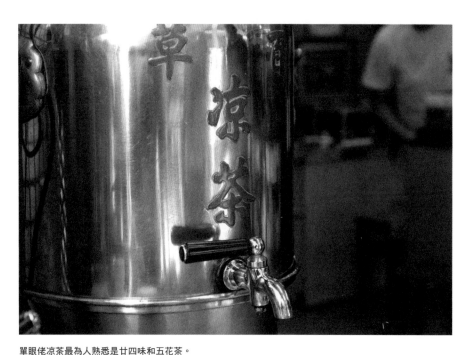

單眼佬涼茶最為人熟悉是廿四味和五花茶。
"24-flavour tea" and "five-flower tea" are the signature products of the herbal tea shop.

除了涼茶和五花茶外，單眼佬涼茶還售賣自家製的便秘丸、滴耳油及琥珀膏等中成藥。全盛時期單眼佬涼茶舖有四間分店，分別在上海街、彌敦道及深水埗，其後只剩下佐敦廟街的店舖，但最終在二〇一八年賣盤暫別。據單眼佬涼茶第四代傳人李兆麟說，這間涼茶舖已有六十多年歷史，由於位處舊式唐樓地舖，需要經常維修保養，帶來了不少營運壓力；但另一方面，他深感創辦人李鏞昌秘製的涼茶已有悠久歷史，不應就此結束，期望日後在區內覓得新舖，繼續為市民提供優質涼茶。

Besides herbal tea and five-flower tea, the shop also sold self-manufactured Chinese patent medicine such as constipation tablets, ear drops and amber ointment. At its apex, the shop had four branches, on Shanghai Street and Nathan Road in Mongkok, on Temple Street in Jordan and in Sham Shui Po. The Jordan branch became the last to close when the business suspended operation as the shop was sold in 2018. Lee Siu-lun, the fourth-generation owner, said the shop had operated in an old Chinese building for over 60 years and the frequent repair and maintenance had made the business difficult to sustain. However, Lee recognized that the herbal tea using secret formulae had a long history and the shop should not be closed. He hoped to find a new shop in the area to continue serving the neighbourhood with premium herbal tea.

Restaurant

X

霓虹美學

3

Neon
Aesthetics

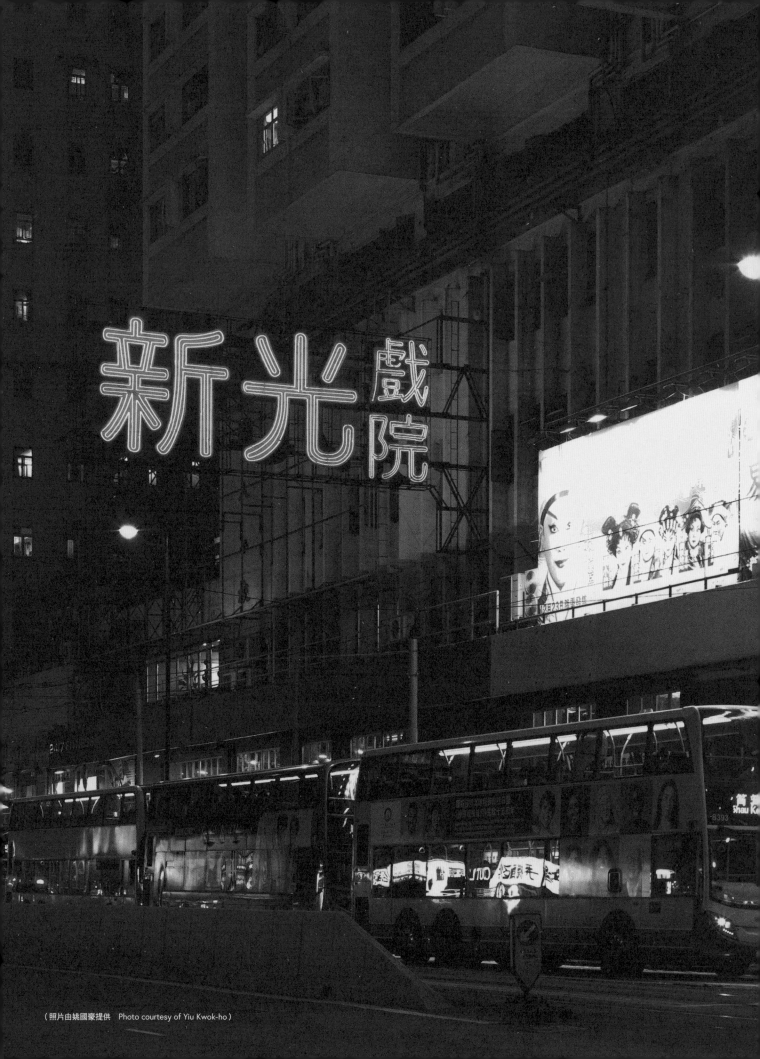

從東方之珠到滄海遺珠

——從香港電影中看霓虹招牌的美學與消逝

When the Pearl of the Orient Becomes Hidden:

Exploring the Aesthetics and Vanishing of Neon Signboards in Hong Kong Cinema

3.1

2046 燈火闌珊 飯戲攻心

蘇絲黃的世界
花街時代
梅艷芳
歲月神偷
英雄本色

The World of Suzie Wong
My Name Ain't Suzie
Anita
Echoes of the Rainbow
A Better Tomorrow
2046
A Light Never Goes Out
Table for Six

霓虹下的紙醉金迷：《蘇絲黃的世界》與《花街時代》

在光影世界裡，香港霓虹燈的色彩和光芒確實能為城市帶來獨特的魅力。香港被形容為「東方之珠」，是以其繁華熱鬧的城市夜景而聞名，而霓虹招牌是其中不可或缺的元素之一。當城市夜幕低垂，霓虹燈以其耀眼、繽紛的光芒點綴香港的街道和建築物。它們不僅增添了城市的動感和活力，還彷彿為整個城市注入了一份神秘浪漫的氛圍。這些霓虹招牌成為了香港的地標之一，吸引來自世界各地的遊客和攝影愛好者前來欣賞和「打卡」。

在香港的電影中，也不乏霓虹的蹤影，它的出現不單豐富了影像的視覺效果，也展現了社會經濟繁華的一面。

一九八五年上映的一齣《花街時代》（ My Name Ain't Suzie ），這是一部描述香港吧女的電影，也是八十年代香港電影的代表作之一。電影故事講述水美麗（夏文汐 飾）為了過上更好的生活，由漁村走到灣仔紅燈區的「Lucky Bar」酒吧當吧女，更與游手好閒帶有半唐番樣子的 Jimmy（黃秋生 飾）戀愛。電影正好透過描寫這風塵女子的命運，來側描八十年代的香港風月場所，特別是灣仔駱克道一帶的紅燈區，這一帶亦是當時美國水兵或外籍旅客喜愛流連消遣的地方。

電影為了捕捉香港是一個紙醉金迷的城市，開首拍攝車子穿梭於街道中，車身倒影了娛樂場所五光十色的霓虹招牌；最終，車子停在荒廢了的 Lucky Bar 和已壞掉的霓虹招牌下。接著，故事才由隔鄰的小食店老闆娓娓憶述五十年代 Lucky Bar 的風光歲月；背景響起五、六十年代十分流行的搖滾音樂，在璀璨的霓虹招牌下，一眾水兵與穿著旗袍的吧女郎在街上載歌載舞。Lucky Bar 的霓虹招牌，用上火辣誘人的紅色，襯托著冰冷藍色的酒杯圖案背景，散發的迷人光芒，令人不禁陶醉於銷金窩的世界。

在電影中，灣仔駱克道一帶的紅燈區展示了昔日最繁華的霓虹景象。觀眾可從中回看甚具代表性的 Club Pussy Cat 和 747 珍寶大餐廳。但最值得留意的，是在 Lucky Bar 旁的美利堅京菜（American Restaurant），它被譽為「名人飯堂」，在灣仔屹立了六十八年，最終在二○一八年結業。這也反映當年灣仔不單酒吧林立，也有不同的食肆進駐。

說到《花街時代》這齣電影，其英文戲名是 *My Name Ain't Suzie*，見到「蘇絲」（Suzie）這個名字，大家必定想起另一齣荷里活電影《蘇絲黃的世界》（*The World of Suzie Wong*）。這是一齣於一九六○年代，在香港背景下展開的愛情電影，改編自英國作家理查德・梅森（Richard Mason）的同名小說。故事講述一位英國畫家羅伯特（Robert Lomax）（William Holden 飾）來到香港尋找靈感，並在那裡遇見了一位妓女蘇絲黃（Suzie Wong）（關南施 飾）。兩人之間逐漸產生了

深厚的感情,並展開了一段跨越種族和社會階層的戀情。

由於這齣電影在香港取景拍攝,所以大量出現香港的街頭景象和庶民生活,珍貴地記錄了當時香港的地標及城市景觀,例如維多利亞港、天星小輪、皇后像廣場、文武廟、大坑蓮花宮,還有中環和灣仔一帶的街道,以及繁華的市區風景。透過真實的拍攝,令西方觀眾可以感受到當時香港的城市氛圍,以及中西文化交融的特色。

電影中,筆者覺得最吸引的片段,是男主角羅伯特離開中環的天星渡輪後前往酒店,途中經過中環再到灣仔,他穿梭於擁擠的人群中,當經過街邊的熟食大牌檔時,看見燒鵝、生腸腸、大腸、牛肚和牛肺等內臟,頓時嚇得目瞪口呆。有文化評論者表示這是以白人為中心的視覺出發的「東方主義」。意思是指西方對東方文化和社會的浪漫化、理想化和刻板印象化。例如這種對街道食物的描繪,可能呈現了白人眼中落後地方的刻板印象。它強調了香港舊街道的破舊、混亂,和與西方現代化社會的差距,故將其定位為一個相對貧困和不發達的地方。又例如蘇絲黃這個角色被塑造成典型的東方女性形象,她身穿高衩旗袍,具有神秘感和誘惑力。她的外貌和風格符合西方對於東方女性的刻板印象,這種塑造是對東方女性的浪漫化和標籤化。

不論導演是否刻意帶有「東方主義」的眼光來看香港,但畫面捕捉了充滿活力的香港街頭景象,例如昔日喧鬧街道上常見的小販和攤檔,它們出售各種商品,例如食品、水果、藥材、零食等。這些攤販的攤位和商品陳列方式,呈現出遺忘已久的市集氛圍。另外,電影也有著墨於香港舊街道上常見的招牌和霓虹燈,在西方人的眼裡,這是香港一個鮮明的特色。這些招牌以中文和英文展示各種商店和服務,例如酒樓、茶餐廳、理髮店等。它們營造出繁華的氛圍,將香港舊街道的商業活力展現得淋漓盡致。筆者也有特別留意當中的招牌,例如在電影中有一場是在正街拍攝,畫面見到正昌肉食公司、保安寧藥行、鴻有肉食公司和多男大茶樓等。原來這幢四層高的多男大茶樓早於一九二〇年已開辦,是最早提供冷氣設施的中式酒樓,但最終於一九九五年結業。

電影藉著這些可憐的小人物(吧女)來反映香港社會的變遷和行業的興衰。酒吧及夜總會在八、九十年代非常盛行,特別在尖沙咀、佐敦和灣仔一帶,例如大富豪夜總會、中國城夜總會、東方夜總會、中國皇宮夜總會、杜老誌夜總會等,大大小小的成行成市,吸引了不少商人特別是日本商人、城中富豪光顧消費或洽談生意。到了九十年代末,因著社會經濟轉變,不少商家轉到內地設廠,很多商業娛樂活動也隨之北移。昔日紙醉金迷、聲色犬馬的夜總會,也因行業逐漸走下坡,到最後相繼結業。五光十色的大型霓虹招牌逐漸減少,街道變得冷清,整個城市也變得沒精打采。

The Indulgence and Dissipation under the Neon Lights:
The World of Suzie Wong and My Name Ain't Suzie

In the realm of illumination and obscurity, the hues and radiance of Hong Kong's neon lights undoubtedly bestow upon the city a distinct charm. Hong Kong, often hailed as the "Pearl of the Orient", is famous for the city's busy and lively nocturnal panoramas, with neon signboards contributing as an indispensable element. As twilight descends upon the city, neon lights adorn Hong Kong's thoroughfares and edifices with their resplendent and multi-coloured glow. They not only augment the dynamism and vitality of the urban landscape, but also infuse the city with an aura of enigmatic romance. These neon signboards are the iconic landmarks of Hong Kong, drawing tourists and photography enthusiasts from across the globe to marvel at and encapsulate their essence.

In the realm of Hong Kong cinema, the prevalence of neon signboards is a familiar scene. Their appearance not only enhances the visual aesthetics of the imagery, but also reflects the city's socio-economic prosperity.

My Name Ain't Suzie (《花街時代》), released in 1985 depicting Hong Kong's bar girls, is considered a quintessential work of Hong Kong cinema in the 1980s. The film centres around Shui Mei-li (portrayed by Patricia Ha), who, in pursuit of a better life, transitions from a fishing village to become a bar girl at "Lucky Bar" in Wan Chai's red-light district. She falls in love with Chinese-American Jimmy (portrayed by Anthony Wong Chau-sang), a carefree man. Through the portrayal of this woman's life, the film offers insight into the nightlife of Hong Kong, particularly in the red-light district surrounding Lockhart Road in Wan Chai, which was frequented by American sailors and foreign tourists at the time.

To capture the essence of Hong Kong as a city of opulence and allure, the film commences with a scene of a car navigating through the streets, with its surface mirroring the vibrant neon signboards of entertainment establishments. Eventually, the car stopped beneath the deserted "Lucky Bar" and its ruined neon signboard. The narrative then shifts to the proprietor of a nearby snack shop who reminisces about the heyday of "Lucky Bar" during the 1950s. Setting against the backdrop of rock music prevalent in the 1950s and 1960s, sailors and bar girls in cheongsam revel and dance beneath the resplendent neon signboards on the streets. The neon signboard of "Lucky Bar", bathed in a seductive hue of crimson amidst a backdrop of frosty blue wine glasses, emits an enchanting radiance that beckons viewers into a realm of glamour and indulgence.

In the film, the red-light district around Lockhart Road in Wan Chai showcases some of the most vivid neon scenes of bygone eras, bringing viewers back to iconic establishments such as "Club Pussy Cat" and "747 Treasure Restaurant". However, what deserves particular attention is "American Restaurant" adjacent to "Lucky Bar", renowned as "celebrity's canteen", which graced Wan Chai

for sixty-eight years until its closure in 2018. This also reflects during that period, Wan Chai was not only populated by bars but also boasted a variety of dining establishments.

The film titled *My Name Ain't Suzie* inevitably evokes recollections of another Hollywood production The World of Suzie Wong (《蘇絲黃的世界》). This film, set in Hong Kong during the 1960s, adapts the novel of the same name by British author Richard Mason. The story is about British painter Robert Lomax (portrayed by William Holden), who comes to Hong Kong for inspiration and encounters a prostitute named Suzie Wong (portrayed by Nancy Kwan). A profound connection gradually develops between them, culminating in a romance that defies both racial and social stratification.

This film was shot in Hong Kong, showcasing numerous street scenes and vignettes of people's daily life. It provides invaluable documentation of the landmarks and urban vistas in the city, including Victoria Harbour, The Star Ferry, Statue Square, Man Mo Temple, Lin Fa Kung in Tai Hang and streets in Central and Wan Chai, as well as captures the vibrant urban landscape during that period. The authentic cinematography allows Western audiences to immerse themselves in the urban ambiance of Hong Kong at that time with its distinctive amalgamation of Eastern and Western cultures.

One of the most striking scenes in the film is when the lead actor Robert disembarks from The Star Ferry in Central and proceeds to his hotel, traversing through Central to Wan Chai. As he navigates the bustling streets, he is taken aback by the sight of food stalls selling roasted goose, raw liver sausages, intestines, tripe and ox lungs among other offal. Some cultural critics interpret this scene as an illustration of "Orientalism" from a Eurocentric perspective, referring to the romanticization, idealization and stereotyping of Eastern cultures and societies by the West. For instance, the portrayal of street food in this manner may propagate a stereotypical notion of backwardness from the viewpoint of the white. It underscores the dilapidation and disorderliness of Hong Kong's old streets, accentuating a disparity between them and Westernized modern societies, thus positioning Hong Kong as relatively impoverished and underdeveloped. Similarly, the character Suzie Wong is fashioned into a quintessential representation of an Oriental woman dressed in a slit cheongsam emitting an air of mystery and allure. Her appearance and style adhere to the Western stereotypes of Oriental women, presenting a romanticized and stereotyped depiction of Eastern femininity.

Whether the director deliberately adopts an "Orientalist" perspective in portraying Hong Kong, the visuals encapsulate the vibrant street scenes of the city. For instance, the scenes depict bustling streets teeming with vendors and stalls, reminiscent of the lively market atmosphere that once prevailed in the past. These vendors sell a variety of wares, including food, fruits, medicinal herbs and snacks. The stalls and their presentation of goods evoke a long-forgotten sense of market ambiance. Moreover, the film also accentuates the ubiquitous signboards and neon lights adorning the old streets of Hong Kong, which

are regarded as distinctive features by Western observers. These signboards exhibit various establishments and services in both Chinese and English, such as Chinese restaurants, Cha Chaan Tengs and barber shops. They contribute to the bustling ambiance, showcasing in great detail the commercial vigour of Hong Kong's old streets. I have paid special attention to the signboards depicted in the film. In a scene shot on Centre Street, the signboards of Jeng Cheong Meat Company, Po On Ning Drug Co., Hung Yau Meat Company and Dor Nam Tea House are visible. Dor Nam Tea House was a four-storey building established as early as in 1920. Being the earliest Chinese restaurant to offer air conditioning, it ceased operations in 1995.

The film mirrors the ups and downs of Hong Kong's society and the entertainment industry with these sympathetic characters, namely the bar girls. During the 1980s and 1990s, bars and nightclubs proliferated, particularly in Tsim Sha Tsui, Jordan and Wan Chai. Examples include Club Bboss, China City Night Club, Oriental Night Club, China Palace Night Club and Tonnochy Night Club. These venues, ranging from large establishments to modest ones, attracted numerous businessmen, notably those from Japan, and affluent locals for leisure pursuits or business negotiations. However, by the late 1990s, owing to socioeconomic shifts, many enterprises relocated their operations to Mainland China and a considerable portion of commercial entertainment activities also migrated northward. The once vibrant and glamorous night clubs gradually waned as the industry declined, ultimately resulting in closures. The resplendent neon signboards faded, desolating the streets and imbuing the entire city with a sense of melancholy.

霓虹下的艱苦歲月：《梅艷芳》與《歲月神偷》

說到觸及八十年代香港影視娛樂和社會經濟變遷的電影，不得不提於二〇二一年上畫的《梅艷芳》。電影以梅艷芳的一生作為藍本，向觀眾呈現了其短暫和不平凡的一生。這齣電影也側面描寫了當時社會的變遷，讓觀眾可從梅艷芳的成長尋回昔日香港的情懷。

有別於前兩齣電影以真實的拍攝手法，呈現昔日香港街頭的景象。《梅艷芳》這齣電影採用了電腦特技效果，來重塑八十年代彌敦道與佐敦道的場景。那段時期，香港的經濟快速增長，大眾的消費水平逐漸提高，造就了娛樂和飲食場所的生意暢旺。街道的霓虹招牌無處不在，這些招牌涵蓋了各行各業，如酒店、商場、餐廳、時裝店、戲院和各種娛樂場所。裕華國貨公司和妙麗中心的孔雀開屏形招牌，更是當時佐敦的地標，並成為了香港上一代人的集體回憶。

說到集體回憶，總不離「獅子山精神」。當時大部份香港人都是努力不懈的工作，希望憑著「頂硬上」（Can Do）的意志，能克服困難，幹出成績，以改善生

活。這種逆境自強的精神，在電影《歲月神偷》（2010）中有清晰的演繹。

《歲月神偷》是羅啟銳導演的半傳記電影，電影以羅生（任達華 飾）在上環永利街開設家庭式的小小鞋舖「羅記皮鞋」為開始點，這間鐵皮舖頭，樓下地舖樓上住人，一切起居飲食盡在斗居之中，反映出昔日生活雖艱苦但努力工作仍可搵食養家。可惜好景不常，先是颱風襲港，害得鞋舖損失慘重，後因大哥羅進一（李治廷 飾）罹患血癌而離開，面對種種人生不幸，羅生望著店舖上的霓虹招牌，「鞋」字的「圭」霓虹光管忽亮忽暗，令他不禁慨嘆說：「『鞋』字半邊『難』！」但為人樂天的羅太（吳君如 飾）則說：「但『鞋』字也是半邊『佳』。」羅生嘆一口氣道：「不論難也好，佳也好，日子總得過。」電影的主旋律就是呈現一種正能量，就算活在艱難時刻，凡事要秉持「一步難一步佳」的信念活下去，這亦反映了七十年代一般市民大眾的艱苦歲月。

說回電影中霓虹「鞋」字的一幕，時亮時暗的霓虹光管處理，是導演的神來之筆。其實不只是電影情節，在現實中也有霓虹招牌因日久失修而鬧出笑話。例如城中某宗教團體的霓虹標語「信耶穌，得永生」，由於招牌字上有一點一劃的光管壞了，最終畫面變成了「信耶穌，得水牛」，因而惹來途人以為信耶穌可以得水牛的大笑話。這似由上天而來的訊息趣事，隨著屋宇署實施招牌清拆令，招牌已遭拆卸。

The Trials and Tribulation under the Neon Lights:
Anita and *Echoes of the Rainbow*

Talking about films that delve into Hong Kong's entertainment industry and socioeconomic shifts in the 1980s, *Anita* (《梅艷芳》) released in 2021 stands as a pivotal work. Drawing inspiration from the entire life of Anita Mui Yim-fong, the film offers audiences a glimpse into her brief yet remarkable existence. It also serves as an indirect portrayal of the transformations of the era, evoking nostalgic reflections upon the bygone days of Hong Kong through Anita Mui's personal journey of growth.

Besides the realistic filming techniques employed in the preceding two films to depict the scenes of old Hong Kong streets, *Anita* utilizes computer-generated special effects to recreate the ambiance of Nathan Road and Jordan Road in the 1980s. During that period, Hong Kong underwent rapid economic growth, accompanied by a surge in the public's spending power, which fuelled the flourishing business of entertainment and dining establishments. Neon signboards were found everywhere, involving a diverse array of businesses including hotels, shopping malls, restaurants, fashion boutiques, cinemas and various entertainment venues. Both the peacock-shaped neon signboard of Millie's Centre and that of Yue Hwa Chinese Products Emporium Ltd. were iconic landmarks in Jordan at the time, evoking collective memories for Hong Kong's previous generation.

When discussing collective memories, one will never overlook the "Lion Rock Spirit". During that era, most Hong Kong people toiled diligently, hoping to overcome the challenges, attain success and improve lives upholding the "can-do" attitude. This spirit of resilience in the face of adversity is vividly depicted in the film *Echoes of the Rainbow* (《歲月神偷》, 2010).

Echoes of the Rainbow is a semi-biographical film directed by Alex Law Kai-yui. The narrative commences with the establishment of the family-owned small shoe store "Law Kee Shoes" by Law Sang (portrayed by Simon Yam Tat-wah) on Wing Lee Street in Sheung Wan. This modest tin shed, with a tiny living quarter above where all daily activities take place, encapsulates the essence of bygone days: despite life's adversities, diligent labour was still able to win bread for the family. Regrettably, good fortunes are short-lived. Initially, a typhoon ravages Hong Kong, inflicting significant damage to the store. Subsequently, Law Sang's elder son, Law Chun-yat (portrayed by Aarif Rahman), died from leukemia. Confronted with an array of misfortunes, Law Sang gazes at the neon signboard above the shop, on which part of the neon tube of the Chinese character "shoe" (「鞋」) flickers intermittently, prompting him to sigh that "the right half of the character 'shoe' is similar to that of the character 'difficult' (「難」)!" However, Law Sang's wife (portrayed by Sandra Ng Kwan-yue), an optimistic character, retorts that "the right half of the character 'shoe' can also be similar to that of the character 'excellent' (「佳」)." Law Sang, adopting a resigned tone, remarks that "whether difficult or excellent, life must go on." The main theme of the film centres on projecting a positive energy, underscoring the belief in persevering through adversity with the motto of "one step difficult, one step excellent." This narrative also serves as a reflection of the hardships endured by the general populace during the 1970s.

Returning to the scene in the film featuring the flickering neon "shoe" character, the manipulation of the neon tubes, alternating between brightness and dimness, demonstrates the director's ingenuity. Indeed, such a nuance has extended beyond the movie plot into reality, where neglected neon signboards have become objects of amusement. For instance, a neon signboard belonging to a religious group in the city, bearing the slogan "Believe in Jesus and Have Eternal Life" (「信耶穌，得永生」) experienced a malfunction concerning a dot and a stroke, resulting in the signboard's reading as "Believe in Jesus and Have a Buffalo" (「信耶穌，得水牛」), prompting passersby to chuckle at the notion of obtaining a buffalo through the faith in Jesus. This seemingly divine message of amusement ultimately vanished with the dismantling of the signboard upon the implementation of the signboard removal order by the Buildings Department.

霓虹的浪漫與暴力美學：《英雄本色》與《2046》

八十年代可說是香港電影的黃金時代，當中警匪、黑幫和英雄動作片更是炙手可熱的主流電影類型。要數代表作，不得不提由吳宇森執導，於一九八六年上映的《英雄本色》。當年《英雄本色》成為一時佳話，吳宇森式的槍戰更成為香港電影經典場面，為人津津樂道。就連荷里活知名導演昆頓塔倫天奴（Quentin Tarantino）也大讚其拍攝槍戰的手法。

電影中最令筆者深刻的一幕，莫過於 Mark 哥（周潤發 飾）在大廈天台上，被譚成（李子雄 飾）打至重傷，他毫不留情以直拳揮向 Mark 哥的鼻中央，Mark 哥的鼻血頓時從鼻孔中以泉水式的噴向天上，此時畫面以大型霓虹招牌作背景，以慢鏡捕捉血花四濺重疊於霓虹燈中，再分不清是鮮紅的血還是霓虹的艷紅，鼻血與霓虹在光影底下，交織了天台作為黑幫活動的既定場景。最終，Mark 哥被打至半昏迷狀態。

由於畫面沒有清晰展示霓虹招牌，為了找出這一幕所出現的霓虹招牌是什麼，筆者特意重看《英雄本色》這一幕多次，最終找出它是日本航空公司（Japan Airlines，簡稱「日航」、JAL）的「鶴丸」（Tsurumaru）或稱「紅鶴」標識圖案。根據網上資料，這個標識於一九五八年由 Jerry Huff 設計，沿用至二○○二年改用由品牌設計公司 Landor 所設計的「Arc of the Sun」標識，截至二○一一年日航重組後，才重新使用「紅鶴」標識。

此外，《英雄本色》中日航的「紅鶴」霓虹招牌，也記載了當時香港深受日本文化所影響。在六十至八十年代，多間日資百貨先後進駐銅鑼灣，例如大丸、松坂屋、崇光和三越等，當時銅鑼灣被稱為「小日本」或「小銀座」。隨著香港與日本之間的經濟和旅遊往來日趨頻繁，亦造就了多間日資航空公司抓緊機遇，開發往來香港與日本的新航線，而日航當然是其中之一。按照昔日拍攝場景的大廈位置推斷，可能是在港島區海底隧道出入口附近的大廈天台拍攝的。那排面向維多利亞港的商業大廈，其天台向來是擺放大型國際品牌廣告招牌的必爭之地。現在設於商業大廈天台的招牌，以內地大型企業品牌佔大多數，而留下的日資品牌只佔少數。一直設於伊利莎伯大廈天台的松下電器（Panasonic）大型霓虹招牌，也於二○二一年改為使用 LED 燈，至此維港兩岸再也不見大型霓虹招牌了。

昔日香港有很多地方都見霓虹招牌，只要其位置是肉眼易見，可達至有效宣傳作用，都會獲廣告商垂青。特別是啟德機場附近一帶，由於這區域是飛機升降航道，大多數大廈都是低層建築，所以大廈天台有各式各樣的霓虹招牌。另外，就是一些低密度住宅區，例如九龍塘一帶，一般都是單幢式平房建築，這些建築可以用作商業用途，例如酒家或酒店，他們都會擺放霓虹招牌在物業天台上。這令筆者想起電影《2046》的「東方酒店」（Oriental Hotel），電影講述在 2046 和

2047 號的房間，與周慕雲（梁朝偉 飾）所發生超越時空交錯的愛情故事。

從電影美學角度，王家衛有著史詩式的浪漫且淒美的美學天份，用色豐富強烈大膽。當中不平衡的構圖運用，讓畫面充滿視覺張力。筆者特別喜歡演繹白玲（章子怡 飾）及王靖雯（王菲 飾）的不同性格與情感，王家衛刻意將她們先後放置在同一空間出現，就是酒店天台上的一角，在前景的「東方酒店」霓虹招牌的點綴下，白玲及王靖雯呆望、抽煙、吃冰棒與沉吟，恍似若有所失。電影還有經典的一幕，當霓虹招牌亮起柔和燈光，畫面滲透著沉鬱的綠調子，一下子充滿懷舊氣氛，此時白玲與周慕雲相互擁抱，愛得纏綿，整個構圖充滿詩意，既浪漫且孤寂。

明顯地，就著電影所描述的時代背景下，這個「東方酒店」霓虹招牌的造型設計，正與本書裡的五、六十年代霓虹招牌手稿設計吻合，其特色就是出現一些弧形線條和圖案化的「裝飾藝術」（Art Deco）設計。在電影中，導演往往就是利用視覺文化符號來說故事。在《英雄本色》中，Mark 哥的鮮血在日航霓虹招牌下，映照出鮮紅色的暴力美學；而在《2046》中，東方酒店的霓虹招牌既有助增強懷舊感，亦為一對戀人添加了熱戀中的浪漫氣氛。

The Romance and Aesthetic Violence of Neon lights:
A Better Tomorrow and *2046*

The 1980s was the golden age of Hong Kong cinema, with genres such as police dramas, gangster films and heroic action movies reigning supreme. Among the standout works, one cannot disregard *A Better Tomorrow* (《英雄本色》) directed by John Woo Yu-sen released in 1986. This film became a sensation, with Woo's distinctive gunplay scenes attaining iconic status in Hong Kong cinema widely acclaimed and extensively discussed. Even esteemed Hollywood director Quentin Tarantino lauded Woo's approach to filming gunfights.

One of the most impressive scenes to me in the film is when Brother Mark (portrayed by Chow Yun-fat) is severely assaulted by Tam Shing (portrayed by Waise Lee Chi-hung) on the rooftop of a skyscraper. Tam Shing mercilessly delivers a direct punch to the centre of Brother Mark's nose, causing blood to gush like a fountain from his nostrils. With a large neon signboard as the backdrop, the scene is captured in slow motion, depicting the splattering blood's merging with the vibrant red colour of the neon light to create an ambiguous blend of vivid reds. Amidst the interplay of lights and shadows, the scene is created on the rooftop, an established setting for gangster activities. In the end, Brother Mark is left in a semi-conscious state following the brutal assault.

As the neon signboard is not clearly showcased in the scene, I deliberately revisited it repeatedly to identify it. Eventually, I found that it was the company

logo of Japan Airlines (JAL), commonly known as the "Tsurumaru" or "Red-crown Crane". According to online sources, the logo was designed by Jerry Huff in 1958 and had remained in use until 2002 when it was replaced by the "Arc of the Sun" logo designed by brand design company Landor. Subsequent to the restructuring of Japan Airlines in 2011, the "Red-crown Crane" logo was reintroduced.

A Better Tomorrow also chronicled the significant influence of Japanese culture on Hong Kong during that era. From the 1960s to the 1980s, various Japanese-owned department stores debuted in Causeway Bay, including Daimaru, Matsuzakaya, Sogo and Mitsukoshi, earning the district monikers of "Little Japan" or "Little Ginza" during the period. With burgeoning economic and tourist exchanges between Hong Kong and Japan, numerous Japanese-owned airlines seized the opportunity to expand new routes between the two, with Japan Airlines being prominent among them. Based on the location of the building depicted, it is inferred that the scenes were filmed on the rooftop of a building near the entrance and exit of the cross-harbour tunnel on Hong Kong Island. The rooftops of commercial buildings facing Victoria Harbour have been highly sought-after for showcasing advertisements of large international brands. Presently, most signboards on the rooftops belong to prominent Mainland Chinese corporate brands, with only a handful of Japanese-owned brands remaining. The large neon signboard of Panasonic, formerly situated on the rooftop of Elizabeth House, was replaced with LED lights in 2021, signifying the vanishing of large neon signs on both sides of Victoria Harbour.

In the past, neon signboards could be found in many places in Hong Kong. As long as they could effectively serve advertising purposes at locations easily visible to naked eye, they would attract the attention of advertisers. In the vicinity of Kai Tak Airport, where most buildings along the takeoff and landing flight paths had low-rise structures, saw plenty of neon signboards of various kinds on their rooftops. Furthermore, certain low-density residential areas such as Kowloon Tong, predominantly featuring standalone houses which could be repurposed for commercial ventures such as restaurants or hotels, often had neon signboards atop the premises. This evokes recollections of "Oriental Hotel" portrayed in the film 2046, which depicts a love story transcending time and space in rooms 2046 and 2047 involving Chow Mo-wan portrayed by Tony Leung Chiu-wai.

From a cinematic aesthetic standpoint, Wong Kar-wai exhibits an epic and poignant flair for visuals, employing rich, intense and bold colours. His use of unbalanced composition instils visual tension within the frames. I particularly admire his depiction of the diverse personalities and emotions of Bai Ling (portrayed by Zhang Zi-yi) and Wang Jing-wen (portrayed by Faye Wong). Wong Kar-wai deliberately situates them in the same space — a corner on the hotel's rooftop, with the neon signboard of "Oriental Hotel" adorning the foreground. Bai Ling and Wang Jing-wen engage in activities like gazing, smoking, eating popsicles and contemplating, exuding an air of introspection.

The film also features a memorable scene where the neon signboard softly illuminates, casting a melancholic green hue across the frame and instantly evoking a nostalgic ambience. In this moment, Bai Ling and Chow Mo-wan tenderly embrace their lingering love, crafting a romantic and solitary composition replete with poeticism.

Clearly, within the context of the era depicted in the film, the design of Oriental Hotel's neon signboard aligns with the hand-drawn neon signboard artworks from the 1950s and 1960s outlined in this book, characterized by the curved lines and "Art Deco" patterns. In films, directors often narrate stories with visual cultural symbols. For instance, in *A Better Tomorrow*, the stark bloodshed beneath Japan Airlines' neon signboard evokes a vivid aesthetic of violence, while in *2046*, the neon signboard of Oriental Hotel not only evokes nostalgia but also imbues a romantic atmosphere to the love affair between the two characters.

霓虹的消逝與回憶：《燈火闌珊》與《飯戲攻心》

自二〇一〇年屋宇署實施招牌清拆令下，過去十多年香港街道上的霓虹招牌已經差不多銷聲匿跡。

當人人惋惜香港霓虹招牌逐漸消失，電影《燈火闌珊》就在這氛圍下開展故事。電影講述主角江美香（張艾嘉 飾）難以接受丈夫楊燦鑣（任達華 飾）已離世的事實，她一直懷念著與亡夫在霓虹招牌下的回憶。後來她走到亡夫的霓虹招牌製作工場「鑣記霓虹」，並巧遇了楊燦鑣的徒弟李登龍（周漢寧 飾）。原來楊燦鑣有一個未圓的心願，就是希望重做一個已被拆卸的舊霓虹招牌。為了完成亡夫的遺願，江美香決心逐步學做霓虹招牌，多得徒弟李登龍的悉心教導，故事最終美香能完成她亡夫的遺願。當然電影並不是單純講述霓虹燈工藝和文化傳承的故事，而是透過霓虹燈這夕陽工業，側描他們喪夫或喪偶的慘痛經歷，希望引起社會關注他們的情緒壓力和傷痛。

回想導演曾憲寧在未開拍《燈火闌珊》之前，特意前來做前期的資料搜集，她稱由筆者所著的《霓虹黯色 —— 香港街道視覺文化記錄》一書，給了她很多寶貴的資料，令她對拍攝該片充滿信心。事實上，曾憲寧很用心，花了很長時間做資料搜集，也訪問了霓虹招牌的老師傅。導演更將以往鮮為人知的霓虹燈工藝，例如如何燒霓虹管，一吹一屈，都有在影片中展示。電影中，楊燦鑣的霓虹燈製造工場，跟我首次到訪南華霓虹燈電器廠有限公司的燒霓虹管製造工場的佈局差不多，相信導演是希望模擬出工場的實際場景和展示霓虹燈師傅高超的技巧。香港曾經擁有美麗璀璨的夜色，實在要多謝這些盡心盡力的師傅。所以，在電影鳴謝中，也有表揚這些已退休和已故的霓虹燈師傅，以紀念他們的貢獻。

熟悉的霓虹招牌帶來熟悉的街道景觀，滋養和連結我們對社區的歸屬感和情感。但當霓虹招牌逐一拆卸，心裡總有不捨。昔日跟地方建立的情感和聯繫，恍似被狠狠地切割。就像電影中美香知悉亡夫所做的霓虹招牌快要被清拆時，她激動地對拆卸工人說：「這個招牌係我老公做的，他現在走咗啦，招牌仲喺度，你要拆，拆埋我呀！」電影的另一幕，美香望著翠華餐廳招牌被拆卸的一刻，不禁有感而發：「幾十年嘅歷史，話拆就拆！」在電影宣傳預告片尾段中，更有這一句：「美好的，熄滅了，心中尚有霓虹，拆不掉。」（Glory days lost, lights gone out, the neon within us still glows）電影正好提醒我們，在街道上的霓虹招牌會逐漸消逝已成定局，這是不能逆轉的事實，但它留在我們心中的一切美好回憶是拆不掉的。

把美好的事情留在心裡，是一個很好的方案。此外，坊間也有很多有心人，願意騰出空間和時間，來拯救不同的霓虹招牌。但要做到這一點，除了有空間、資源和時間之外，最重要的，是有心。在過去幾年，有很多文化機構和團體不斷拯救霓虹招牌，他們願意投放金錢，租貨倉擺放收集回來的大型霓虹招牌，不單止這樣，他們還會連繫一些霓虹燈師傅，把舊招牌復修，這方法既可將霓虹招牌復修並適當保存，也可讓霓虹燈師傅藉著復修工程而得以維持生計，甚至可以把工藝傳授給年輕人。他們也藉著舉辦文化講座、展覽和文化導賞團等推廣霓虹燈，以對香港的霓虹燈保育和文化傳承作出貢獻。

正如《飯戲攻心》的女主角馮靜（Monica）（鄧麗欣 飾），對拯救即將拆卸的招牌，猶如熱鍋中的螞蟻般，不顧一切瞓身地拯救霓虹招牌。不知大家有沒有留意電影其中一場，在大哥陳鴻（黃子華 飾）的家中一角，藏有不少舊式招牌，筆者見到實在十分感動。但最令招牌保育人士有所共鳴的，是 Monica 看不過眼同事和上司視招牌為垃圾，不禁憤慨地說：「招牌執返嚟，唔係垃圾嚟，這些垃圾叫做『文物』，它們至少個個都有三十幾年歷史。」在這裡值得討論的是，Monica 看招牌並不是單純從物件的層面，而是昇華至文物級別的看待。怪不得就連 M+ 博物館也要收藏霓虹招牌。當然博物館不能收藏所有的霓虹招牌，唯有靠民間力量。Monica 以一人之力，盡可能收藏最多的招牌，希望打造民間招牌資料庫。

電影到了尾聲，大哥和二哥和好如初，大家在街上抬頭望向家中窗戶所掛的「有福叉燒」霓虹招牌。這個霓虹招牌是用了由本港開發和設計的「李漢港楷」字體；而霓虹燈的製作，則是由「九龍霓虹」本地製造。導演陳詠燊更巧妙地將「有」字中間兩個橫畫的霓虹管做暗了，變了「冇福叉燒」，這正好反映出霓虹燈最有趣和最人性化的地方，時暗時亮。一時「有」福，一時「冇」福。這個點子，跟電影《歲月神偷》中的「鞋」字，「半邊難，半邊佳」一脈相承。最終整套電影想帶出，不論事情是禍是福，不在於環境是否處於困難，而在於個人心境能否轉變，劇情至尾當然是大團圓結局收場，最後以一家之主陳鴻的肺腑之言作

結：「屋企人喺邊度，邊度就係我哋屋企」，電影結尾的畫面便是大家熟悉的香港夜景。

The Disappearance and Memory of Neon Lights:
A Light Never Goes Out and *Table for Six*

Since the implementation of the signboard removal order by the Buildings Department in 2010, neon signboards have almost disappeared from the streets of Hong Kong over the past decade.

As people feel sorry for the gradual disappearance of neon signboards in Hong Kong, the film *A Light Never Goes Out* (《燈火闌珊》) unfolds its story under this atmosphere. The movie follows the journey of the protagonist, Kong Mei-heung (portrayed by Sylvia Chang Ai-chia), as she struggles to come to terms with the passing of her husband, Yeung Chan-biu (portrayed by Simon Yam Tat-wah). She fondly recalls the memories shared with her late husband under the glow of neon signboards and often sorts through his relics at home. Later, she visits his neon signboard production workshop, "Biu Kee Neon", where she coincidentally encounters his apprentice, Lee Deng-lung (portrayed by Henick Chou). It is revealed that Yeung harboured an unfulfilled wish — to recreate an old dismantled neon signboard. Determined to honour his wish, Mei-heung resolves to learn the craft of making neon signboards. With the patient guidance of Lee Deng-lung, ultimately, Mei-heung succeeds in fulfilling her late husband's desire. The film transcends mere craftsmanship and cultural heritage but employs neon lights as a metaphor to depict the poignant experiences of people losing their spouses, to arouse social awareness of their emotional anguish and suffering.

During the pre-production phase of *A Light Never Goes Out*, director Anastasia Tsang Hin-ning came to us to conduct meticulous preliminary research. She noted that my book *Fading of Hong Kong Neon Lights —The Archive of Hong Kong Visual Culture* provided her with valuable insights, bolstering her confidence in making the film. In fact, Tsang dedicated significant time to gathering data and interviewing seasoned craftsmen of neon signboards. She showcased lesser-known aspects of neon light craftsmanship in the movie, including the intricate process of heating, blowing and bending neon tubes, offering viewers a glimpse into these techniques. The layout of Yeung's neon light workshop in the film resembles Nam Wah's neon tube workshop during my initial visit. It is apparent that the director sought to authentically recreate the workshop's environment and highlight the exceptional skills of neon light craftsmen. These artisans played a pivotal role in shaping Hong Kong's once vibrant nightlife. Consequently, the film credits acknowledge the contributions of retired and deceased neon light craftsmen as a tribute to their legacy.

Familiar neon signboards evoke familiar street scenes, nurturing and intertwining our sense of belonging to and emotions towards the community. When neon

signboards are dismantled one by one, a palpable sense of reluctance pervades. The emotional ties forged with places in the past appear to be brutally severed. Similar sentiments are mirrored in the film when Mei-heung discovers that her husband's neon signboard is slated for dismantling. She emotionally tell the workers that "my husband crafted this signboard. Now he's gone and only his creations remain. If you have to dismantle it, dismantle me too!" Another poignant moment in the film occurs when Mei-heung watches Tsui Wah Restaurant's signboard being taken down, and she lamented that "the signboard with decades of history has now been dismantled in just one second!" The closing line of the film's promotional trailer echoes these sentiments: "Glory days lost, lights gone out, the neon within us still glows." The film serves as a reminder that the inevitable disappearance of neon signboards from our streets is an irreversible reality. Nonetheless, the cherished memories in our hearts remain indelible.

Preserving cherished memories in one's heart is a commendable endeavour. Moreover, there are numerous dedicated individuals in our society who willingly carve out space and time to rescue various neon signboards. However, achieving this goal requires more than just physical space, resources and time but unwavering determination. In recent years, many cultural institutions and organizations have worked tirelessly to conserve neon signboards. They invest funds in renting warehouses to store salvaged large neon signboards. They also invite neon signboard craftsmen to restore the old signboards, not only to ensure the appropriate restoration and safeguarding of neon signboards, but also sustain the livelihoods of the craftsmen and facilitate the transmission of their crafts to younger generations. Through initiatives such as cultural talks, exhibitions and guided cultural tours, they actively promote neon signboards and contribute to the conservation and cultural heritage of neon signboards in Hong Kong.

In *Table for Six* (《飯戲攻心》), the lead actress Monica (portrayed by Stephy Tang Lai-yan) mirrors the industriousness of ants in a hot pot as she tirelessly rescues neon signboards on the brink of demolition. Many viewers may notice a scene in the corner of the eldest brother Chan Hung's (portrayed by Dayo Wong Tze-wah) home, where numerous old-style signs are stored, a moment that deeply touches me. However, what struck preservationists most is Monica's righteous indignation when her colleagues and superiors dismiss the signboards as rubbish. She passionately exclaims that "these signboards we bring back are not rubbish. These 'rubbish' are 'cultural relics', each with a history of at least thirty years." Monica elevates the signboards to more than objects and considers them as cultural relics. It's no surprise that even M+ Museum is now collecting neon signboards. Of course, museums cannot collect every neon signboard and the conservation relies on community efforts. Monica, single-handedly, endeavours to gather as many signboards as possible, aiming to establish a grassroots signboard database.

As the film draws to a close, the eldest brother and the second brother reconcile and both of them gaze up at the 「有福叉燒」 ("Good Luck Barbecue

Pork") neon signboard hung on their home windows. This neon signboard features the locally developed and designed "Lee Hon Kong Kai" font, with the neon lights locally crafted by "Kowloneon". Director Chan Wing-san astutely darkens the two horizontal strokes within the Chinese character 「有」, transforming it into 「冇福叉燒」 ("No Luck Barbecue Pork"), reflecting the interesting and humanistic nature of neon lights — they flicker, sometimes radiating "luck" and other times "no luck". This concept echoes the 「鞋」 ("shoe") character in the film *Echoes of the Rainbow*, representing both ups and downs in one's life. Ultimately, the film seeks to convey that whether something is a boon or a bane hinges not on the circumstances but whether one can change his/her perspective. The narrative culminates in a happy ending. The last scene features patriarch Chan Hung's declaration from the bottom of his heart: "wherever our family members are, that's our home" and a familiar Hong Kong night scene.

結語

電影建構天馬行空的故事，也反映社會的實況。筆者從一九六〇至二〇二二年間，揀選了幾齣電影來淺談香港電影和霓虹燈美學的關係，那只是個人觀影後的觀點。

霓虹招牌在香港街道上逐漸消失已是不爭的事實，我們需要思考的是如何將昔日璀璨的霓虹招牌保留和傳承下去。這不單純在畫面上展示，我們要著手從歷史文獻、工藝及霓虹招牌手稿中，發掘更多知識及推敲延伸的可能性，以讓更多人得以認識霓虹招牌的歷史文化，以及懂得欣賞其工藝美學。

Epilogue

Films weave imaginative narratives while also mirror societal realities. I have selected a few films from 1960 to 2022 to briefly explore the interplay between Hong Kong cinema and the aesthetics of neon lights. These reflections stem from personal viewing experiences.

The gradual disappearance of neon signboards from the streets of Hong Kong is an undeniable fact. What warrants consideration is how to preserve and pass on these resplendent neon signboards from bygone eras. This entails more than mere visual exhibition. Delving into historical archives, craftsmanship and neon signboard artworks can unearth additional insights and foster further exploration. Such endeavours will facilitate a deeper understanding of the historical and cultural import of neon signboards, fostering an appreciation for their artistic craftsmanship.

霓虹燈上的視覺圖案
Visual Patterns on Neon Signboards

3.2

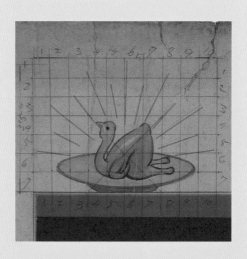

昔日電視屏幕還未普及，若要推銷產品，畫師會以手繪方式將產品圖案直接呈現在霓虹招牌底盤上，這些精緻又生動的圖案，可說是當時街上最吸引目光的視覺刺激，較常見的圖案，有餐廳的招牌菜式或代表店舖名字的符號。

當廣告競爭漸趨激烈，單靠文字或口號的文宣廣告，已不能滿足市場的需求及達致有效的宣傳效果，霓虹招牌於是逐漸加上寫實手繪圖案，圖文並茂。霓虹招牌或戶外廣告，不單純為滿足行人的視覺愉悅感，也透過強化視覺經驗，增強消費者對品牌或商號的辨識度和忠誠度，讓它們能從芸芸的競爭對手中脫穎而出。

回顧昔日的招牌廣告，當中的藥物招牌原來早已採用手繪插圖作為招牌的底圖，並以霓虹光管勾勒藥物包裝的主要輪廓作為圖案，以強化產品和商標的獨特性，加深消費者對產品的記憶，並提供資訊，提醒消費者購買正貨。面對大量商號及產品，消費者未必記得個別商號名稱，但獨特的圖案或商標所產生的視覺訊息，總是較容易讓人留下深刻印象，例如「雞仔嘜」的雞仔商標，或是「利工民」的跳躍馴鹿，都已深入民心，所以廣告商或商戶對霓虹招牌圖案尤其看重。

從手稿上的畫工和視覺圖案中，可見當年的繪畫風格，例如不少霓虹燈手稿畫師，會參考中外的繪畫風格，務求讓霓虹招牌的視覺更加生動吸引。根據香港設計歷史學家田邁修（Turner, 1988）指出，香港早期的設計美學受「現代化中國風格」影響，把中國傳統風格與外國的設計特色融合一起。其中，被視為是當年畫師創作靈感及重要參考材料的中國著名畫冊《芥子園畫譜》和月份牌畫，我們也不難在香港的霓虹招牌上看到相似的畫工和風格：以《芥子園畫譜》為基礎，採用不對稱和對角構圖，而當中的空間或留白位置，可加上廣告商標。至於圖案上的顏色配襯，則取材自色彩鮮艷的廣東年畫和嶺南派花鳥畫。

霓虹招牌手稿上的細膩筆觸和畫法，亦與田邁修所提到的年畫和花鳥畫有近似的技巧。當中田邁修提到比較有趣的，是昔日的中國畫師喜歡將外國裝飾或圖案如玫瑰花放到作品之中，而「玫瑰花可說是英國維多利亞時代後期的典型象徵」（同上，18頁）。在六十年代的「玫瑰餐廳」手稿裡，也用上玫瑰花作為這間餐廳的視覺符號。當然，昔日的手稿師傅或店東是否為了營造西化的感覺而使用外國的圖案就不得而知，然而這些裝飾圖案，亦常見於招牌的外框設計之上。香港設計文化學者黃少儀及田邁修分別提到，早期的香港設計推手均為一些逃難到港的中國畫師或美術家，故此便能進一步推論，手稿在一定程度上體現了現代化的中國風格。

不過，霓虹招牌始終與一般繪畫不一樣，例如霓虹光管只能屈曲成簡單線條、幾何圖形或簡單的圖像，而油畫顏料則讓畫家能真實和細緻地在畫布上描繪出物件的光線、紋理、質感和色彩。但話說回頭，雖然霓虹光管無法完全展現出像繪畫般的細節或全貌，但它卻令強調幾何圖形及線條的裝飾藝術在霓虹招牌上盡情展

現其特色。從欣賞角度看霓虹燈手稿，畫師繪畫工藝的精湛實在令人讚歎。然而，這些畫師在當時並未受社會尊崇，他們大多來自內地，移居香港後也並未受僱於任何公司，而是以自由業者身份提供商業美工服務，坊間不少人稱他們為「畫佬」。據南華霓虹燈電器廠的劉師傅憶述，南華初期的製作部門也是聘請內地畫師進行美工製作，他們大多在廣州或上海等地接受傳統的美術訓練。

我們將蒐集得來的手稿，讓不同的霓虹招牌師傅辨認，均認為有不少皆來自同一位畫師「麥師傅」的手筆。他在行內為人所熟悉，其作品也遍佈香港霓虹業界。可惜麥師傅本人已不在，有關於他的資料無從入手，流傳下來的只剩下他的霓虹手稿。因此，這批手稿甚為珍貴，就如美術館中的每幅珍貴畫作，極具社會、文化、美學和工藝意義。

至於研究團隊現有的二百一十八張食肆招牌手稿中所用上的圖案，大致可歸納出二十八類。雖然其他以文字為主的招牌手稿佔大多數，但這也不代表它們沒有從視覺出發，事實上，為免視覺觀感過於單調，這些招牌也採用不少視覺元素，例如用上簡單幾何圖案或線條作為招牌背景襯托，又或者使用中式或西式花紋作為招牌外框，有些索性將整個招牌結構化做成箭嘴形狀，直接指示店舖方向。

歸納出的二十八類霓虹圖案中，我們再以圖案的屬性或特徵來分為五大類：動物、植物、物件、文字商標及幾何圖案，以下的段落將逐一介紹其特色。

In the past before photography and television became popular, neon signboards were used as a major means of advertising. Artists directly drew by hand pictures of products on neon signboard backgrounds. These detailed and life-like images became the most eye-catching elements on streets at the time, visually exciting to all passersby. Signature dishes of restaurants and shop logos were the most commonly depicted.

As the advertising industry grew more competitive, putting texts and slogans on printed advertising was insufficient to meet market needs and achieve promotional effects, so realistic illustrations drawn by hand were added to neon signboards which included both texts and pictures. Neon signboards and outdoor billboards were not only designed to please the eyes of the pedestrians, but also to enhance recognition by consumers and boost their loyalty to brands and business names through heightened visual experiences, so that the companies could stand out from their competitors.

Among signboard advertisements in the past, the medicine ones began using hand-drawn illustrations on neon signboards' backgrounds early on. Neon tubes were bent to form the major outlines of the medicine's packaging, to highlight the uniqueness of the products and the logos, making them more memorable to consumers. Product information was also included to remind shoppers not to buy counterfeit products. When faced with a deluge

of available options, consumers may not be able to recall specific company names, but they will find visual information delivered by unique imagery and logos impressive. For instance, the iconic chick logo of "Chicks" and the prancing deer of "Lee Kung Man" are both very familiar to Hong Kong people. Thus, advertising companies and business owners greatly value the use of imagery on neon signboards.

The drawing skills and visual patterns used in the artworks of neon signboards reflected the art styles at that time. Many neon light drafting artists referenced local and foreign works to make the neon signboards more dynamic and attractive. According to veteran historian of Hong Kong design Matthew Turner (1988), early local design was influenced by "modern Chinese style", a blend of traditional Chinese style with foreign design elements. Famous Chinese drawing handbook *The Manual of the Mustard Seed Garden* and calendar poster art were major references and sources of inspiration for illustrators in the past. Their influences were easily recognizable in the designs of Hong Kong's neon signboards. Many artists adopted the asymmetrical and diagonal compositions shown in the manual and placed business logos in the empty spaces. For the vibrant colour palettes, artists took reference from Guangdong new year drawings and Lingnan landscape paintings.

The delicate brushwork and exquisite rendering manifested on neon signboard artworks were similar to those in new year and landscape paintings, as pointed out by Turner. One of the interesting facts that Turner mentioned was that Chinese artists in the past liked to include foreign decorations or imagery like roses in their works. "It can be said that the rose is the most iconic symbol of the United Kingdom's late-Victorian era" (Ibid, p.18). The artwork of Rose Restaurant from the 1960s featured a rose as the visual symbol of the restaurant. We don't know for certain if the artwork painter or the shop owner purposely used foreign imagery to convey a Western feeling, but these types of decorative elements were also common on neon signboard frames. Hong Kong design culture scholar Wong Siu-yi (2018) and Turner respectively mentioned that as most early local designers were painters and artists fled from Mainland China to Hong Kong, it could be inferred that the artworks reflected the influences of modern Chinese style to some extent.

However, neon signboards were different from traditional drawing, since neon light tubes could only be bent to form clean lines, geometric shapes and simple images, while oil paint allowed drawers to realistically and meticulously portray lighting, patterns, textures and colours of objects on canvases in great detail. Though there was no way for neon light tubes to perfectly replicate the details to show the whole pictures like paintings, they were well-suited to bring into full play on neon signboards the unique features of Art Deco which emphasized geometric patterns and outlines.

The finely detailed works of the drafting masters showcased on neon signboards definitely deserve appreciation. Unfortunately, these painters did not receive recognition during their time. Most of them relocated to Hong Kong from

Mainland China during the Cultural Revolution. These "painter guys" — as many people called them — were not employed by any company but worked as freelancers providing commercial art services. According to a veteran neon maker Lau Wan of Nam Wah Neonlight & Electrical Mfy. Ltd., the company's production department hired Mainland painters for art services during the early days. Many of them received traditional art training in Guangzhou or Shanghai.

We showed different neon light masters the artworks in our collection, and they recognized that many of them came from the same painter called "Master Mak", who is well known in the industry with his works found throughout Hong Kong's neon light industry. Unfortunately, Master Mak is no longer with us and not much information about him is left other than his neon sign artworks. As a result, these artworks are as precious as works in art museums, carrying great social, cultural, aesthetic and technical significance.

We divided the 218 restaurant neon signboard artworks in our collection into 28 categories according to the imagery. Though many artworks had texts as their main feature, it didn't mean that visual elements were not considered. In order to avoid the signboards' being overly plain, a number of visual elements were added, such as geometric shapes or lines on the backgrounds, or Chinese or Western patterns on the frames. Some signboards were even made into the shape of arrows pointing to the shops' directions.

The 28 categories of neon signboard imagery were further divided into five main groups according to their natures or characteristics, namely animals, plants, objects, logotypes and geometric patterns. Features of each group are introduced in the following section.

動物圖案 ANIMALS

在食肆手稿中，動物圖案有十種，包括香港人至愛吃的雞、鴨、鵝。使用這些圖案的，大多是傳統飯店或酒家，它們把自己的馳名菜式放在招牌上，也就是所謂的「招牌菜」。當中，鹽焗雞圖案有六個之多，包括「東江酒樓」、「鴻運來酒樓」、「滿堂紅酒家」、「好彩酒家」、「醉瓊樓」和「泉章居」。團隊在翻查有關繪畫鹽焗雞霓虹招牌的手稿資料時，找到一幅昔日「泉章居」的霓虹招牌的原稿彩圖，圖中的鹽焗雞，腿部被修正向下，這樣的修改用意，估計是希望令鹽焗雞在視覺上顯得更肥美，令人垂涎欲滴。現在，有鹽焗雞圖案的霓虹招牌已經買少見少，僅餘深水埗的「中央飯店」。另外，燒鴨和北京填鴨圖案，均在「泰豐樓」手稿中看到。由此可見，昔日鹽焗雞和燒鴨都是平民百姓外出用膳經常吃到的家常菜式。

平民菜式反映當年社會的飲食文化，而一些另類的菜式，同樣也是一個時代的見證，例如以魚翅聞名的貴價食肆「新同樂魚翅酒家」，其招牌手稿上畫有魚翅圖案，正反映七十年代股市暢旺，香港人流行以魚翅撈飯的日子，至今，在該店外仍可找到魚翅招牌。至於海鮮酒家，香港人吃海鮮講求生猛，所以以魚作為霓虹招牌上的圖案是十分普遍。例如在食肆手稿中，「海角漁舫海鮮酒家」就使用了三條魚作為該酒家的商標。

而除了用來烹調成菜式的海鮮、家禽，食肆霓虹招牌上，也會用上其他動物圖案，例如「鹿苑茶廳」用上威風凜凜的野鹿、「梁堅記餅家」用上飛躍奔騰的飛馬、「新西蘭茶餐廳」用上展翅震天的飛鷹等，都是以動物圖案作為標誌。另外，也有一些食肆採用了中國傳統吉祥圖案，例如「龍苑餐廳」和「龍子酒樓」的騰雲駕霧，展現出皇者風範的飛龍；「慶今逢大酒樓」則以雙鳳凰作食肆商標，這些都是充滿中國傳統寓意的符號。

Ten different types of animals were found in the restaurant neon signboard artworks, including chicken, duck and goose favoured by the locals. These images were mostly used by traditional Chinese banquet halls or restaurants to denote their signature dishes. Six images of salt-baked chicken were found in our collection, involving Dong Kong Grand Restaurant, Hung Wan Loi Restaurant, Full House Restaurant, Ho Choi Restaurant, Tsui King Lau and Chuen Cheung Kui. When the research team searched for information about neon signboard artworks with salt-baked chicken images, we discovered a coloured old master copy made for Chuen Cheung Kui, on which the drumstick was amended downwards, possibly to make the salt-baked chicken appear even more meaty, tasty and mouth-watering. Nowadays, it is hard to find neon signboards featuring salt-baked chicken, except the two at Central Restaurant in Sham Shui Po and Chuen Cheung Kui in Mong Kok respectively. The latter one was closed down in 2021.

Besides, images of roasted duck and Peking duck were seen in the drawings for Tai Fung Lau. From them, we know that in the past, salt-baked chicken and roasted duck were simple dishes that common folks of Hong Kong would enjoy while eating out.

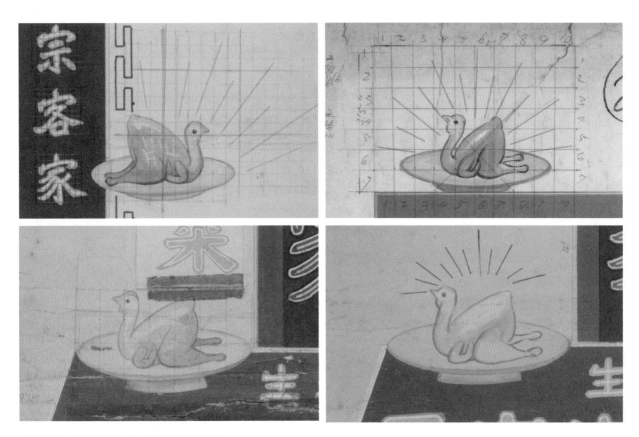

鹽焗雞是最多出現的圖案，這亦反映出其受歡迎程度。

The images of salt-baked chicken were commonly seen on neon signboard
artworks, reflecting the popularity of the dish.

北京填鴨圖案

The images of Peking duck.

Common people's dishes reflected the food culture of the society at that
time, while alternative dishes were also like the witnesses of past eras. For
example, upscale restaurants such as Sun Tung Lok Sharks Fin Restaurant famous
for shark fin soup used shark fin imagery on its neon signboard, reflecting the
trend of eating shark fin with rice in Hong Kong during the 1970s when the
stock market boomed. Today, the signboard is still hung outside the restaurant.
Meanwhile, since Hong Kong people liked eating fresh seafood, it was very
common for seafood restaurants to feature fishes on their neon signboards.
For example, the neon signboard drawing for Ocean Court Restaurant featured
three fishes as the restaurant's logo.

Besides depicting seafood and poultry used in dishes, neon signboards of
restaurants also incorporated other animals. For example, the majestic deer
on Luk Yuen Restaurant's signboard, the flying horse on Leung Kin Kee Pastries'
and the eagle on New Zealand Restaurant's. They all used animal imagery as
their logos. Other restaurants used traditional auspicious Chinese symbols,
such as the dragons flying through lucky clouds on the signboards of Dragon
Court Restaurant and Dragon Seed Restaurant to show royalty, as well as the
pair of phoenixes in the logo of Hing Kam Fung Restaurant.

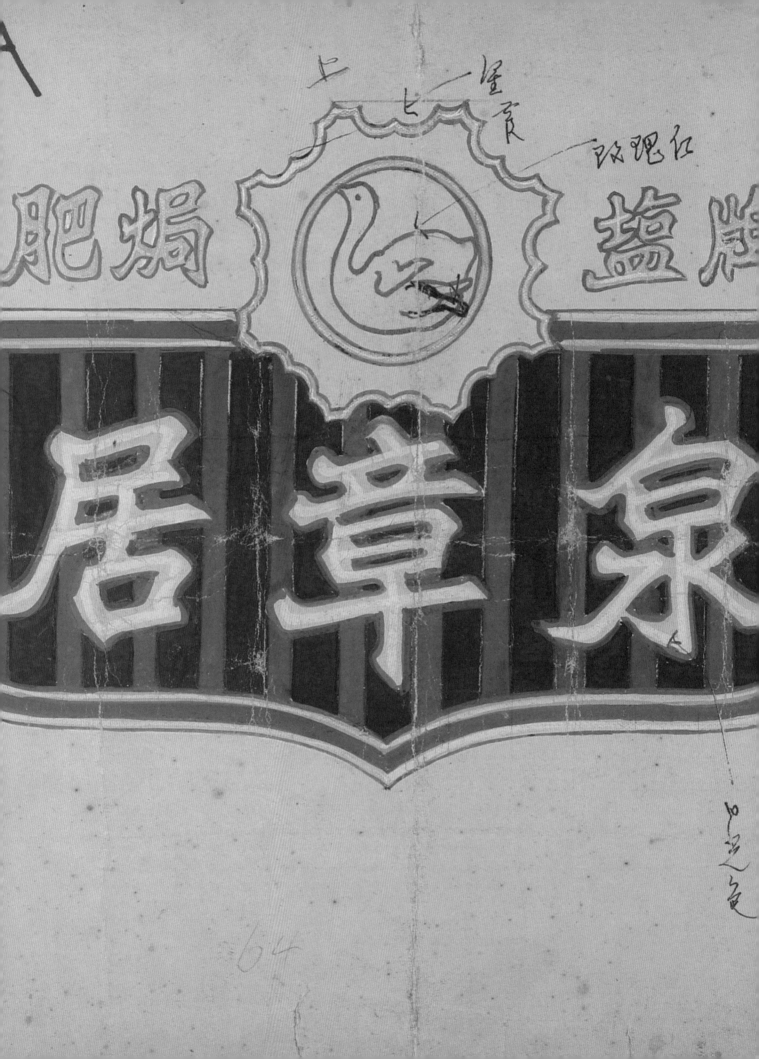

← | 鹽焗雞的腿部被修正向下，估計是希望在視覺觀威上顯得更肥美。（手稿由「長春社文化古蹟資源中心」提供）
The drumstick of the salt-baked chicken was adjusted to point downwards, possibly in hopes of making the image appear even more tantalizing. (Neon artwork courtesy of The Conservancy Association Centre for Heritage)

→ | 「海角漁舫」巧妙用了三條魚作為酒家的商標圖案。
Ocean Court Restaurant cleverly used three fishes in its business logo.

↘ | 「新同樂魚翅酒家」的手稿上畫有魚翅圖案。
Shark fin was drawn on the artwork for Sun Tung Lok Sharks Fin Restaurant.

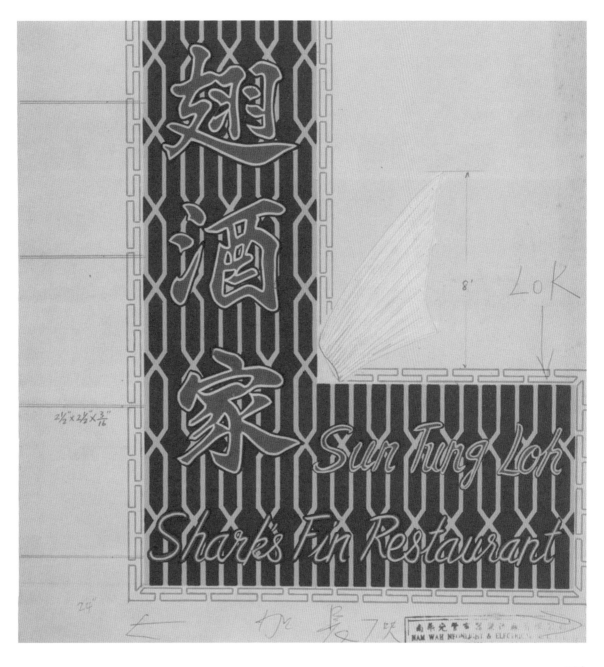

II 植物圖案 PLANTS

在我們現有的霓虹手稿中，可找出七種植物，當中出現較多的植物圖案是麥穗。所謂大地生長萬物，是人類的衣食母親；在農務社會，人們常以麥穗來比喻衣食豐足。因此，在霓虹招牌上，不少食肆也以麥穗作為圖案，例如「牛記酒家」、「新界大酒樓」和「大華飯店」等。此外，我們也找到五種有關花的圖案，包括菊花（「諾維食店」）、牡丹花（「富麗華酒樓」）、玫瑰花（「玫瑰餐廳」）、梅花（「梅江飯店」）和木棉花（「紅棉麵飽」）等，皆有花開富貴、大展鴻圖的寓意。另外，「景生大酒家」的手稿，也有明月與山景的有趣圖案，招牌兩側還放上鮮花營造出中國園林山景的仙境氣氛，雖然手稿是創作的初稿，但這種嶄新創意在昔日的招牌設計上實屬罕有。

Seven types of plants were found in our collection of neon signboard artworks, with the ear of wheat being the most common. Everything grows from the earth, the mother of food and clothing for human. In agricultural communities, people use wheat as a metaphor when talking about having plenty of sustenance. Therefore, many restaurants included images of the ear of wheat on their neon signboards, for example Ngau Kee Restaurant, New Territory Restaurant and Cafe de Chine. Besides, we also found five types of flowers in the drawings, including daisy (Nok Wai Eatery), peony (Fu Lai Wah Restaurant), rose (Rose Restaurant), plum blossom (Mui Gong Restaurant) and tree cotton (Kapok Bakery), symbolizing fortune and prosperity. The artwork for King Sang Restaurant featured an interesting mountain scene with a bright moon above and flowers on both sides of the signboard, creating a magical ambience of Chinese landscape. Though the artwork was only the first design draft, it displayed original creativity rarely seen in old neon signboard designs.

III 物件圖案 OBJECTS

有關物件的圖案有八種，這些圖案，皆旨在讓人直接或間接聯想到該食肆的名稱或類型，例如直接以燈飾圖案作為商標的華「燈」餐廳；間接的例子，有「環球茶餐廳」的咖啡杯、「揚記粉麵」的碗麵與筷子，「泰豐樓」則以煙囪涮鍋，讓人聯想到北京菜，還有使用巴黎鐵塔圖案的「法國飯店」——招牌借用一些具代表性的建築物或城市景點作為圖案，觀看的人會一併接收其所附帶的意識形態，就是帶出高尚、西化、高級、休閒和品味的文化符號訊息，例如提起法國，人們自然會想起葡萄酒和高級時裝；意大利，常跟意粉或名貴手袋有關；瑞士，會想起名錶和工藝等。當然，也有一些商號刻意透過圖案，展現食肆不同的地位和涵蓋的消費服務，例如以皇冠比喻皇者氣派的「金華大茶廳」，也有使用皇冠、音符和酒杯圖案的「瓊華大酒樓」等，都是透過不同文化符號和圖案來營造品牌形象，建立市場定位。

Eight types of objects were used on our neon signboards, intending to help people recall the restaurants' names or their characteristics. For instance, BLR directly used a lamp as its logo ("L" represents "lamp"), while indirect examples included the coffee cup used by Wan Kau Cha Chaan Teng, the noodle bowl and chopsticks used by Yeung Kee Noodles, the chimney pot used by Tai Fung Lau to symbolize Pekingese cuisine and the Eiffel Tower used by French Restaurant. Iconic constructions and cityscapes were used as cultural symbols to communicate certain ideologies or messages to viewers, such as classiness, westernization, luxury, relaxation and good taste. For instance, people would associate France with wine and high-end fashion, Italy with pasta and luxury handbags and Switzerland with luxury watches and handcrafts. Some businesses deliberately used pictures to highlight their statuses and consumption services. For example, Kam Wah Tea House used a crown to symbolize its royalty, while King Wah Restaurant used a crown, music notes and wine glasses. They tried to convey brand identity and develop market positioning with the use of different cultural symbols and imagery.

IV

文字商標圖案

LOGOTYPES

從文字商標圖案中，可再分為三種商標：一是以數字作為食肆的商標，例如369數字配以襟花背景的「新三六九酒樓」；二是以中文字作為食肆的商標，例如寫了「麪」字的「新全記」、以「囍」字配上齒輪形背景的「金喜樓」、寫上「波斯」二字的「波斯大餐廳」、在「嶺南」二字配上祥雲的「嶺南酒樓」等；三是以英文字母作為食肆商標，例如以「TPK」簡寫作為商標的「太平館餐廳」、以「OGR」作為商標的「敍香園飯店」，以及以全寫「CHOW MING KEE」的「周明記大飯店」等。

There were three types of logotypes. The first applied numbers to the restaurants' logos, for example New 369 Restaurant which used the number "369" accompanied by the picture of a corsage on the background. The second involved the use of Chinese texts in the logos, such as the character 「麪」 (meaning "noodles") used by New Chuen Kee Noodle Shop, 「囍」 (meaning "double happiness") against a cogwheel background used by Kam Hei Lau, 「波斯」 (meaning "Persia") used by Percival Restaurant and 「嶺南」 with lucky clouds used by Ning Nam Restaurant. The last type was English logotypes, with examples including "TPK" and "OGR", the short forms of Tai Ping Koon Restaurant and Orchid Garden Restaurant used as their logos respectively, as well as "CHOW MING KEE", which was the full spelling of Chow Ming Kee Restaurant.

V

幾何圖案

GEOMETRIC PATTERNS

在霓虹招牌手稿裡，也會出現一些幾何圖案及紋樣，雖說它們並不是主角，只是作為背景圖案或襯托，但當亮著霓虹燈的時候，卻有助豐富視覺效果，特別是使用在動態霓虹招牌上，效果就更顯著。在我們的記錄中，找到中式吉祥花紋、祥雲、如意、萬字邊、西式花紋、弧形、菱形、腰果紋、間條紋、六角形紋、紅磚紋、海浪圖案、酒杯形、圓形花邊等。雖然它們看起來只用簡單線條勾劃而成，但點、線和面是設計範疇的基本視覺元素，若運用得宜是可以創造出很大的視覺感染力。另外，有些幾何圖案甚至作為整個招牌外觀設計，例如「寶時茶餐廳」、「滿堂紅酒家」、「大華飯店」、「玄妙觀小吃部」均使用了箭嘴形狀作為整個招牌設計。還有一張無名的手稿，該店利用了茶葉形狀作為霓虹招牌，可以想像這獨特的霓虹招牌，在街道上會格外顯眼。

Geometric shapes and patterns were often seen on neon signboard drawings, though usually as background motifs or decorations rather than the main subjects. They enhanced the overall visual impact when the signboards were lit up, especially those dynamic ones. Our documentation included Chinese auspicious patterns, lucky clouds, ruyi (meaning "as one wishes"), the "wan" pattern (meaning "ten thousand" and "infinity" in Chinese), Western patterns, arcs, diamonds, cashews, stripes, hexagons, bricks, waves, wine glasses, circular floral borders and more. They may appear simplistic, but points, lines and surfaces are the basic visual elements of design which can create striking visual impact when used properly. Additionally, some neon light signboards were made into different geometric shapes, such as the arrow-shaped signboards of Po Si Tea House, Full House Restaurant, Cafe de Chine and Yuen Miu Koon Snack Shop. In our collection, there was an anonymous draft for a neon light signboard shaped as a tea leaf. One can imagine how eye-catching this unique signboard was on the street.

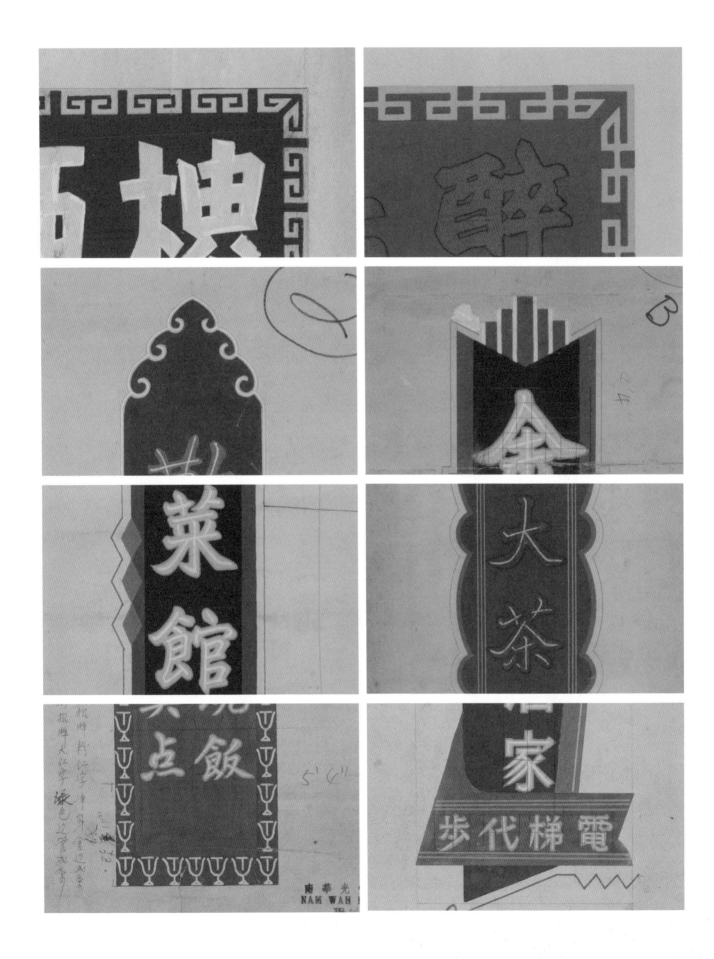

鹿苑茶廳 冷氣
西餅飲品 炒粉麵飯

揚記粉麵霸
楊

京菜
泰豐樓
PEKING FOOD TAI FUN LAU

樂琼
茶餐廳

龍苑餐廳

梁堅記餅家

龍苑餐廳
UNG YUEN
RESTAURANT

麵
新全記
酒菜粥粉

九六三新
樓酒
京滬名菜 蘇錫麵點 小意隨 夜宵飯晚

金華大茶廳
茶粉 美點

EST. 1955
WAH RESTAURANT
瓊華大酒樓

占飛餐廳
麵食
飲品
JAN FAIR CO. LTD.
Restaurant

法國飯店
FRENCH
Restaurant

NOVY COMPANY
諾維餅食

廳餐大斯波
PERSVAL
Restaurant

A65
正宗潮州菜

歡喜大茶樓
酒菜
茶麵

金海茶廳
酒菜
茶麵

DRAGON SEED
Restaurant
龍子酒樓

牛記酒家
NGAU KEE
RESTAURANT

囍
金喜樓
名 壽
茶 筵
美 喜
點 酌

叙香園飯店
ORCHID GARDEN RESTAURANT

嘉頓酒樓

紅棉麵�⾷
餅 糖
乾 菓

寶石酒家
長代梯電

玫瑰餐廳

一品香菜館

大人茶樓
名 海
茶 鮮
美 晚
点 飯

金牌蒸肥鵝 紅燒乳猪
泉章居

天虹大茶廳

新界大酒樓
NEW TERRITORY Restaurant

梅江飯店 梅江飯店 梅江飯店 梅江飯店 梅江飯店 梅江飯店

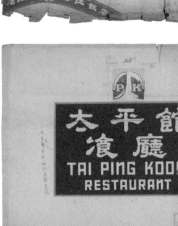
太平館飡廳
TAI PING KOO RESTAURANT

嶺南酒樓
NING NAM RESTAURANT

華燈飡廳
BLR

今慶

Hing Kam Fung Restaurant

美學的演變
The Aesthetic Evolution

3.3

利國光管有限公司
NECO NEON CO., LTD.
TEL.: 5-447561, 12-235181-4

比例
Scale:
尺寸
Size of Signs:
字之尺寸及色
Size & Colour of letters:
邊圍及顏色
Border & Colour:
此圖不符從實如不合格退回
If not acceptance, please return.

二百一十八張手稿，來自不同年份、橫跨數十年，透過整理及仔細閱讀，可進一步了解在不同時期，霓虹招牌在視覺及設計上的轉變。在整理的過程中，我們先查證每張手稿的繪畫年份，再按年份排序，嘗試分辨各個時期出現的設計和轉變。

這個步驟並不容易，事關明確寫上繪畫年份和日期的手稿佔極少數，專家及行內朋友也沒有頭緒。於是團隊參考了外國的研究文章，如遇到類似問題，會以當時所用的電話號碼長短作為時期的對照。這個方法是否可套用在香港？我們嘗試以舊報紙上的電話號碼長短，來推論報紙出版的時期，結果歸納出：五個字的電話號碼大概是五十年代，六個字的電話號碼是六十年代，七個字的電話號碼就是七十年代。

解決了時間上的推論方法後，研究團隊再次翻查手稿，就發現每張手稿上都印有霓虹燈招牌製作公司的印章或貼上生產標貼，兩者皆有公司電話號碼，方便客人聯絡或查詢。所以，我們根據電話號碼的長短來估計手稿大概的製作或繪畫時期。雖然這種以電話號碼長短作為製作時期的推論，並不完全準確，但由於它是根據現有方法中最有效及可靠的，所以這次整理也以此為時間上的推斷。另外，為了加強準確性，我們也嘗試尋找其他佐證，例如查證昔日年報上對應的商業登記號碼是否吻合，從而加強推斷年份的可靠性。

從二百一十八張食肆手稿中，能找到電話號碼的有一百七十八張。按一百七十八張手稿上的電話號碼長短來推論，屬於五十年代的手稿有五十四張，六十年代有七十八張，七十年代有四十六張，另有四十張手稿是沒有電話號碼的。但由於這些手稿只屬其中一間公司，所以數字未能反映整個行業的真實情況，例如七十年代數量下降至四十六張，有可能是手稿已被顧客取回保存，而未必是整個行業走下坡。在資料有限的情況下，這數字只能作參考，也只可供團隊作為分析或切入點。為了更有效分析手稿上的招牌美學，團隊以電腦重新勾畫手稿上的每一個招牌外框，這樣就可將顏色和圖案部份先撇除，以集中分析招牌外框和形態的轉變。團隊會按相似的造型或形態分類，線條結構複雜的手稿歸為一類，相同年份的手稿會歸為一類。這種分類的好處，是可以按每一次整理的結果，來個別分析它們所呈現的特殊性，以及找出當中的共通點。

The collection comprises 218 artworks produced in different years spanning several decades. Organising and reviewing the collection in detail allowed us to further understand the evolution in neon signboards over time in terms of their visual features and designs. To go through the collection, we began by identifying the year in which each artwork was produced. The artworks were arranged in chronological order so that we could attempt to identify the definitive designs and compare the changes found in each period.

This process was far from easy. Only very few sketches were marked with the

從印章中的電話號碼長短，可推斷出手稿大概的繪畫年份。

The approximate production years of the artworks could be identified based on the number of digits in the telephone numbers on the company stamps.

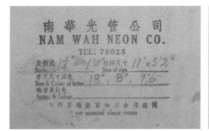

五十年代 The 1950s

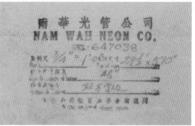

六十年代 The 1960s

七十年代 The 1970s

比較不同年份《華僑日報》頭版的電話號碼，發現五個字的電話號碼大概是五十年代，六個字的電話號碼是六十年代，七個字的電話號碼是七十年代。

By comparing the telephone numbers found on mastheads on newspapers published in different years, we could identify the different publication times from the lengths of the numbers.

一九五八年（1958）

五個字的電話號碼

Five-digit telephone number

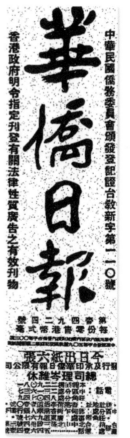

一九六八年（1968）

六個字的電話號碼

Six-digit telephone number

一九七八年（1978）

七個字的電話號碼

Seven-digit telephone number

exact years or dates of production, and even industry experts and craftsmen were unable to shed light on the issue. Therefore, our team referenced articles written by overseas researchers who faced similar problems and determined the years based on the number of digits in the telephone numbers at the times. The question was: would this work in Hong Kong? We tested by using telephone numbers of different lengths found on old newspapers to corroborate the dates of their publication and concluded that telephone numbers with five digits were from the 1950s, those with six digits the 1960s and seven digits the 1970s.

Though this method was not entirely accurate, it was the most effective and reliable out of all the available options. As such, we adopted it for organizing the collection. Moreover, in order to improve accuracy, we also tried to look for other supporting evidences, such as checking if the business registration numbers matched those listed on old annual reports, to enhance the credibility of our estimated years.

Out of the 218 artworks, 178 carried telephone numbers, while 40 did not. 54 pieces were from the 1950s, 78 from the 1960s and 46 from the 1970s. However, since all the artworks were acquired from one single neon signboard company, the figures may not be able to represent the entire neon light industry. For instance, the number of artworks from the 1970s amounted to only 46, which could be due to the fact that the artworks were taken and kept by clients, instead of the decline of the industry. Amid the limited availability of information, the figures could only be referenced as a starting point for analysis for the team. To analyze the aesthetics on the sketches more effectively, the team traced the frame of each signboard with a computer to remove the colours and patterns, so that they could focus on studying changes in the frames and the overall forms. The team then grouped the sketches according to their shapes and forms, such as considering artworks with complex line structures as belonging to one category, and those from the same decade the other. This kind of categorization allowed us to analyze the uniqueness of each category and identify their common attributes from the organization results.

用作製作霓虹招牌手稿的印章。
A stamp used on neon signboard artworks.

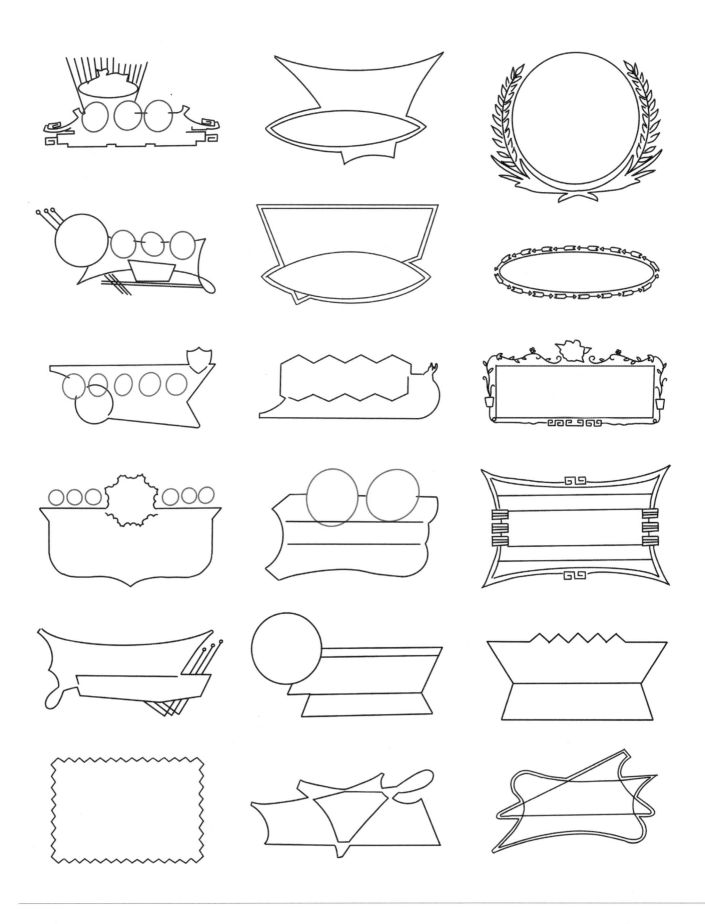

五十年代招牌設計樣式

Signboard Frame Design in the 1950s

五十年代的招牌設計豐富多樣，圖案也較複雜。

Signboards from the 1950s were distinctive of design diversity with relatively complex patterns.

六十年代招牌設計樣式

Signboard Frame Design in the 1960s

六十年代的招牌設計百花齊放，各類造型均有出現。

Signboards from the 1960s saw a complete collection of different forms and designs.

七十年代招牌設計樣式

Signboard Frame Design in the 1970s

七十年代的招牌線條趨向簡約，形狀以四邊形為主。

Signboards from the 1970s tended to feature simple lines with most of them being quadrilateral.

初步分析，以橫向式招牌設計為例，五十年代的招牌設計使用極多不規則造型，圖案也較複雜，設計充滿創意及跳躍感，整體造型也跟裝飾藝術相近。六十年代，招牌多採用弧形線條和稜角造型，部份招牌也多用垂直和簡約線條，以長方形為基本造型的招牌亦開始出現。整體上，六十年代招牌的設計百花齊放，各類圖形或造型均有出現。到了七十年代，採用簡約線條的招牌越來越多，以四邊形招牌為主，弧形和複雜的造型則相對地減少。

五十至七十年代的招牌，造型從複雜走向線條簡約，有這轉變當中涉及的原因很多，估計其中之一：要製作一個複雜的招牌，所需的技術甚高，成本也很高昂，加上後期製作相當費時，在市場競爭激烈的情況下，採用一些簡單線條的招牌設計，可縮減成本，並能加快推出時間；此外，懂得做複雜圖案招牌和造型的師傅越來越少；而自七十年代開始，設計趨向現代化，著重簡約主義，會將一些多餘的裝飾去蕪存菁，奉行「簡單就是王道」的原則。

五十年代 The 1950s　　六十年代 The 1960s　　七十年代 The 1970s

總括而言，我們可以看到五十年代的招牌設計充滿創意、有動感，這可能受到源自三十年代盛行的裝飾藝術所影響；六十年代，招牌造型多樣化，複雜與簡約共冶一爐；至七十年代，招牌趨向簡約與收斂，有點到即止之感。左圖可見三個不同年代招牌特色的轉變。

Using horizontal signboards as an example, our preliminary analysis showed that designs from the 1950s featured plenty of irregular shapes with relatively more complex patterns, demonstrating creativity and liveliness as influenced by the Art Deco style. In the 1960s, signboards began to feature more arcs and angular shapes, with some of them becoming vertical with simple lines. Rectangular signboards also began to emerge. On the whole, the 1960s was a time with the blossoming of all sorts of designs featuring a wide range of shapes and forms. During the 1970s, an increasing number of signboards adopted simple designs.

From the 1950s to the 1970s, signboard designs went from being complex to simple. There were many reasons for the change, and one of them could be cost-related. Creating a complex signboard involved great skills, high cost and time-consuming post-production. Under intense market competition, simple designs allowed for lower costs and quick launch. Another factor concerned the decreasing number of craftsmen who could produce signboards with complex designs and forms. Lastly, since the 1970s, designs started to become modern and minimalistic with the removal of unnecessary embellishments, in adherence to the principle of "simple is the key".

All in all, neon signboards from the 1950s brimmed with creativity and dynamics, as influenced by the Art Deco style prevailing in the 1930s. Signboard designs diversified in the 1960s, with complexity and simplicity being on a par with each other. In the 1970s, signboard designs became simple and subdued, looking modest to avoid overdoing. The images on the left show the changing characteristics of signboards in the three different periods of time.

招牌手稿色彩學
Colour Theory on Neon Signboard Sketches

3.4

霓虹招牌手稿上鮮艷奪目的色彩，是用了水粉顏料，它們大多來自香港本土生產的顏料製造商。昔日，香港最重要的顏料製造商，皆在第二次世界大戰期間或之前開業，顏料大部份都是以輸出為主。香島漆廠便於一九三八年成立，其創辦人伍澤民為化學工程師，曾於西雅圖就讀高中及大學，畢業後回流廣東，並開設顏料公司。日佔時期，伍氏帶同旗下部份技工，從廣東遷到香港，其所生產的漆油和顏料種類繁多，當中水粉與瓷漆只佔總銷量的一小部分（Lo, 2017）。另一間本地有名的漆油製造商中華製漆亦是成立於一九三〇年代，主要創辦人之一梁孟齊曾於美國接受化學訓練（同上），他也是早期在海外留學歸來後，開設顏料公司的華人。

隨著製造業的發展，以及人口不斷增長，香港於一九六〇年代大量興建房屋，當時亦有不少大型建設落成，例如香港第一間美式購物商場海運大廈落成，也帶動了本地的漆油銷量。到了一九六〇年代末，有見東亞和東南亞一帶國家開始工業化並自行生產漆油，於是香港也投放更多資源擴展本地漆油市場（Lo, 2017）。這些針對本地市場的漆油業務，對於香港霓虹招牌底盤的漆油廣告繪畫而言，有很大的貢獻。

從霓虹招牌的顏色學，可見當時的設計美學邏輯。在設計學裡，色彩學是最重要且複雜的一環，適當使用顏色可以影響一個人對產品或設計的良好觀感，例如鮮艷的顏色，令人雀躍；深沉的顏色，令人有穩健踏實的感覺。在霓虹招牌的設計上，顏料與顏色的配搭運用可增加層次感，讓招牌發揮更大的效果。除了霓虹光管可散發出不同顏色的光芒外，當霓虹招牌底盤也髹上不同的顏色，在日光之下，就能清晰看到不同顏色的霓虹招牌，並能突顯出招牌的主題和輪廓。

一般人對霓虹招牌的顏色印象，都是以紅色為主，但從招牌手稿中可見，當中所採用的顏色，比我們想像中的更多元化。招牌的用色豐富，混色大膽，有一種要懾人眼球的氣勢。下頁的圖表，是我們根據現有的手稿，嘗試統計出不同時期的招牌手稿，其底色配搭及色彩的流行程度。

歸納分析所得，深藍色是最為普及的霓虹招牌底色，不論是單色、雙色、三色，以及四色組別，都發現有深藍色的影子；此外，它也是配搭其他顏色的首選。而在顏色的配搭方面，單色的有一百一十八份、雙色配搭的有五十六份、三色配搭的有二十一份、四色配搭的有三份。

至於在三個不同的年代中，招牌底盤的顏色運用，單色的使用佔最多。五十年代有十七個、六十年代有四十八個、七十年代有三十二個；而雙色的使用，五十年代及六十年代各有二十個，七十年代有九個，但三色和四色配搭則相對少用。

The bright and eye-catching colours on the neon light signboard sketches were gouache, mostly produced by local paint makers. Hong Kong's most prominent paint makers were established during or before World War II, with most paints produced for export purposes. Island Paint Company Ltd. was founded in 1938 by Ng Chak-man, a chemical engineer who attended high school and university in Seattle. He returned to Guangdong after graduation and established the paint company. During the period of Japanese occupation, Ng moved the company's operations to Hong Kong together with some of his technicians. Island Paint produced an extensive catalogue of paints and pigments, with gouache and enamel contributing to only a small portion of its total sales (Lo, 2017). Another renowned local paint maker is The China Paint Mfg. Co., also founded in the 1930s. Liang Meng-tsi, one of the key founders, received chemistry training in the United States (Ibid). He is another early example of a Chinese who returned to establish a paint company after studying overseas.

Along with the growth in the manufacturing industry and Hong Kong's population, a lot of houses were built in the 1960s. Many large-scale construction projects were completed too, such as Ocean Terminal, the first American-style shopping mall in Hong Kong. They helped boost local paint sales. In the late 1960s, countries in East and Southeast Asia began to undergo industrialization and started to produce their own paints. Companies in Hong Kong therefore allocated more resources to expand the local paint market (Lo, 2017). They, targeting the local market, contributed greatly to Hong Kong's neon light industry with regard to the lacquer-painted advertising on the background of signboards.

The use of colour on neon signboards reflected the aesthetic logic of designs at that time. In the study of design, the colour theory is the most important and complicated topic. The proper use of colours can shape people's perception of a product or a design. For instance, bright colours evoke excitement, while dark colours give a sense of security and stability. On a neon signboard, the matching of paints and colours can enrich gradations and strengthen the effects of the signboard. Apart from lights of different colours emitted from the neon tubes, the backgrounds of the signboards can also be painted with different colours. This way, signboards in different colours can be read clearly in daylight with prominent themes and shapes.

Most people have the impression that neon signboards are red, but the sketches showed that the colours used in the neon signboards were much more diverse than imagined. With rich colours and bold colour matching, the sketches aimed at catching people's attention. The following chart was created by identifying from the sketches the popularity of different colours and colour matching on signboard backgrounds in different times.

According to our analysis, dark blue was the most common background colour. It was used on signboards with single, two, three and four colours. It was also the most preferred colour to match other colours. In terms of colour

matching, 118 sketches were monochrome, 56 featured a combination of two colours, 21 featured three colours and 3 featured four colours.

Signboard backgrounds were mostly monochrome during the three periods, with 17 from the 1950s, 48 from the 1960s and 32 from the 1970s. Signboards using two colours amounted to 20 respectively in the 1950s and the 1960s, as well as 9 in the 1970s. Signboards using three or four colours were relatively rare.

霓虹招牌業的蓬勃發展，也刺激起對本地漆油的需求。
The boom of the neon signboard industry boosted local demand for paint.

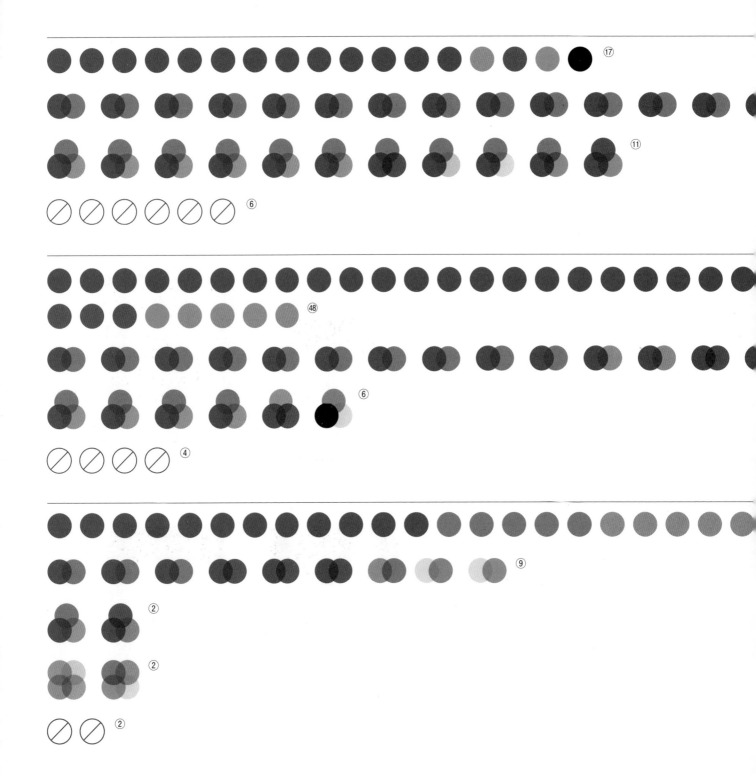

招牌手稿底色
Background Colour of Signboard Sketches

在招牌手稿的顏色統計中，深藍色是最熱門的招牌顏色。
The colour analysis of signboard sketches showed that dark blue were the most popular signboard colour.

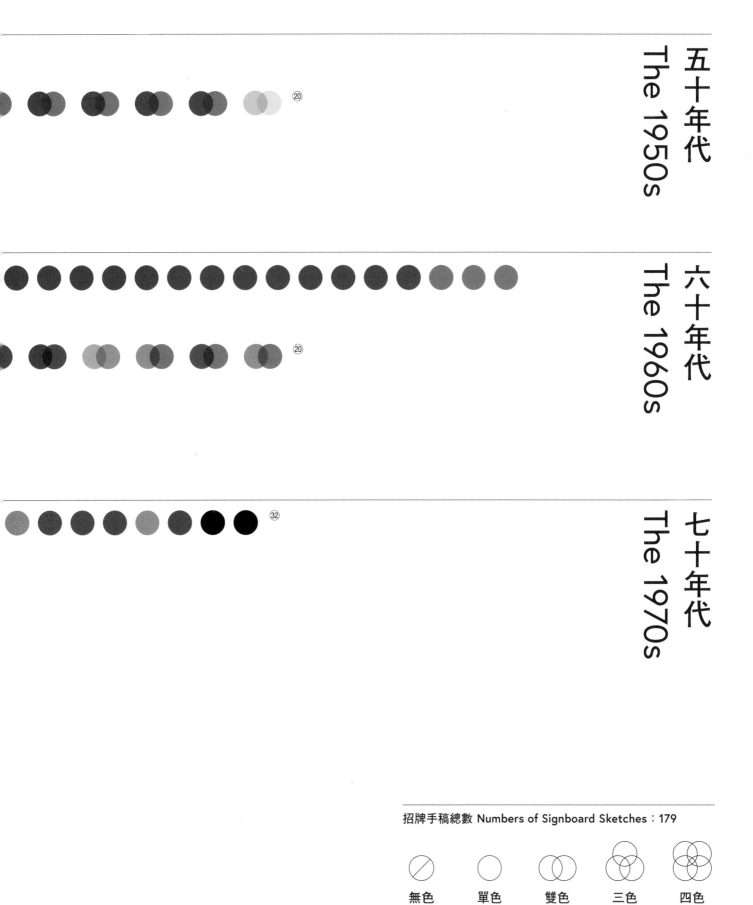

五十年代
The 1950s

六十年代
The 1960s

七十年代
The 1970s

招牌手稿總數 Numbers of Signboard Sketches：179

無色	單色	雙色	三色	四色
None	Single	Duo	Trio	Quad

霓虹招牌手稿分析案例
Case Studies

3.5

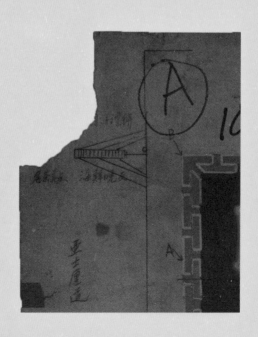

在霓虹招牌手稿資料庫中，每一張手稿都反映出昔日社會對美學的要求。透過分析招牌手稿，可窺探行業的轉變與社會的變遷。

霓虹招牌手稿除了展示其本身的視覺美學，例如顏色、字體、圖案和造型等，手稿還記錄了一些額外的資訊。一份完整的霓虹招牌手稿定必附上工程製作文件，例如招牌安裝文件、霓虹光管接駁工程文件、霓虹燈設計的注意事項、工程合約文件等。但由於我們只有這些招牌設計概念圖，並沒有其他相關工程文件，因此我們只能單靠手稿上的資訊來作分析。

在分析的過程中，我們發現手稿上與招牌有關的資訊，都是製作師傅、畫師跟客戶溝通時所寫下的筆記，從中我們可以看到手稿背後的設計想法、修改內容和製作過程等。雖然我們並不知道作出修改的原因，但透過手稿上所修改的內容和關注的事項，可引發我們更多的思考。以下展示了六張招牌手稿的分析。

Every piece in our archive of neon signboard artworks reflects the society's aesthetic expectations in the past. Therefore, by analyzing these artworks, we can see transformations in both the industry and the society.

In addition to manifesting visual aesthetics of their own, such as colours, fonts, images and shapes, the artworks also contain extra information. In fact, a complete set of neon signboard artwork should include technical production documents related to signboard installation, neon tube connection, design notes, project contract and more. However, we only had the conceptual artworks of the signboards but not other related project documents, so we could only analyze each sketch based on the information on it.

From the analysis, we found that information on the artworks were actually the communication notes between the maker, the painter and the client concerning the signboards, from which we could uncover details such as the design concepts behind, the amendments and the production processes. Though the reasons behind the amendments were unknown, the changes and the concerns recorded on the artworks inspired us to think. Presented below are the analysis for six neon signboard artworks.

案例一　　　　　　　　Case 1

鹿苑茶廳
Luk Yuen
Tea House

手稿尺寸 (毫米)｜582 × 300
招牌尺寸｜15'3" × 5'
手稿年份｜約五十年代

Artwork dimension (mm)｜582 × 300
Signboard dimension｜15'3" × 5'
Year of creation｜circa the 1950s

Ⓐ 招牌手稿的年份是根據霓虹招牌製作公司印章上的電話號碼數目來推測的，一般而言，五位數字代表五十年代、六位數字代表六十年代、七位數字代表七十年代。從這份手稿來看，估計是五十年代。

We estimated the decade an artwork belonged to from the phone number on the stamp of the neon signboard production company. In general, a phone number with five digits indicates the sketch is from the 1950s, six digits the 1960s and seven digits the 1970s. Therefore, we deduced that this particular artwork was created in the 1950s.

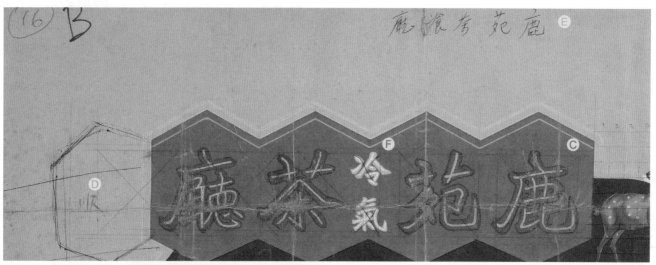

Ⓑ 在霓虹招牌手稿資料庫中，每張手稿除了印有製作公司字樣外，也印上相關製作的資料列表，以方便寫上實質招牌尺寸，包括手稿比例、尺寸和招牌字的大小。就以這張「鹿苑茶廳」的手稿為例，手稿比例是 1":1'；招牌尺寸是 15'3" x 5'；招牌字大小是 10" 和 24"。另外，最底的一項寫上「雙面平邊」，是指示招牌是否前後兩面安裝霓虹管，而這張鹿苑茶廳的手稿，就是要做雙面平邊。

In our archive of neon signboard artworks, apart from the production company's name, each artwork is also printed with a form to be filled in with production information, including the actual size of the signboard, the scale and dimension of the artwork as well as the font size on the signboard. Take this artwork for Luk Yuen Tea House as an example. The ratio of the artwork to the actual signboard is 1 inch : 1 foot, with the dimension of the signboard being 15 feet 3 inches x 5 feet and the character sizes being 10 and 24 inches respectively. The bottom of the form reads "double-sided", indicating neon tubes should be installed on both the front and back sides of the signboard.

C ｜畫師在畫紙上輕輕畫上輔助線，這有助畫出同樣大小的餐廳名稱。

The painter drew faint guidelines on the paper, helping to paint each character of the tea house's name in a consistent size.

D ｜招牌由原先四個字的餐廳名稱「鹿苑茶廳」改為五個字的「鹿苑茶湌廳」，因此畫師在招牌的左手邊加多一個六邊形圖案，以在招牌上增加文字。

The name of the tea house was changed from four Chinese characters to five, so the painter added a hexagon on the left to make room for the additional character.

E ｜新修改的店舖名稱「鹿苑茶湌廳」寫在畫紙的頂部。

The revised tea house name was written at the top of the paper.

F ｜「冷氣」兩個字以紅筆打上交叉，表示刪除「冷氣」這兩個字。一九五〇年代的香港，餐廳冷氣開放並不普及，所以餐館會利用冷氣等字眼來作招徠。

"Air-conditioning" was crossed out in red, indicating deletion. In the 1950s, air conditioning in restaurants was uncommon, so some restaurants wrote this on their signboards as a selling point.

G ｜招牌正面由「西餅飲品 炒粉麵飯」，改為「炒粉麵飯 冷氣調節」。昔日，西餅被認為是一種西式消費，隱藏「高級」和「現代」的訊息，餐廳使用西餅字眼可招徠年輕、時尚的顧客。

The characters on the front of the signboard were changed from "Western cakes and drinks; stir-fried noodles and rice" to "stir-fried noodles and rice; air-conditioning". At the time, Western cakes were regarded Western products, synonymous with luxury and modernity, so tea houses used the wording of "Western cakes" to attract young and fashionable customers.

H ｜招牌背面標明「麵飽西餅」和「冷熱飲品」。

Characters on the back of the signboard read "bread and Western cakes, cold and hot drinks".

I ｜招牌手稿特別指示招牌的正面是面向塘尾道。

The special note on the sketch indicates that the front of the signboard should face Tong Mi Road.

J ｜這招牌用了當時流行的書法風格──魏碑體。

The signboard is in Weibei script, a popular calligraphic style at the time.

K ｜手稿上畫上小鹿插圖，其像真度十分高。小鹿背後打上網格，是方便日後師傅按網格比例放大插圖之用。

The hand-drawn deer on the artwork looks life-like. The underlying grid behind it was for the convenience of signboard makers to enlarge the illustration to scale for production.

L ｜此招牌邊框用上當時流行的裝飾藝術 Art Deco 的幾何圖案，這種視覺表現的興起可追溯至一九二〇年代歐美的現代藝術風格。

The frame features a geometric outline as influenced by the Art Deco style common at the time. The popularity of such visual expression can be traced back to the 1920s when modern art styles emerged in Europe and America.

案例二　　　　　　Case 2

福來酒家
Fook Loi
Restaurant

手稿尺寸 (毫米) | 535 × 275
招牌尺寸 | 16' × 4'
手稿年份 | 約七十年代

Artwork dimension (mm) | 535 × 275
Signboard dimension | 16' × 4'
Year of creation | circa the 1970s

A | 早於五十年代，利國光管有限公司已在香港成立，是早期華資及規模較大的霓虹光管招牌製作公司之一。至七十年代初，利國賣盤予南華霓虹燈電器廠有限公司。

Neco Neon Co., Ltd. was founded in Hong Kong in the 1950s as one of the earliest and largest Chinese-funded neon signboard manufacturers. In the early 1970s, it was bought out by Nam Wah Neonlight & Electrical Mfy, Ltd.

B | 手稿上可見，繪圖員原本所畫的「福來酒家」招牌用上楷書，不過，這份手稿附有額外文件，該文件為福來茶樓酒家的專用信紙，信紙上的酒家字樣為隸書，並標明「請照此字樣放」，估計是在招牌設計初稿交付酒家時，酒家希望招牌文字沿用隸書。另外，酒家亦提出把「茶樓」兩字刪除，只保留「福來酒家」四字。

As seen on the artwork, the illustrator originally drew the restaurant's name in Kaishu. However, this artwork has an attached document with Fook Loi Restaurant's official letterhead, on which the restaurant's name is in Lishu. Thus, the instruction on the artwork reads "please follow this style for the characters", likely a feedback from the restaurant about the use of Lishu instead after receiving the initial design draft. The restaurant also proposed to delete "tea house" from its name and keep only the four Chinese characters of "Fook Loi Restaurant".

C | 文件下方，也列出五點「摘要附註」，提醒招牌師傅必須留意的事項，包括：

1）安裝要離牆六呎；

2）邊管每面兩條綠色；

3）16' x 4' 雙面招牌底色藍身；

4）通心光管紅色紅字每字三呎；

5）每個字體要黐發光紙（紅色）。

Listed at the bottom of the document are five important notes, reminding signboard makers of the followings:
1) the installation should be six feet away from the wall;
2) the frame should comprise two green tubes on each side;
3) the double-sided signboard should measure 16' x 4' with a blue background;
4) red characters three feet wide each to be made with red hollow neon tubes;
5) every character should be covered with reflective paper (red).

D | 在這處改為使用「邊管雙線綠色」，意即將原先的藍色招牌邊框改用綠色霓虹光管，並以雙管呈現。

This was revised to "frame with double green tubes", meaning that the original blue frame should be replaced with double green neon tubes.

E | 霓虹燈字的處理，在這裡清楚地表達。師傅寫上「字貼發光紙紅色」、「字通心紅管」、「字底紅色發光紙」、「北河街 104 號」。明顯地，這些指示是寫給不同製作霓虹燈的部門要特別注意的地方，例如「北河街 104 號」估計是為師傅列明安裝霓虹燈招牌的位置；而「字貼發光紙紅色」、「字底紅色發光紙」等資訊，則是給髹霓虹燈底盤的師傅。

The handling of the neon light characters are clearly indicated here. The master wrote "characters covered with red reflective paper", "hollow red tube characters" and "104 Pei Ho Street". These were apparently instructions to different neon sign production departments, reminding them of points to note. For instance, "104 Pei Ho Street" indicated the location of the signboard for installation workers, while other information such as "characters covered with red reflective paper" and "red reflective paper under characters" was for workers in charge of background painting.

案例三　　　　　　　　Case 3

國喜茶樓酒家
Kwok Hei Tea House and Restaurant

手稿尺寸 (毫米) | 580 × 290
招牌尺寸 | 21'1/2" × 6'11"
手稿年份 | 約六十年代

Artwork dimension (mm) | 580 × 290
Signboard dimension | 21'1/2" × 6'11"
Year of creation | circa the 1960s

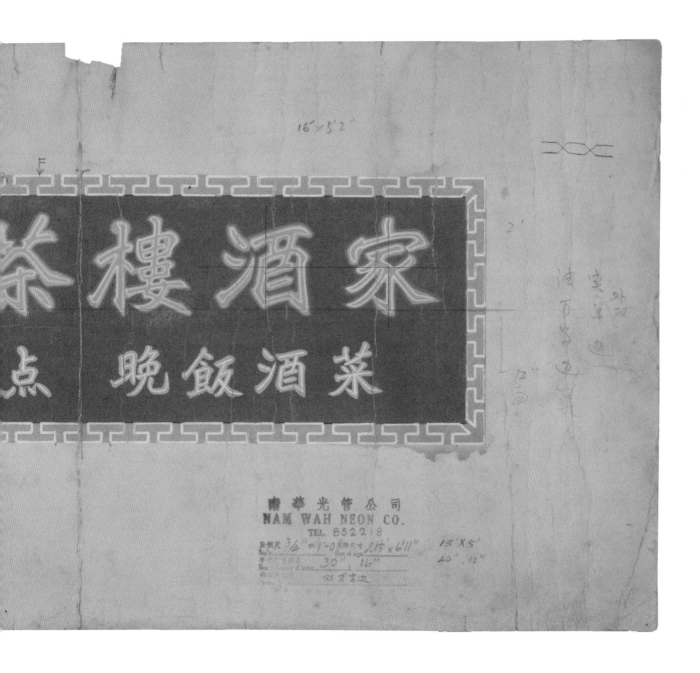

A ｜ 在招牌手稿上，可見外框旁寫上「實外雙單邊，油萬字邊綠」，估計意思是招牌外框用上雙霓虹光管，使用萬字圖案，並用上綠色霓虹光管。

A note beside the outer frame on the sketch reads "solid double tubes on single side for outer frame, to be painted with green 'wan' pattern on the frame", which possibly indicates using double green neon tubes for one side of the signboard's outer frame in "wan" pattern.

B ｜ 招牌手稿上除了招牌內容的修改指示外，偶爾也會發現其他初稿或繪圖，例如這張安裝指示圖，師傅畫上簡單線條來解釋招牌的方向及其內容，譬如向北京道的右邊內容是「茗茶美點 海鮮晚飯」，背面則是「壽筵喜酌 月餅禮餅」。

Apart from revision remarks, other early drafts or illustrations were sometimes found on the artworks. Take this installation instruction as an example. The signboard maker drew simple lines to indicate the orientation with signboard contents: the right side of the signboard reads "tea and dim sum; seafood and dinner" should face Peking Road, so the side reading "celebration banquets; moon cakes and bridal cakes" should be at the back.

C ｜ 這幅指示圖，以鳥瞰角度讓安裝師傅清晰了解招牌的方向，例如向亞士厘道的下方，為「茗茶美點 海鮮晚飯」字樣，上方則是「壽筵喜酌 月餅禮餅」。

The instruction written here clearly indicated to installation workers the orientation of the signboard from a bird's eye view: the lower side facing Ashley Road should read "tea and dim sum; seafood and dinner", while the upper side should read "celebration banquets; moon cakes and bridal cakes".

D | 這幅正面圖，標明招牌安裝在二樓，與牆身相隔三呎，用米字形支架結構延伸招牌，招牌大小為闊二十一呎六吋、高七呎，而招牌的加固鋼纜，安裝在四樓外牆，以確保招牌安全。

This front view image indicates that the signboard should be installed on the second floor, 3 feet away from the exterior wall, with the extension to be supported by an asterisk shaped structure. The signboard should be 21 feet 6 inches long and 7 feet tall. Reinforcing steel cables should be attached to the fourth floor exterior wall to ensure safety.

E | 在手稿上，會看見畫師隨手畫下的草稿，從草稿上的線條，可想像招牌外框的幾何線條圖案。

Illustrators' casual drafts were also found on the artworks. The lines on this artwork indicate the geometric patterns to be used on the signboard's frame.

F | 每幅霓虹招牌手稿都有很多輔助線，這有助畫師將字體和視覺元素正確無誤地畫在招牌之上。例如①第一輔助線是招牌上下的正中位置，而②第二輔助線是招牌字的中心位置，透過這些輔助線，畫師能夠確保將字整齊地寫在招牌的特定位置上。

All neon signboard artworks contain many guidelines, helping illustrators to correctly position characters and other visual elements on the signboards. For example, guideline ① marks the vertical centre of the signboard, while guideline ② mark the vertical centres of the Chinese characters. With these lines, illustrators could make sure the characters were neatly painted in their predetermined positions on the signboards.

泉章居
Chuen Cheung Kui

手稿尺寸（毫米）| 455 × 320
招牌尺寸 | 8'10" × 4'5"
手稿年份 | 約五十年代

Artwork dimension (mm) | 455 × 320
Signboard dimension | 8'10" × 4'5"
Year of creation | circa the 1950s

霓虹手稿由「長春社文化古蹟資源中心」提供
Neon artwork courtesy of The Conservancy
Association Centre for Heritage (CACHe)

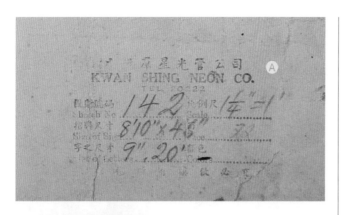

A | 這張手稿雖然是在南華霓虹燈電器廠有限公司發現的，但從公司印章上見到，這張手稿是屬於羣星光管公司的手稿。

Although this sketch was obtained from Nam Wah Neonlight & Electrical Mfy. Ltd., we deduced from the company stamp that it actually belonged to Kwan Shing Neon Co.

B | 泉章居招牌外形獨特，左右對稱，驟眼看似盾牌。整個招牌用上深淺藍色間條圖案為主，但看手稿上的備註，招牌外框邊要改為大紅色。

Chuen Cheung Kui's neon signboard had a unique shape. It was symmetrical and looked like a shield at a glance. The entire signboard featured stripes in different shades of blue, yet the note on the artwork indicates a change in border colour to bright red.

C | 畫師在手稿上寫的筆記十分潦草，既似「彩綠」，也像「彩線」，但相信是跟字型的顏色有關。

The illustrator's handwriting is very messy that the note either reads "vibrant green" or "multi-coloured lines" in Chinese, most likely a comment on font colour.

D | 這裡所指的，相信是使用白色霓虹光管作泉章居的字型顏色。

The note here indicates using white neon tubes for the characters "Chuen Cheung Kui".

E | 金牌鹽焗雞是泉章居的招牌菜，所以招牌中央亦用上鹽焗雞的圖案，但若仔細看，鹽焗雞的雞髀位置有所改動，特別刻意將雞髀的方向向下移，這種細微改動十分有趣。

Salt-baked chicken, the signature dish of Chuen Cheung Kui, is featured at the centre of the signboard. We studied the artwork carefully and discovered a fun detail that the position of the chicken leg was deliberately revised to make it tilt downwards.

F | 泉章居的招牌字用了當時流行的魏碑體書法風格。

Chuen Cheung Kui's neon signboard was in Weibei script, a popular calligraphic style at the time.

案例五　　　　Case 5

美香園涼茶
Mei Heung Yuen Herbal Tea

手稿尺寸（毫米）｜ 465 × 290
招牌尺寸｜不詳
手稿年份｜不詳

Artwork dimension (mm) ｜ 465 × 290
Signboard dimension ｜ Unknown
Year of creation ｜ Unknown

| 這份手稿的一邊，寫上其他設計的提議或修改，例如招牌外框使用「弓」字的線條形狀作為裝飾，招牌向山的一面，應為「美香園蔗汁」，向海的一面則為「美香園涼茶」。顏色方面，向海那面的店舖名字提議用上粉紅色，「涼茶」用白色，招牌邊框用藍色，並註明招牌應離牆五呎。

Written on the side of this artwork are suggestions and amendments related to the design. For example, one note suggests using battlement pattern to decorate the border. Another note says that the side reading "Mei Heung Yuen cane juice" should face the hills, while the side reading "Mei Heung Yuen Herbal Tea" should face the sea. As for the colours, a remark suggests using pink for the restaurant's name, white for "Herbal Tea" and blue for the border on the side facing the sea. It is indicated that the signboard should be installed 5 feet away from the wall.

Ⓑ｜在另一邊，設計方案則提議「美香園」用紅色光管，「涼茶蔗汁」用白色光管，招牌邊框用綠色光管，招牌底盤用墨綠色。

For the other side, it is recommended to use red tubes for "Mei Heung Yuen", white tubes for "herbal tea and cane juice", green tubes for the border and dark green for the background.

Ⓒ｜至於招牌面向，向山的一面要展示「蔗汁」，向電車路的一面則展示「涼茶」，由此估計，這個招牌位置應在港島。

Regarding the orientation, the side that reads "cane juice" should face the hills, while the side that reads "herbal tea" should face the tram tracks. Based on these clues, we could conclude that the signboard was located on Hong Kong Island.

案例六　　　　　　　　　Case 6

榮發冰室
Wing Fat
Ice Chamber

手稿尺寸 (毫米) | 485 × 292
招牌尺寸 | 8'10" × 3'5"
手稿年份 | 約六十年代

Artwork dimension (mm) | 485 × 292
Signboard dimension | 8'10" × 3'5"
Year of creation | circa the 1960s

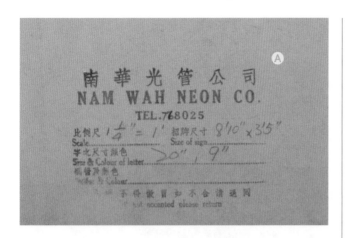

A | 南華光管公司在香港扎根六十多年，公司電話由五十年代的五個字號碼，至及後以人手改為六個字號碼。

Nam Wah Neon Company has operated in Hong Kong for over sixty years, with its telephone number changing from 5 digits in the 1950s to 6 digits later as shown by the manual revision on this artwork.

B | 手稿旁，畫下不同的設計想法和筆記，例如提議餐廳名稱為「榮發喫啡廳」（而並非手稿上霓虹招牌所畫的「榮發冰室」），下面部份為宣傳字句「出爐麵飽西餅」，招牌外形則以簡單線條勾勒成一組上大下小的邊框。

Various design ideas and notes were drawn on the edge of the artwork, such as the suggestion about changing the restaurant's name to "Wing Fat Cafe" (from "Wing Fat Ice Chamber" as seen on the artwork). The lower part houses the promotional slogan of "freshly baked bread and Western cakes". The signboard's shape is outlined with simple lines forming a set of upper and lower borders that vary in size.

C | 草稿採用兩組簡單重疊的長方形，看上去更簡約。

This artwork depicts a simple design that comprises two overlapping rectangles.

D | 這個招牌外形設計呈四邊弧形線條，動感十足。

This lively sketch of signboard shape features four arcs.

E | 這個設計跟手稿上畫的霓虹招牌風格完全不同，主要以幾何圖形組成：上半部用了四個六角形，寫著「榮發冰室」，而下半部則用上三角形，把兩種圖案放在一起，造型獨特。

This design is completely different in style from the signboard drawn on the artwork. It is mostly formed by geometric shapes: the upper part features four hexagons written with "Wing Fat Ice Chamber" in Chinese, while the lower part is a triangle. The combination of the two shapes creates vividness.

F | 畫師簡單畫上幾筆，展示招牌外形的不同設計想法。

The illustrator showed different design ideas about the shape of the signboard with a few simple strokes.

食肆手稿的常用中文字體
Commonly-used Chinese Letterings on Restaurant Sketches

3.6

香港的霓虹招牌佈滿鬧市街道，縱橫交疊的視覺衝擊讓世界各地的人對香港留下深刻印象。除此之外，香港的霓虹招牌也有另一重要的獨特之處——中文書法。有中文字的霓虹招牌，如今在亞洲已不多見，而香港不少招牌上的霓虹光管乃按照書法字體來屈曲的，這樣除了使商店的品牌風格更突出外，也令香港的招牌更具特色及本土味道。

在未有電腦輔助設計前，霓虹招牌字都是先請人寫下所需的書法字，然後再按字形來屈曲的。寫招牌字的人，有些是在街頭以寫書法維生的人，也有些商家會花錢找來著名的書法家為其題字，一來會使招牌更具特色，二來也可借助書法家的名氣，提升自己商號的知名度。當年著名書法家如區建公、蘇世傑和卓少衡的招牌墨寶便遍佈於香港街頭。

在我們蒐集得來的霓虹招牌手稿中，集中整理飲食業的手稿共二百一十八張，經常出現的中文字體可歸納成三大類：分別為魏碑體（50.4%）、楷書（23.4%）及隸書（16.5%）。其餘的還有行書以及其他字體（9.7%）。

在三種經常出現的字體中，歷史最悠久的是自秦朝已出現的隸書。隸書的字體較扁，向左右伸展，多年來研究隸書的人形容它有「一波三折」、「蠶頭雁尾」等特徵。而楷書，其實也源自隸書，字體方正，筆畫包含點、橫（兩畫）、豎、撇（兩撇）、捺、鉤等八筆，結構更緊密。

而魏碑體，也稱為「北魏楷書」，演變自隸書與楷書之間，在北魏時期各種造像記的碑刻作品中廣泛使用，特點是筆勢剛勁及尖銳。第二次世界大戰後，香港一些知名書法家如區建公便常用魏碑體為招牌題字，並引起仿效風潮。由於其誇張的筆畫使文字甚為易讀，讓行人在遠處也可清晰辨認，因而廣為各行各業採納作為招牌書體。在六、七十年代，魏碑風格的招牌字在街道上非常流行，不只霓虹招牌，它也被廣泛應用在普通招牌、門匾等。

由於用在招牌之上，書法字的易讀性非常重要，亦需同時兼顧美學與實際功能，所以招牌書法家必須熟知字形的佈局，考慮發光筆畫之間的空間感，也要平衡字形本身的美感。這些美學是糅合了對書法的認識和對工藝製作的熟悉，是書法家與霓虹師傅經過長期磨練而沉澱出的智慧。

魏碑
Weibei

楷書
Kaishu

隸書
Lishu

Hong Kong's neon-filled cityscape is so impressive, and the dazzling composition created by vertically and horizontally overlapping signboards always leaves a striking visual impact on visitors from around the world. Another important and distinctive feature of Hong Kong's neon light signboards is Chinese calligraphy. Neon signboards containing Chinese characters have now become rare in Asia, while in Hong Kong, many of them have neon light tubes twisted following the forms of traditional calligraphy, highlighting the styles of the brands and adding distinctiveness and local flavours to the signboards.

Before computers were used to assist design work, the characters on neon signboards were handwritten by calligraphers, then neon tubes were bent into their corresponding shapes. While some were written by street calligraphers, some business owners hired renowned calligraphers to write for them, to make their signboards unique and to uplift the business' reputation through associating with famous calligraphers. Works from renowned calligraphers like Au Kin-kung, Su Shi-jie and Cheuk Siu-hang could be seen all over the streets of Hong Kong in the olden days.

We focused on sorting the 218 pieces of restaurants neon signboards out of the sketches we collected. The three most commonly-used Chinese calligraphy were Weibei (50.4%), Kaishu (Regular script) (23.4%) and Lishu (Clerical script) (16.5%), with the remaining including Xingshu and others (9.7%).

Of the three commonly-used scripts, Lishu is the oldest, which has been in use since the Qin Dynasty. The characters have a flat and wide shape, and veteran Lishu researchers describe its well-known characteristic strokes as having "twists and turns" as well as "silkworm heads and wild goose tails". Meanwhile, Kaishu, evolved from Lishu, has a more rigid structure and a square form with eight basic types of stroke, including dot, horizontal (two horizontal strokes), vertical, throw (two throws), press and hook.

Weibei script, also known as "Beiwei Kaishu", evolved from both Lishu and Kaishu. Featuring robust and pointy strokes, Weibei script was often used for the inscriptions of sculptures and monuments during the Northern Wei period. After World War II, Weibei script was usually used for signboard calligraphy, a trend started by renowned Hong Kong calligraphers such as Au Kin-kung. The exaggerated strokes heightened the legibility of the characters, making the texts clearly recognizable by pedestrians even from a far distance. Therefore, it was widely adopted by various industries as the calligraphy style of their signboards. During the 1960s and 1970s, Weibei script was so popular on streets that it was not only used on neon signboards but also ordinary signboards and door plaques.

As scripts were used on signboards, their legibility is of utmost importance, while aesthetical appeal and practicality must also be given consideration. Therefore, signboard calligraphers need to understand each character's structure, consider the spacing between the light-emitting strokes and at the same time retain its aesthetic attractiveness. Combining calligraphy knowledge and craftsmanship familiarity, the art involves the wisdom of calligraphy and neon masters accumulated from many years of practices.

招牌異體字
Variant Characters on Neon Signboards

3.7

在整理大量霓虹招牌手稿時，我們的另一個發現，是不少招牌手稿上的中文字也用上了異體字，例如「鵝」的異體字為「鵞」、「羣」的異體字為「群」，它們與正體字寫法有差異，但意思及發音皆相同。

異體字，原來自古就有。古代文字學家根據《說文解字》將漢字分為「正體」和「俗體」，凡不記載於此書的字體，一律稱為「俗體」，後稱「異體字」。異體字是指同音、同義，但寫的方法有輕微差別，在未有正體規範前，異體字可說是約定俗成的，其字形的變化會因人而異。

一九五五年，中華人民共和國文化部和中國文字改革委員會曾發佈一系列的繁體異體字，名為《第一批異體字整理表》，到目前為止已歸納出幾百組正體字。至於香港，是直至一九八四年，為了確立正體字的寫法以作教育標準參考，香港教育署語文教育學院（現已合併於香港教育大學，並為大學內其中一個學院）才聯同多間院校學者組成「常用字標準字形研究委員會」審訂各參考字形，並先後發表《常用字字形表》，以及有較全面的修訂版本。

由於招牌是民間所做，用上的異體字，其實正反映文字在民間使用時的演變過程。

在霓虹招牌手稿找到的異體字，既是手寫書法遺留下來的墨寶，也是民間文化一種重要的記錄。當時的書法家或街頭寫字佬，會刻意使用異體字來突顯招牌字體的獨特性，以突出該店舖，例如「龍子湌廳」和「嘉頓湌廳」，它們的招牌用了異體字，就是將餐廳的「餐」寫成「湌」；此外，還有「新全記」，也採用了異體字，將「麵」寫成「麫」。香港人最愛的麵包舖也經常採用異體字，例如「麵包」寫成「麪飽」、「麵飽」、「麵麭」，還有簡化字「面包」。另一例子，就是酒樓的「樓」，也有不同的異體字寫法。

異體字的使用無分對錯或準則，大多是按商家或書法家的喜好及風格。相對於現時劃一的電腦字，手寫的異體字看上去或許有點突兀，卻也同時多了一份手寫的溫度和人文氣息。

酒樓的「樓」字也有不同的異體字寫法。
The character 「樓」 in 「酒樓」 (meaning
Chinese restaurant) has many variants.

While sorting the many sketches of neon signboards, we had another discovery: the Chinese texts on many signboards were written in variant Chinese characters. For example, the Chinese character of 「鵝」 (goose) can also be written as 「鵞」, while 「羣」 (group) can also be written as 「群」. Despite their different shapes, they carry the same pronunciations and meanings.

Variant Chinese characters have existed since ancient times. Ancient philologists divided Chinese characters into "standard characters" and "folk characters" according to the oldest Chinese dictionary *Shuowen Jiezi*. Characters not documented in the dictionary were considered folk, later called variants, referring to the slightly different forms of writing carrying the same pronunciations and meanings. Before writing was standardized, variant characters were established by common usage, so their writing could vary from person to person.

In 1955, the Ministry of Culture of the People's Republic of China and the Chinese Language Reform Committee published *The First List of Standardized Variant Chinese Words*, which currently consists of several hundred sets of standardized traditional Chinese variants. In Hong Kong, the Research Committee for the Standardized Graphemes of Commonly-Used Chinese Character was established in 1984 to standardize the writing of most commonly-used Chinese characters, to be referred to for educational purposes. The Committee comprised scholars from various academic institutions gathered by the Institute of Language Education under the Education Department (now a faculty in The Education University of Hong Kong). The Committee reviewed various reference graphemes and published the *List of Graphemes of Commonly-used Chinese Characters* and later the more comprehensive revised editions.

Since signboards are produced by common folks, the use of variants reflects how the usage of Chinese characters evolves over time among the general public. The sketches of variants on neon signboards are not only valued records of handwritten calligraphy but also an important documentation of common culture. Renowned calligraphers or street writers deliberately used variant characters to highlight the uniqueness of the signboards and promote the respective shops. For example, 「龍子餐廳」 (Dragon Seed Restaurant) and 「嘉頓飡廳」 (Garden Restaurant) used 「飡」 as a variant of 「餐」 on their signboards. Another example is 「新全記」 (New Chuen Kee), whose signboard replaced 「麵」 with its variant of 「麵」. Many bakeries in Hong Kong use variant characters. Instead of 「麵包」 (meaning bread, the love of Hongkongers), characters such as 「麵飽」, 「麪飽」, 「麪麭」 and the much simplified 「面包」 are used. Meanwhile, the character of 「樓」 in 「酒樓」 (meaning restaurant) also has many variants.

There is no standardized use of variant characters. They are often adopted by calligraphers or business owners following their preferences or personal styles. In comparison to standardized words typed on a computer, hand-written variant characters may strike readers as strange, but at the same time, they are imbued with warmth with a human touch.

霓虹燈師傅——梁榮光
Neon Master -
<u>Leung Wing-gwong</u>

3.8

「我是一九五九年七月十一日入『大華』。」梁榮光師傅出生於澳門,中學畢業便去香港,在到港一星期後,就跟隨姐夫到當時位於灣仔謝斐道的大華霓虹光管公司學師。梁師傅記得,當年學師,每天朝九晚六,一年做足三百六十天。「當時只休五月初五、八月十五、新曆年(元旦),過年就休兩天。」

一九六〇年代,梁師傅形容是個很窮困的年代,在搭巴士一毫子一程、雲吞麵三毫子一碗的日子,學師時只有月薪港幣數十元。三年後,學滿師的梁師傅轉到瓊華霓虹光管公司工作,月薪隨即倍增至港幣一百八十元。

他形容,學師時期是艱苦的,什麼也要做,例如吹玻璃管、打鐵、安裝,這三個主要項目一定要識。吹玻璃管,即是行內說的「吹管」,拿著玻璃管,用火槍高溫燒軟,然後慢慢把它屈成一個形狀。「吹霓虹管最辛苦之處就是要站著,一天站足八個小時,不能坐,所以雙腳會很累;加上工場十分熱,只有一把風扇,吹著雙腳,上半身不能用風扇吹,因為風扇會吹動火槍的火勢。以前沒有冷氣,所以那時候沒有人願意學吹玻璃管。」

至於做鐵箱(即招牌底盤),「要將它們駁在一起,然後裁剪,剪到招牌的樣子,再把它們合成,中間放上一個八吋的電箱,然後用窩釘直接用手揼進去,連鐵框都是我做的」。梁師傅說,這樣的底盤,由兩至三個人做,製作大概需時兩至三天。

除了吹管、做底盤,還要到現場安裝。一般安裝霓虹招牌,都需先搭棚,在建築物外牆鑽洞,把一條鐵「種進去」,再以螺絲鎖實和鋪上英泥。其後,等到英泥乾透,用滑輪把招牌「扯上去」。因為這是霓虹招牌,所以還要駁電,以前都是從地舖拉線駁電到招牌。梁師傅稱,一個二十呎高、四隻大字的招牌,只需用上數隻火牛,而火牛都是本地出品的。

梁師傅提到，以往還會親手調校光管顏色。「以前的年代，光管主要是白色、綠色、藍色和大紅色；若要一些其他古靈精怪的顏色，那就需要自己調配粉末。」調校顏色不單止要以精準的比例混和不同顏色的粉末，還要考慮玻璃管本身的顏色。「粉紅色不用調配的，只要用藍色的管，再加紅色的粉，就會是粉紅色了。」

梁師傅在五十年代末入行，剛好能趕上六十年代霓虹業起飛的時期。他說，當時有很多大公司設在彌敦道，所以那裡的霓虹招牌最多；然後是灣仔駱克道。他形容彌敦道是「非常誇張，尤其是娛樂場所的霓虹招牌」。及後，香港有燈火管制，梁師傅記得當時是七十年代末，所有招牌要在晚上十一時關掉，生意頓變得慘淡，大華的老闆為維持生計，一度轉行賣凍肉。捱過了燈火管制，香港霓虹招牌在八十年代重拾光芒，八十年代末至九十年代初，香港開始出現動態的霓虹光管，招牌就有更多花樣。「早期的霓虹招牌，相對死板，放上去就算了。」而梁師傅印象較深的，是二〇〇〇年代安裝在灣仔碼頭附近的中國移動通信霓虹招牌，當時因為時間緊迫，要在一個月內做兩個鐵架，他形容招牌巨型，比四層樓還要高。

梁師傅回想自己做霓虹招牌逾半世紀，輾轉在不同的霓虹公司打工，至八十年代末、九十年代初自立門戶接工程，做過的霓虹招牌遍佈港九，至大約二〇一二年退休。

"I joined Dai Wah on 11th July 1959," said Master Leung Wing-gwong, who was born in Macau and came to Hong Kong as soon as he graduated from high school. A week later, he went along with his brother-in-law to join and work as an apprentice at Dai Wah Neon Company, which at that time was located on Jaffe Road in Wan Chai. Master Leung recalled that during his apprenticeship, he worked from nine in the morning to six in the evening every day, 360 days a year. His only holidays were 5th May and 15th August of the lunar year, New Year's Day and two days during Chinese New Year.

The 1960s, as described by Master Leung, was an era marked by poverty. At a time when the bus fare was only ten cent and a bowl of wonton noodles cost only thirty cents, the monthly salary of an apprentice was measly a few dozen dollars. After finishing his apprenticeship three years later, Master Leung switched to King Wah Neon Company, where his monthly salary surged to 180 Hong Kong dollars.

He said the apprenticeship involved a lot of hard work. "You had to do everything. Apprentices must be competent in three tasks: tube bending, forging and installation. Tube bending, also known as 'glass blowing' within the industry, means melting the glass tubes over high heat and slowly bending them into desired shapes. The hardest part of neon tube bending was that you had to stand for eight hours a day and you were not allowed to sit, so it put serious strain on the legs. The workshop was overwhelmingly hot. There

was only one fan that blew at your legs instead of at your body since the current would affect the flames. There was no air conditioning back in the day, so no one was willing to learn it."

As for the iron box (the chassis of the signboard), "you had to weld the pieces together, then cut the chassis into the shape of the signboard and assemble the text and the chassis. You then placed an 8-inch electric box in the middle and fixed it with rivets by hand. I made even the entire iron frame by hand," explained Master Leung. An average chassis would take two to three workers about two to three days to make.

After blowing glass tubes and forging, it was time for on-site installation. Typically, a scaffold would be erected outside the building and holes would be drilled on the exterior wall for the implantation of iron bars fixed with screws. After that, the holes would be filled with concrete. After the concrete became fully dried, the signboard would be lifted by a pulley. The electrical power required by the neon signboard was drawn directly from the ground-floor shop via electrical wires. According to Master Leung, a four-character signboard about 20 feet tall required only a few transformers produced locally.

Master Leung also talked about tuning the colours of the tubes by hand. "White, green, blue and bright red were the main colours used in the past. To create special colours, you had to mix the powders yourself." To tune the colours, you not only had to blend powders of different colours in precise proportions, but also take the colours of the glass tubes into consideration. "You didn't have to mix powders to get pink but simply put red powder into a blue tube."

According to our preliminary analysis of the colours on the sketches, most neon lights used dark blue backgrounds, while the texts were mostly in red. Regarding this matter, we consulted Master Leung, who stated that "in the past, the vast majority of signboards had backgrounds in dark blue, which we referred to as peacock blue within the industry. The primary purpose was for clarity, so that the texts or the information could be clearly seen. Aside from dark blue, we also used dark green, which is rarely used now. As for the choice of red for the texts, it was not always the case. For example, fluorescent purple was once popular in the late 1970s. It was very eye-catching and we referred to it as luminous purple. Alternatively, white was also commonly used for texts."

For these Nam Wah neon light signboard sketches, we tried to search for their painters from various sources, but failed until we obtained some clues from Master Leung. "There was a painter named Chan Ban, who was the same age as Tam Wah-ching. Chan Ban worked as a neon light signboard sketcher at Lee Kwok and Dai Wah neon light companies and was also one of the founders of the Neon Light Union. I have the impression that Chan Ban was a nice and knowledgeable person who had been working at Lee Wah Neon Light Company. Another painter was Cheng Ka-yee, who graduated from the

Guangzhou Arts School. There was another painter who I personally know, whose surname is Mak, so everyone called him 'Fat Mak'. He specialized in drawing neon light sketches for Nam Wah. Just tell him some ideas of the neon signboard, such as the font style and the colours, and he could turn these into a sketch. The neon light signboard sketch of Luk Yuen Tea House, for example, was painted by him." As Master Leung recalled, there were quite a few neon light sketchers, including Chan Ban, Cheng Ka-yee, Tsang Tsz-ki, Fat Mak, Leung Cheong and So Yan. However, as time goes by, he has lost contact with many of them, and some have even passed away.

Joining the industry in the late 1950s, Master Leung was just in time to ride the boom of the industry during the 1960s. He said that back in the day, neon light signboards concentrated on Nathan Road, where most major companies located, followed by Lockhart Road in Wan Chai. He described Nathan Road as "overwhelmed by the signboards, especially those of entertainment venues." Later, Hong Kong experienced a blackout period. Master Leung remembered that it was during the late 1970s when all signboards had to be switched off by 11 pm. As the neon light business plummeted, at one time Dai Wah's owner switched to sell frozen meat to earn a livelihood. Having overcome the blackout, neon signboards regained their popularity in the 1980s. Between the late 1980s and the early 1990s, animated signboards began to emerge in Hong Kong, allowing designs to become more playful. "Early neon signboard designs were relatively straight forward, with texts just put on the backgrounds." One of the most impressive signboard to Master Leung was that for China Mobile near Wan Chai Pier in the 2000s. Since time was tight, two iron frames had to be made within a month. He said the sign was massive, measuring more than four storeys in height.

Master Leung reminisced that after spending over half a century making neon light signboards for different companies, he started his own business to take orders in around the late 1980s and the early 1990s. He created works which could be found across Hong Kong before he retired in around 2012.

霓虹招牌手稿
分類

4

The
Categorization
of
Neon Light
Sketches

根據從南華霓虹燈電器廠有限公司接收了的食肆霓虹招牌手稿，研究團隊按照食肆的類型分為三大類別：中式、西式及港式食肆，再把三大類別細分為十四個組別。這些組別的分類，有助我們認識自五十年代起香港食肆的歷史演變。例如在五十年代，香港食肆以茶樓和茶廳居多；六十年代則湧現了不少酒家和酒樓；七十年代以後，西式餐廳的招牌數量越來越多。

以下將精選一百張手稿作展示，可看到不同年代手稿的特色。

The research team divided the restaurant signboard sketches collected from Nam Wah into three categories according to restaurant types, namely Chinese, Western and Hong Kong-style. The three categories were further divided into 14 groups to help us understand the historic evolution of Hong Kong's restaurants since the 1950s. For instance, in the 1950s, most local restaurants were tea houses and tea rooms, until Chinese restaurants came into the scene during the 1960s. From the 1970s onwards, there were an increasing number of Western restaurant neon signboards.

100 selected sketches are displayed below to reflect the characteristics of different times.

手稿列表
List of Artworks

五十年代　The 1950s

六十年代　The 1960s

年份不詳　Unknown Year

七十年代　The 1970s

八十年代　The 1980s

○ / 年份不詳 Unknown Year

╳ / 原大裁切 Original Size Cropping

太湖廳 Tai Wu Restaurant
The 1950s │ 501 mm (w) × 293 mm (h)

南 華 光 管 公 司
NAM WAH NEON CO.

泉章居 Chuen Cheung Kui
The 1950s ｜ 455 mm (w) × 320 mm (h)

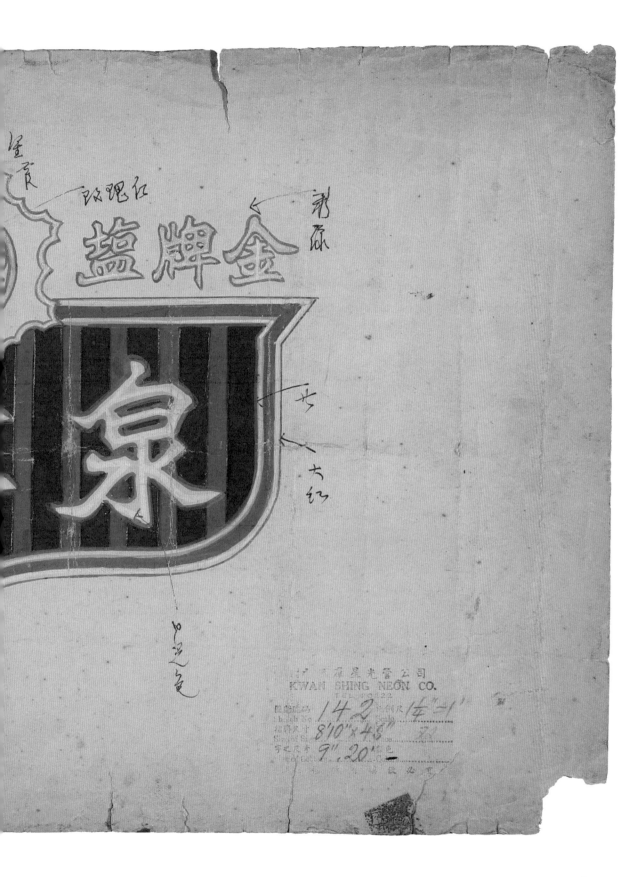

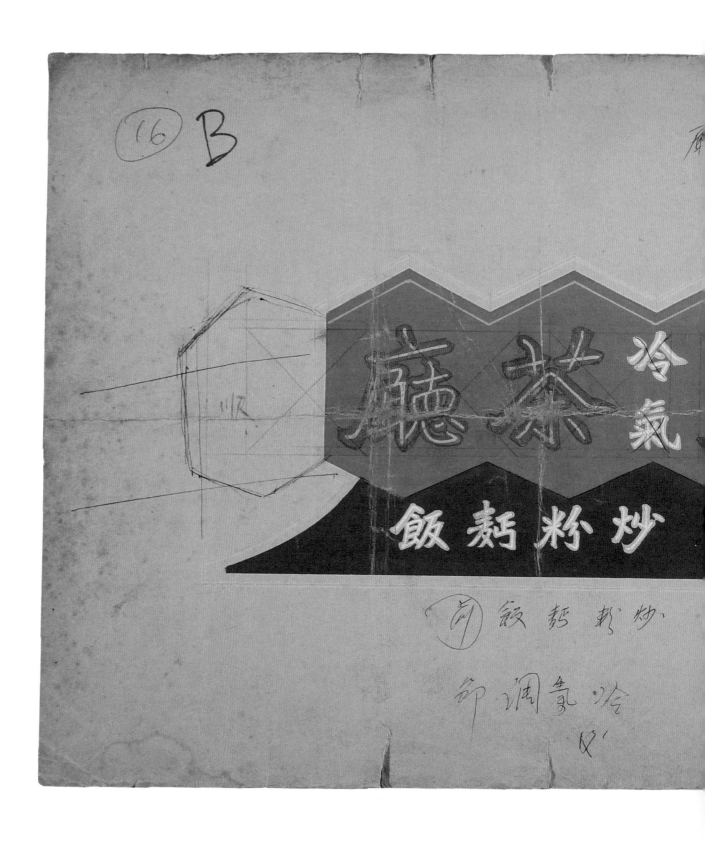

鹿苑茶廳 Luk Yuen Tea House
The 1950s │ 582 mm (w) × 300 mm (h)

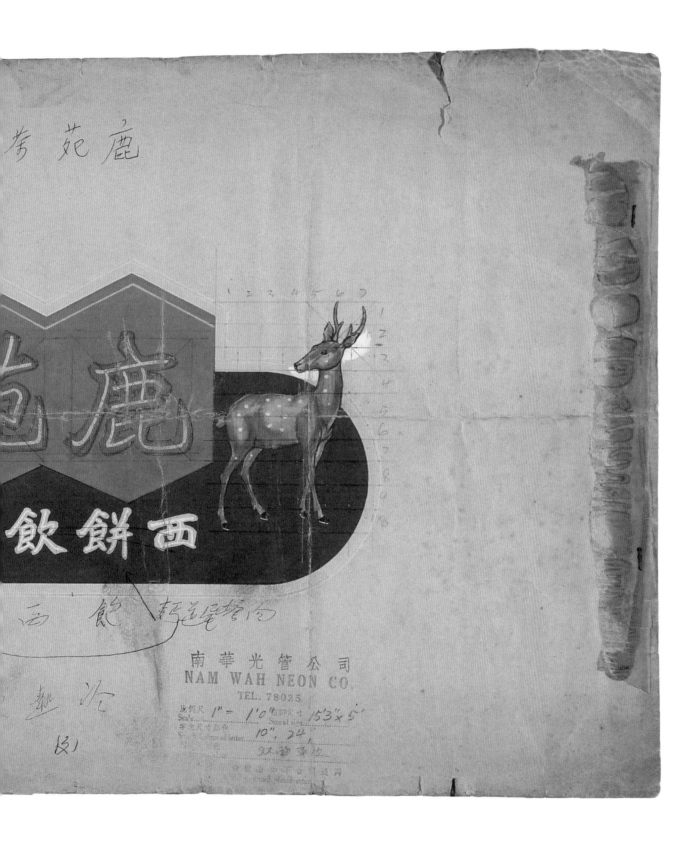

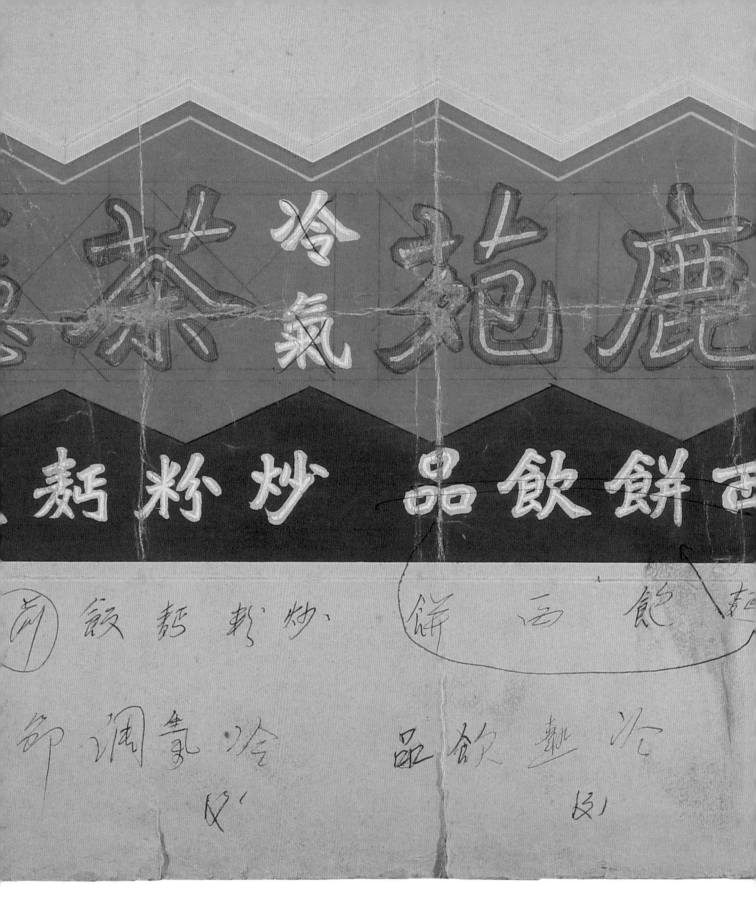

冷氣　苞鹿

麨粉炒　品飲餅

飲　麨　粉　炒　餅　西　飲　麨

節調氣冷　品飲熱冷

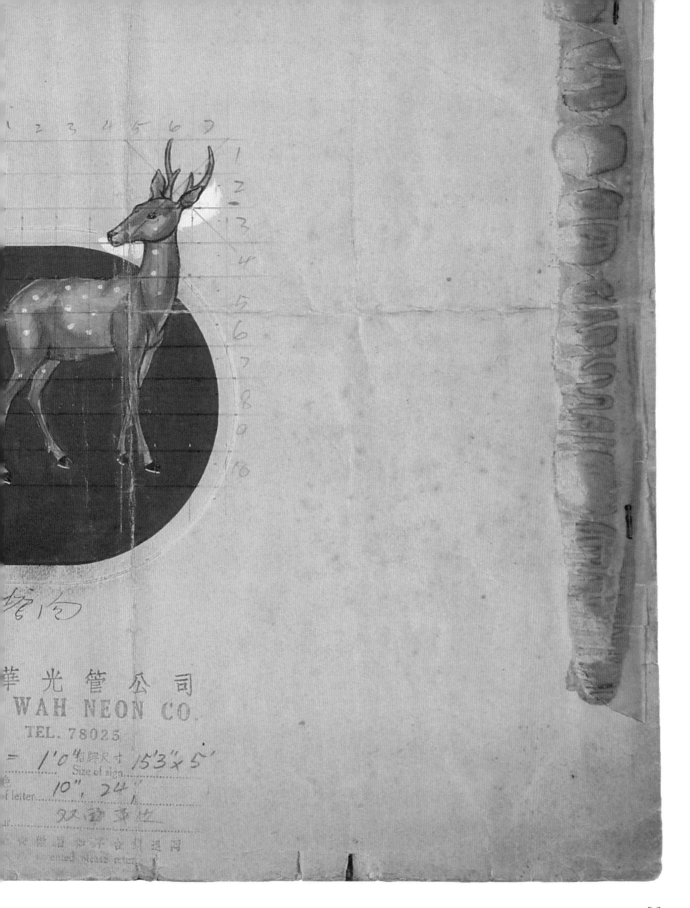

皇都大茶廳 Wong Dou Tea House
The 1950s │ 510 mm (w) × 269 mm (h)

皇子餐廳 Prince Restaurant
The 1950s　|　520 mm (w) × 295 mm (h)

南 華 光 管 公 司
NAM WAH NEON CO.
TEL. 78025

比例尺 Scale _1" = 1'_ 招牌尺寸 Size of sign _12' x 3'_
字之尺寸顏色 Size & Colour of letter _24"_
燈管及顏色 Tube & Colour _____
如 鄉 不 得 做 買 如 不 合 請 退 回

金華茶廳 Kam Wah Tea House
The 1950s │ 502 mm (w) × 295 mm (h)

新全記 New Chuen Kee
The 1950s ｜ 500 mm (w) × 285 mm (h)

南 華 光 管 公 司
NAM WAH NEON CO.
Tel.

比例尺
Scale
招牌尺寸
Size of sign
字之尺寸顏色
Size & Colour of letter
邊管及顏色
Border & Colour

此圖不得做買如不合請退回
If not accented please return

城南茶廳 Sing Nam Tea House
The 1950s │ 257 mm (w) × 383 mm (h)

榮華茶冰室 Wing Wah Tea and Ice Chamber
The 1950s │ 245 mm (w) × 583 mm (h)

榮泉茶餐廳 Wing Chuen Cha Chaan Teng
The 1950s │ 265 mm (w) × 715 mm (w)

威利民餅家 Wai Lei Man Pastries
The 1950s ｜ 290 mm (w) × 765 mm (h)

敘香園飯店 Orchid Garden Restaurant
The 1950s | 290 mm (w) × 760 mm (h)

香香雪糕 Heung Heung Icecream
The 1950s │ 245 mm (w) × 580 mm (h)

天虹大茶廳 Rainbow Tea House
The 1950s │ 290 mm (w) × 647 mm (h)

寶時茶餐廳 Po Si Tea House
The 1950s │ 200 mm (w) × 580 mm (h)

錦添花筵席飯店 Kam Tim Fa Banquet Restaurant
The 1950s ｜ 178 mm (w) × 664 mm (h)

瑞華茶樓 Shui Wah Restaurant
The 1950s ｜ 230 mm (w) × 665 mm (h)

樓

晚飯小菜　星期美點

南美光管公司

NAM MI TUBOIL CO.

½"=1'　　35'x6'3"
4', 14"

梁堅記餅家 Leung Kin Kee Pastries
The 1950s ｜ 235 mm (w) × 575 mm (h)

揚記粉麵 Yeung Kee Noodles
The 1950s │ 280 mm (w) × 581 mm (h)

龍子餐廳 Dragon Seed Restaurant
The 1950s │ 213 mm (w) × 578 mm (h)

金華大茶廳 Kam Wah Tea House
The 1950s ｜ 253 mm (w) × 760 mm (h)

冠華樓 Kwun Wah Lau
The 1950s │ 250 mm (w) × 760 mm (h)

金海茶廳 Kam Hoi Restaurant
The 1950s │ 244 mm (w) × 718 mm (h)

萬華大茶樓 Man Wah Restaurant
The 1950s │ 255 mm (w) × 755 mm (h)

景生大酒家 King Sang Restaurant
The 1950s ｜ 255 mm (w) × 750 mm (h)

劉揚記酒菜茶廳 Lau Yeung Kee Restaurant
The 1950s ｜ 255 mm (w) × 760 mm (h)

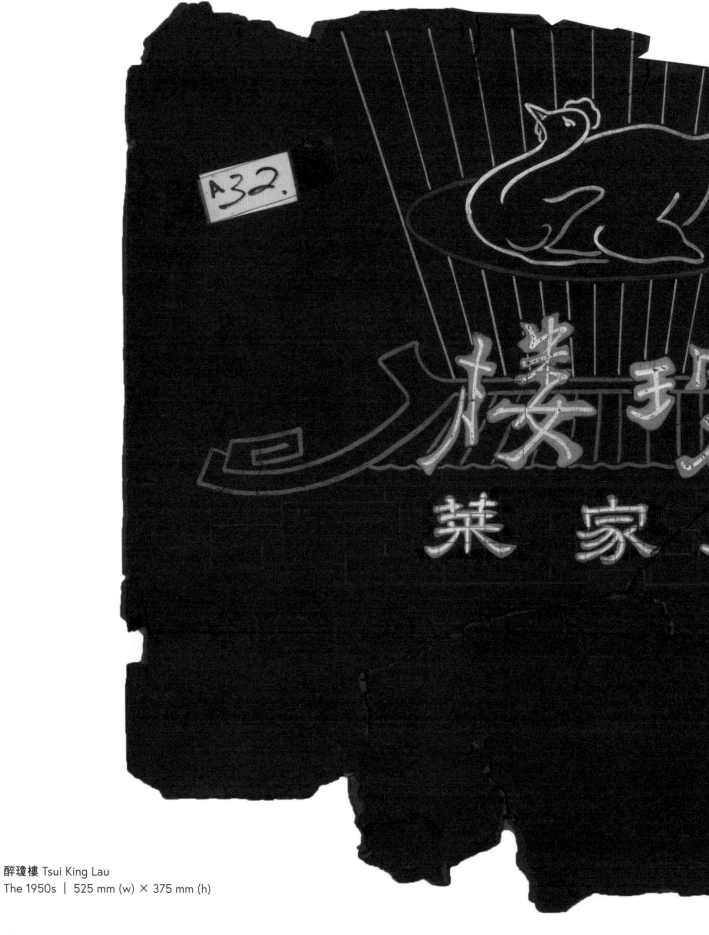

醉瓊樓 Tsui King Lau
The 1950s │ 525 mm (w) × 375 mm (h)

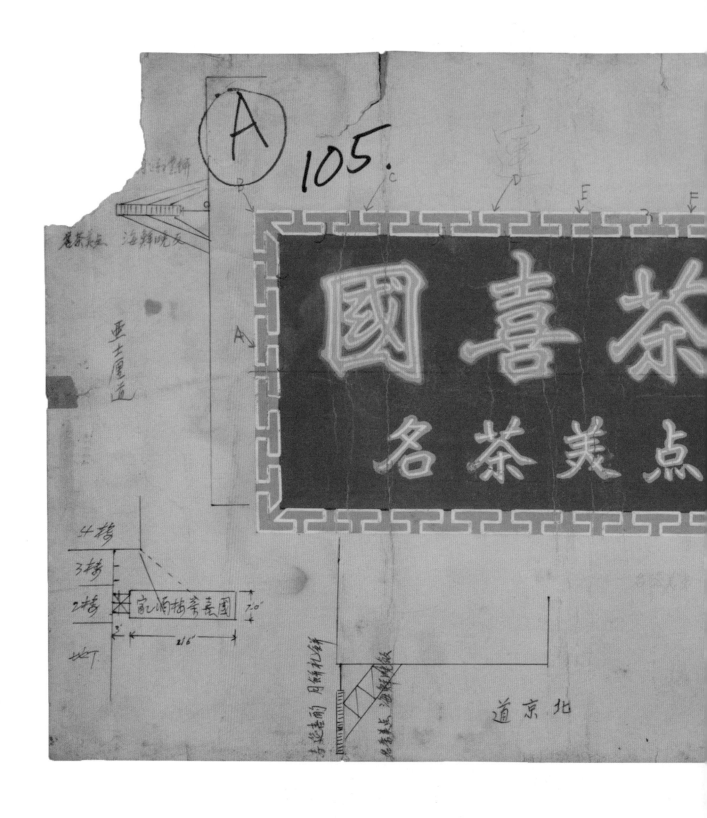

國喜茶樓酒家 Kwok Hei Tea House and Restaurant
The 1960s ｜ 580 mm (w) × 290 mm (h)

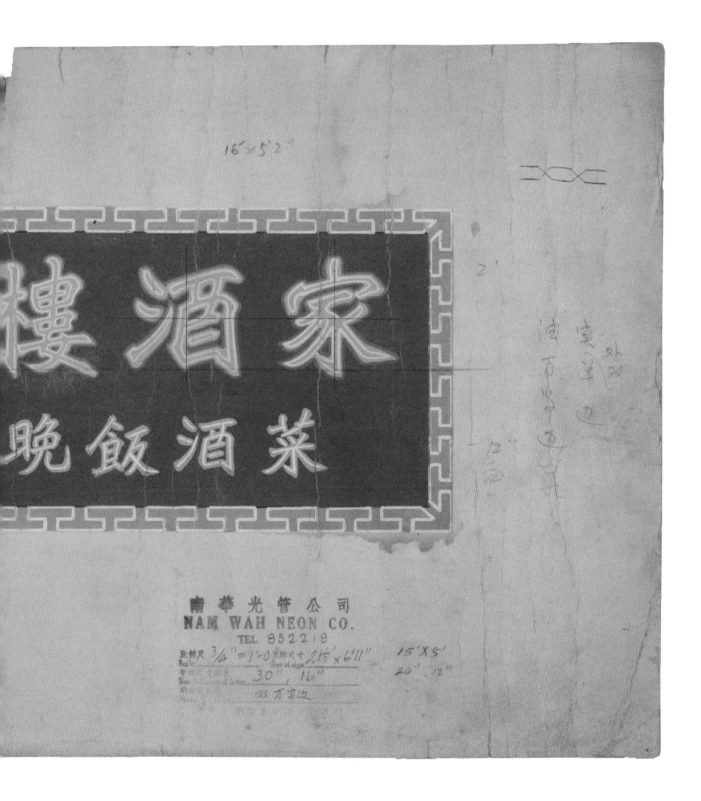

16′×5′2″

南華光管公司
NAM WAH NEON CO.
TEL 852219

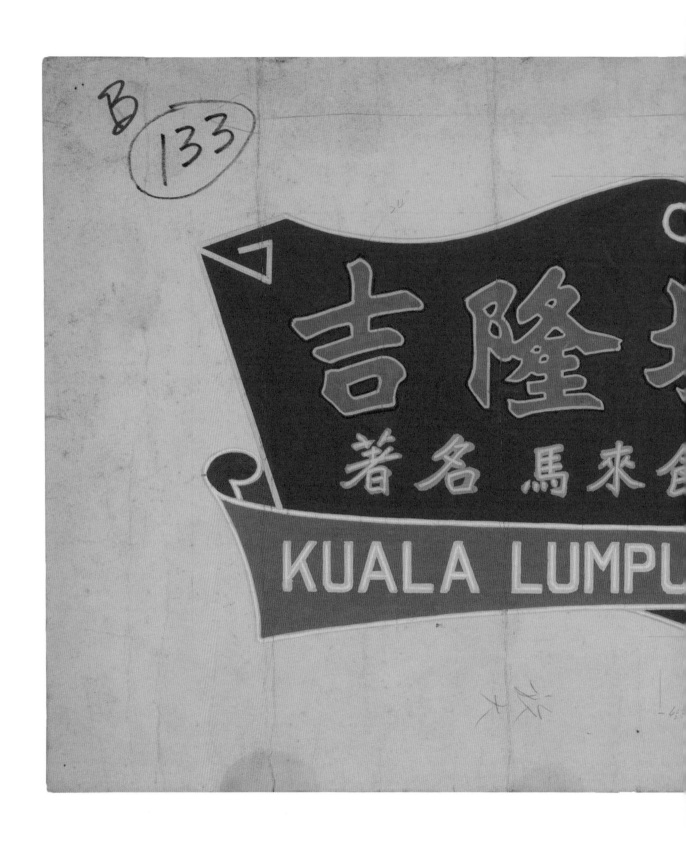

吉隆坡餐廳 Kuala Lumpur Restaurant
The 1960s │ 580 mm (w) × 305 mm (h)

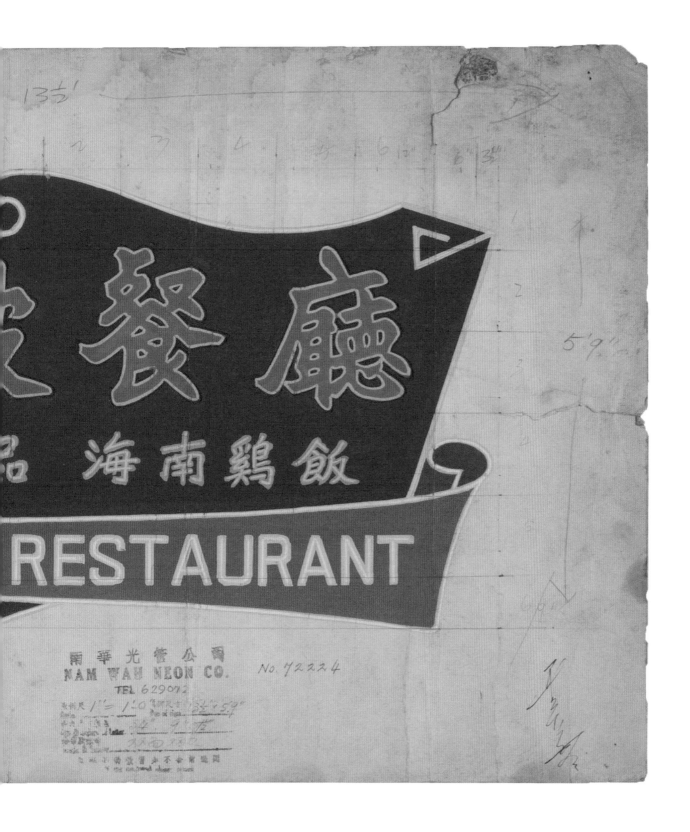

花都海鮮麵家 Fa Dou Seafood Restaurant
The 1960s ｜ 480 mm (w) × 265 mm (h)

波斯大餐廳 Percival Restaurant
The 1960s │ 581 mm (w) × 297 mm (h)

大光明菜館 Tai Kwong Ming Restaurant
The 1960s │ 481 mm (w) × 290 mm (h)

吳源記主理 Ng Yuen Kee Restaurant
The 1960s ｜ 590 mm (w) × 300 mm (h)

$450

吳源記酒家 Ng Yuen Kee Restaurant
The 1960s ｜ 500 mm (w) × 308 mm (h)

嘉年酒樓 Ka Nin Restaurant
The 1960s ｜ 580 mm (w) × 300 mm (h)

香香餐廳 Heung Heung Restaurant
The 1960s ｜ 506 mm (w) × 288 mm (h)

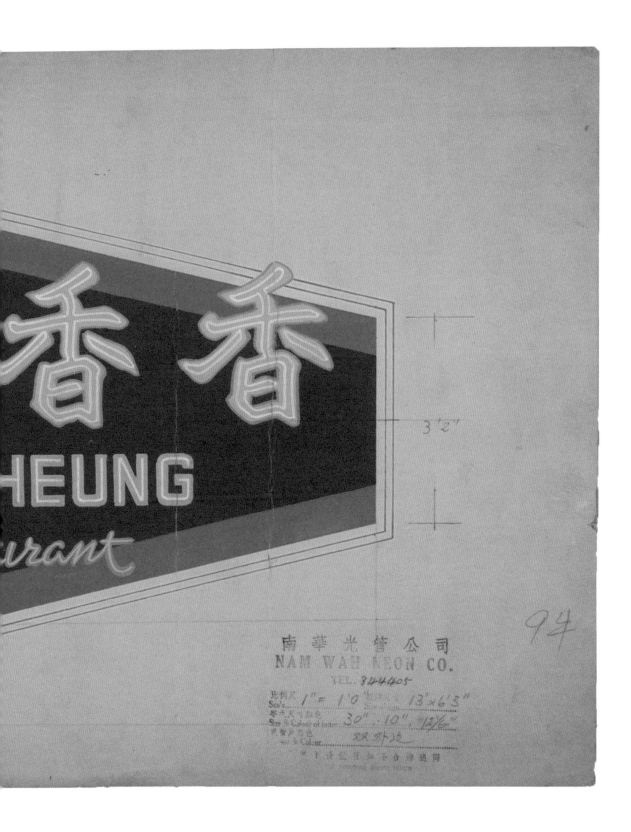

南華光管公司
NAM WAH NEON CO.
TEL. 844405

好運 Good Luck
The 1960s │ 460 mm (w) × 290 mm (h)

玫瑰餐廳 Rose Restaurant
The 1960s ｜ 265 mm (w) × 585 mm (h)

新西蘭餐廳 New Zealand Restaurant
The 1960s │ 292 mm (w) × 597 mm (h)

聯誼茶餐廳 Luen Yee Cha Chaan Teng
The 1960s │ 240 mm (w) × 550 mm (h)

鳳城餐廳 Fung Sing Restaurant
The 1960s ｜ 255 mm (w) × 582 mm (h)

周明記大飯店 Chow Ming Kee
The 1960s ｜ 276 mm (w) × 760 mm (h)

瑞園餐廳 Swee Ying Restaurant
The 1960s │ 280 mm (w) × 638 mm (h)

占飛餐廳 Jam Fair Co., Ltd. Restaurant
The 1960s │ 300 mm (w) × 685 mm (h)

金喜樓 Kam Hei Lau
The 1960s │ 250 mm (w) × 765 mm (h)

渣華晚飯酒菜 Java Restaurant
The 1960s │ 250 mm (w) × 680 mm (h)

榮發冰室 Wing Fat Ice Chamber
The 1960s ｜ 485 mm (w) × 292 mm (h)

蔗汁涼茶 Cane Juice and Herbal Tea
The 1960s │ 478 mm (w) × 290 mm (h)

法國飯店 French Restaurant
The 1960s ｜ 581 mm (w) × 317 mm (h)

玄妙觀小吃部 Yuen Miu Koon Snack Shop
The 1960s │ 468 mm (w) × 290 mm (h)

華燈餐廳 BLR
The 1960s ｜ 506 mm (w) × 290 mm (h)

榮發咖啡廳 Wing Fat Cafe
The 1960s │ 480 mm (w) × 284 mm (h)

餅飽炉出←———何弱街口

南華光管公司
NAM WAH NEON CO. 品飲热冷

768025

肇

冠天茶樓 Kwun Tin Restaurant
The 1960s │ 580 mm (w) × 296 mm (h)

南華光管公司
NAM WAH NEON CO.
TEL. 852219

金喜茶樓酒家 Kam Hei Restaurant
The 1960s ｜ 587 mm (w) × 303 mm (h)

南 華 光 管 公 司
NAM WAH NEON CO.
TEL. 647038

金石酒家 Kam Shek Restaurant
The 1960s │ 585 mm (w) × 305 mm (h)

好彩酒家 Ho Choi Restaurant
The 1960s ｜ 320 mm (w) × 760 mm (h)

東江酒樓 Dong Kong Restaurant
The 1960s │ 280 mm (w) × 760 mm (h)

歡喜大茶樓 Foon Hei Restaurant
The 1960s │ 260 mm (w) × 760 mm (h)

南 華 光 管 公 司
NAH WAH NEON CO.

TEL. 78025

月 餅
禮 餅

酒 茶
菜 麪

金龍大酒家 Golden Dragon Restaurant
The 1960s ｜ 280 mm (w) × 760 mm (h)

金輝大酒樓 Gold Dright Restaurant
The 1960s ｜ 295 mm (w) × 765 mm (h)

大人茶樓 Tai Yan Restaurant
The 1960s │ 295 mm (w) × 765 mm (h)

一品香菜館 Yat Pun Heung Restaurant
The 1960s │ 265 mm (w) × 582 mm (h)

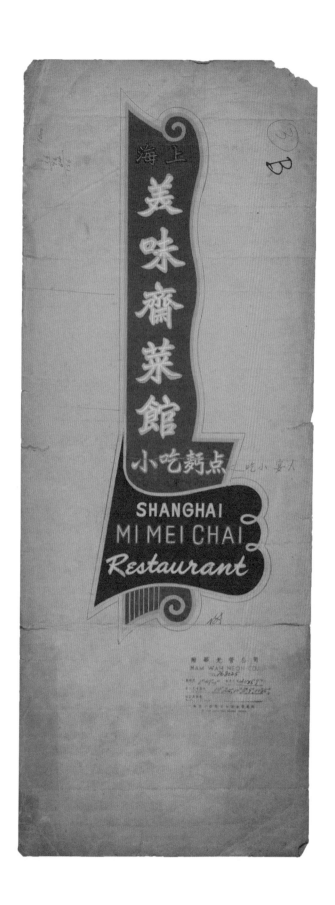

上海美味齋菜館 SHANGHAI Mi Mei Chai Restaurant
The 1960s ｜ 292 mm (w) × 755 mm (h)

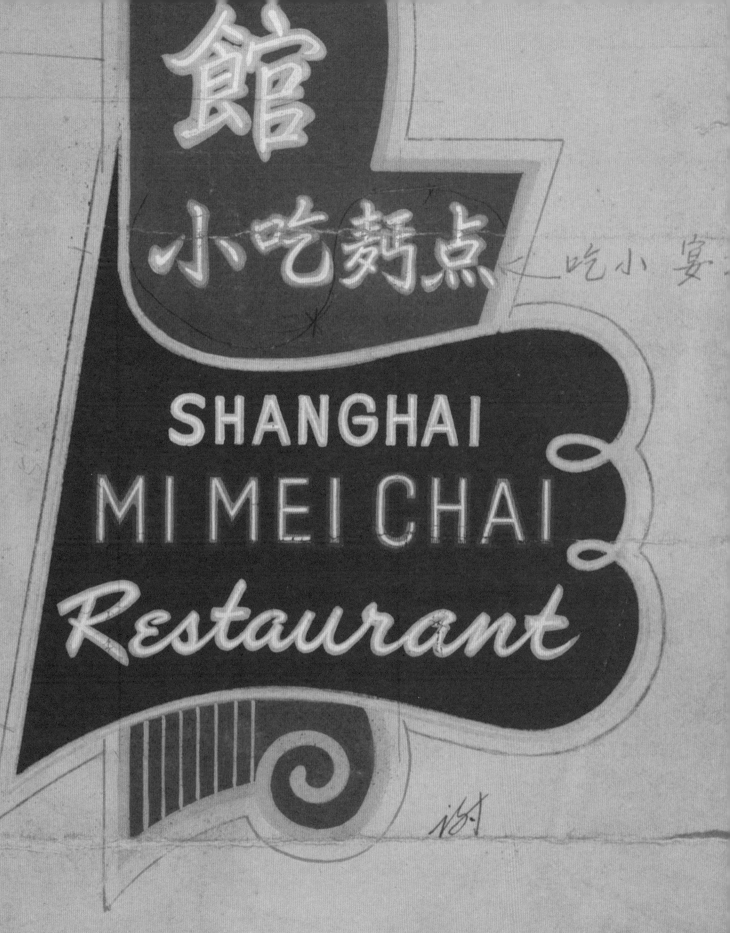

館
小吃 荊点 吃小宴

SHANGHAI
MI MEI CHAI
Restaurant

雨華光管公司
NAM WAH NEON CO.
TEL 768025
比例尺 1"=1'-0" 實際尺寸 20"x69"

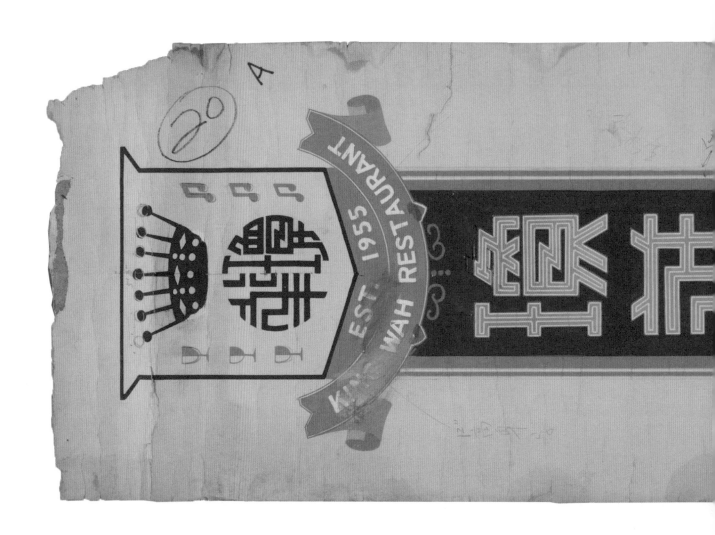

瓊華大酒樓 King Wah Restaurant
The 1960s | 295 mm (w) × 920 mm (h)

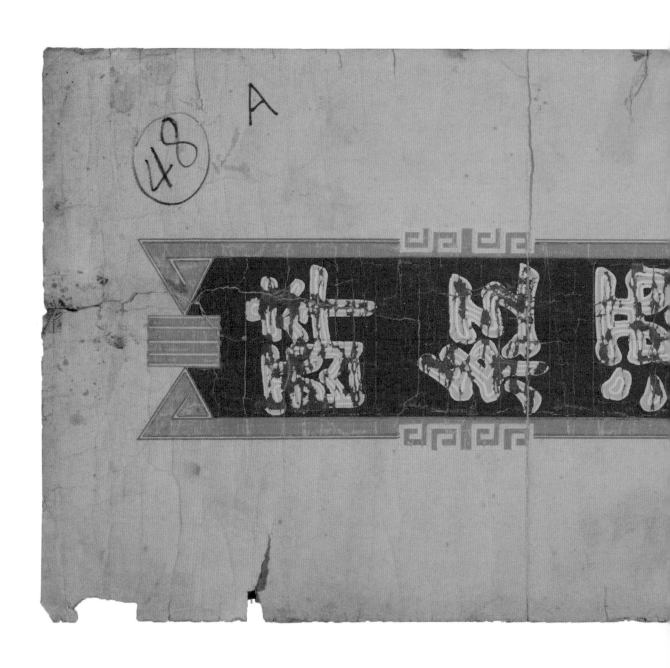

醉紅酒家 Tsui Hung Restaurant
The 1960s ｜ 295 mm (w) × 700 mm (h)

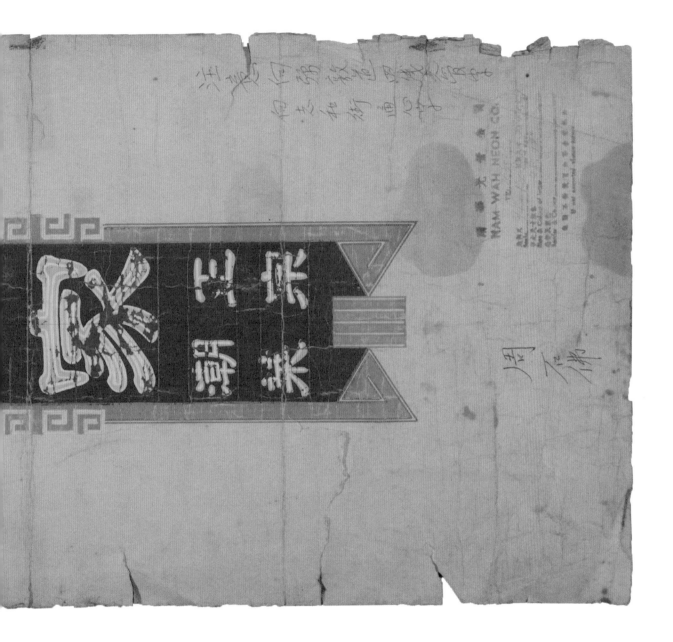

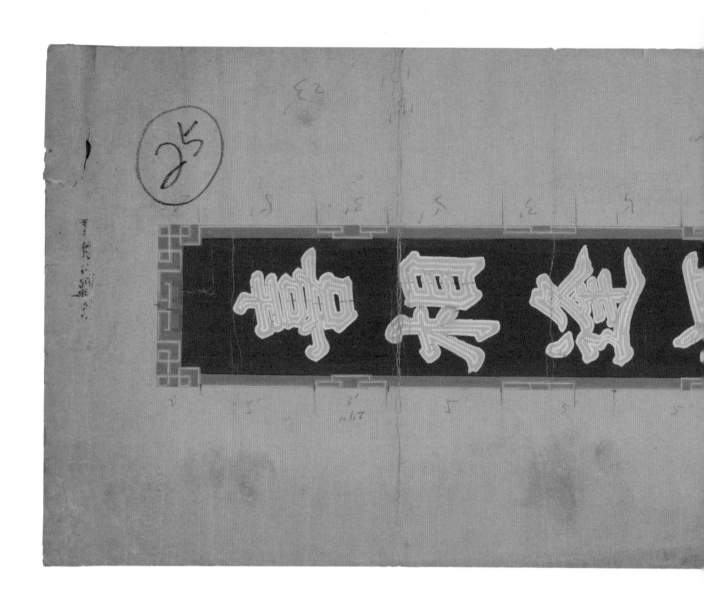

喜相逢酒家茶樓 Hei Sheung Fung Restaurant
The 1960s　│　280 mm (w) × 760 mm (h)

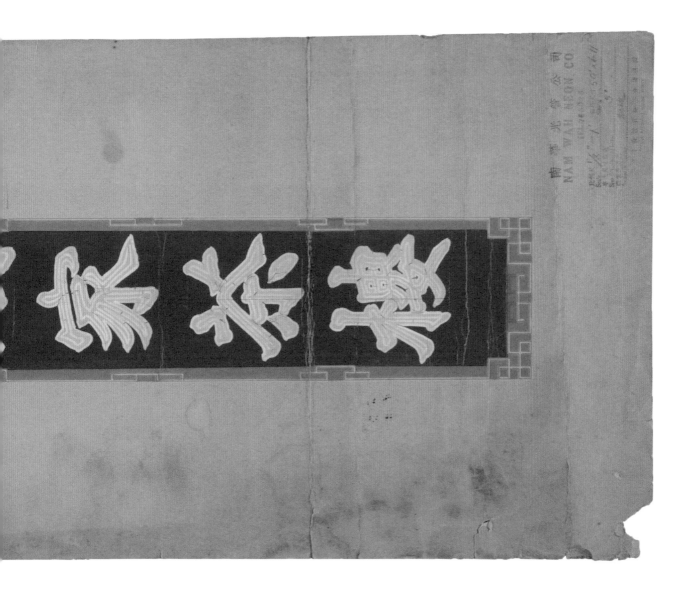

光和冰室 Kwong Wo Ice Chamber
The 1960s ｜ 297 mm (w) × 588 mm (h)

↖ | 嘉頓餐廳 Garden Restaurant
The 1970s | 590 mm (w) × 205 mm (h)

↙ | 諾維食店 Nok Wai Eatery
The 1970s | 582 mm (w) × 256 mm (h)

➡ | 牛記酒家 Ngau Kee Restaurant
The 1970s | 298 mm (w) × 765 mm (h)

利園光管有限公司
NECO NEON CO., LTD.
TEL. 5-447561 12-236181—4
比例 1"~6" 裝置尺寸 76"×2'9"
Scale _____ Size of Sign _____
字之尺寸顏色
Size & Colour of letters ____ 20"
邊管及顏色
Border & Colour _____
此圖不得塗改如不合請退回
If not acceptance, please return.

南華光管電器製造廠有限公司
NAM WAH NEONLIGHT & ELECTRICAL MFY. LTD.
TEL: 12-235181, 12-235182

比 例 英制: 1"=1'-0" 招牌尺寸 英制: 21' X 5'
Scale 公制: Size of Signs 公制:

字之尺寸顏色 英制: 3'
Size & Colour of letters: 公制:

邊 之 尺寸顏色
Border & Colour:

此圖不得使買如不合請退回
If not acceptance, please return.

新三六九酒樓 New 369 Restaurant
The 1970s ｜ 587 mm (w) × 316 mm (h)

342

好彩燒臘飯店 Ho Choi Barbecue Restaurant
The 1970s ｜ 590 mm (w) × 284 mm (h)

萬金龍酒樓 Man Kam Lung Restaurant
The 1970s ｜ 765 mm (w) × 295 mm (h)

筱竹林 Siu Chuk Lam
The 1970s ｜ 512 mm (w) × 250 mm (h)

金慶酒樓 Kam Hing Restaurant
The 1970s ｜ 760 mm (w) × 285 mm (h)

南華光管電器製造廠有限公司
NAM WAH NEONLIGHT & ELECTRICAL MFY. LTD.
TEL: 12-235181, 12-235182

比例 英制 1"=1'-0"招牌大小 英制 18' x 5'
Scale: 公制Size of Signs: 公制

字之大小顏色 英制 36"
Size & Colour of letters: 公制

邊掌及顏色
Border & Colour

此圖不得做冒如不合請退回
If not acceptance, please return.

醉紅樓酒家 Tsui Hung Lau Restaurant
The 1970s ｜ 512 mm (w) × 318 mm (h)

№ 1130

南華光管公司
NAM WAH NEON CO.

東江樓 Tung Kong Lau
The 1970s ｜ 580 mm (w) × 220 mm (h)

南華光管電器製造廠有限公司
NAM WAH NEONLIGHT & ELECTRICAL MFY. LTD.
TEL.: 12-235181, 12-235182

比例 英制 1″＝1-0″　　　　　　　　英制 13-8″x 5-6″
Scale : 公制 ... Size of Signs: 公制

字之尺寸顏色　　英制 36″ - 18″
Size & Colour of letters: 公制 ...

建型及顏色
Border & Colour : ...

此圖不得收百如不合請退回
If not acceptance, please return.

喜慶酒樓 Hei Hing Restaurant
The 1970s ｜ 775 mm (w) × 290 mm (h)

南華光管電器製造廠有限公司
NAM WAH NEONLIGHT & ELECTRICAL MFY. LTD.
TEL: 12-235181, 12-235182

↑ | 福來酒家 Fook Loi Restaurant
The 1970s | 535 mm (w) × 275 mm (h)

↓ | 天龍餐廳 Delon Restaurant
The 1970s | 580 mm (w) × 255 mm (h)

羊城茶廳 Yeung Sing Tea House
The 1970s │ 260 mm (w) × 760 mm (h)

龍苑餐廳 Lung Yuen Restaurant
The 1970s │ 255 mm (w) × 585 mm (h)

敘香邨酒樓 Orchid Village Restaurant
The 1970s │ 292 mm (w) × 757 mm (h)

新界大酒樓 New Territory Restaurant
The 1970s │ 312 mm (w) × 1145 mm (h)

富麗華酒樓 Fu Lai Wah Restaurant
The 1970s │ 295 mm (w) × 1005 mm (h)

嶺南酒樓 Ning Nam Restaurant
The 1970s ｜ 295 mm (w) × 860 mm (h)

新同樂魚翅酒家 Sun Tung Lok Sharks Fin Restaurant
The 1970s │ 290 mm (w) × 765 mm (h)

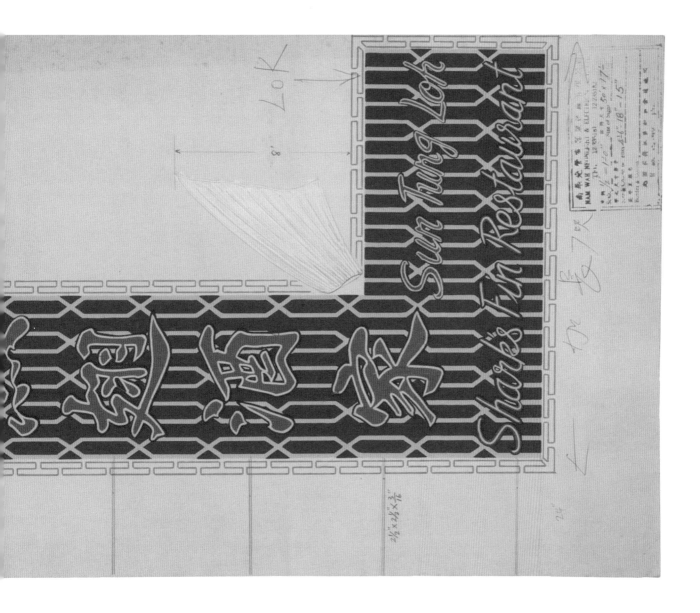

雅麗餐廳 Alice Restaurant
The 1970s ｜ 294 mm (w) × 760 mm (h)

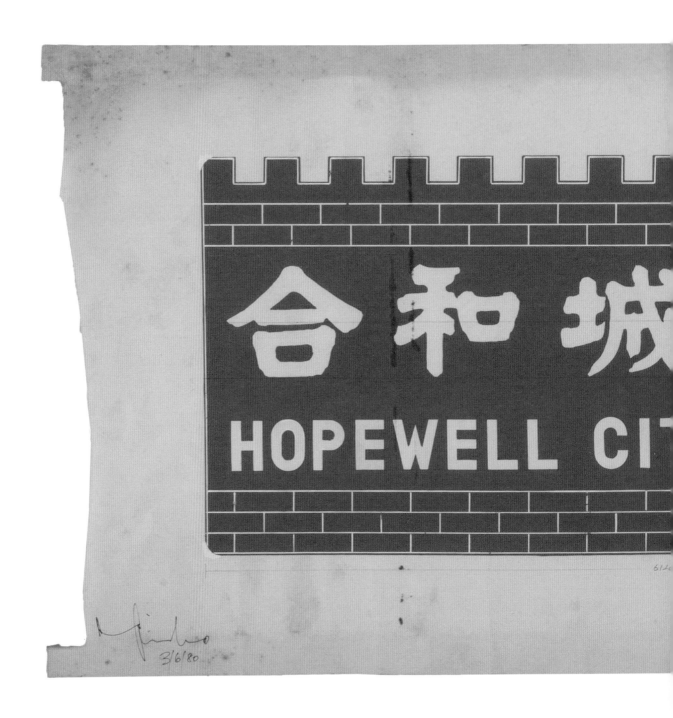

合和城大酒樓 Hopewell City Restaurant
The 1980s ｜ 760 mm (w) × 350 mm (h)

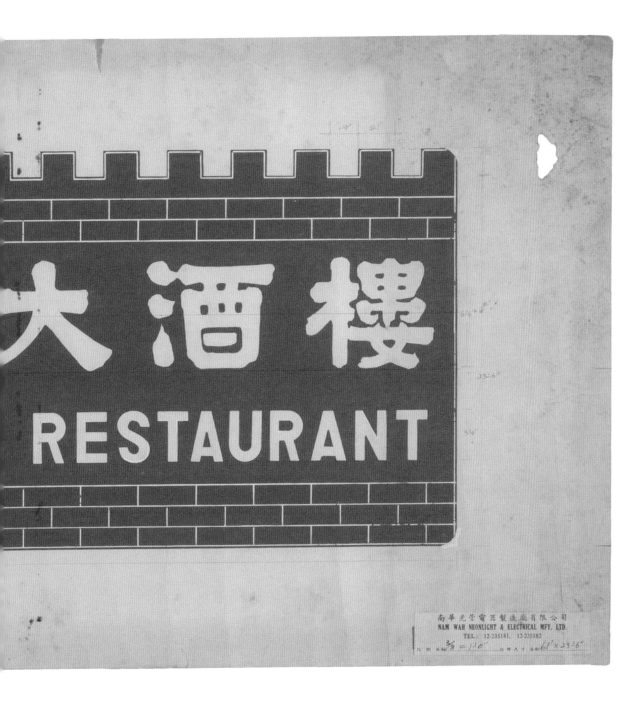

滿堂紅酒家 Full House Restaurant
◒ | 320 mm (w) × 660 mm (h)

海角漁舫海鮮酒家 Ocean Court Restaurant
⊖ | 250 mm (w) × 645 mm (h)

大華飯店 Cafe de Chine
⊖ | 275 mm (w) × 580 mm (h)

百德茶樓酒家 Pak Tak Restaurant
⊖ | 270 mm (w) × 765 mm (h)

寶石酒家 Precious Stone Restaurant
⊖ | 245 mm (w) × 510 mm (h)

寶石酒家

步代梯電

泰豐樓 Tai Fung Lau
㊀ | 500 mm (w) × 305 mm (h)

五福樓酒家 Ng Fuk Lau Restaurant Ltd.
⊖ | 480 mm (w) × 370 mm (h)

鴻運來酒樓 Hung Wan Loi Restaurant
⊖ | 602 mm (w) × 357 mm (h)

金國酒家茶樓 Golden Palace Restaurant
⊖ | 645 mm (w) × 293 mm (h)

慶相逢酒樓 Hing Sheung Fung Restaurant
⊖ | 700 mm (w) × 310 mm (h)

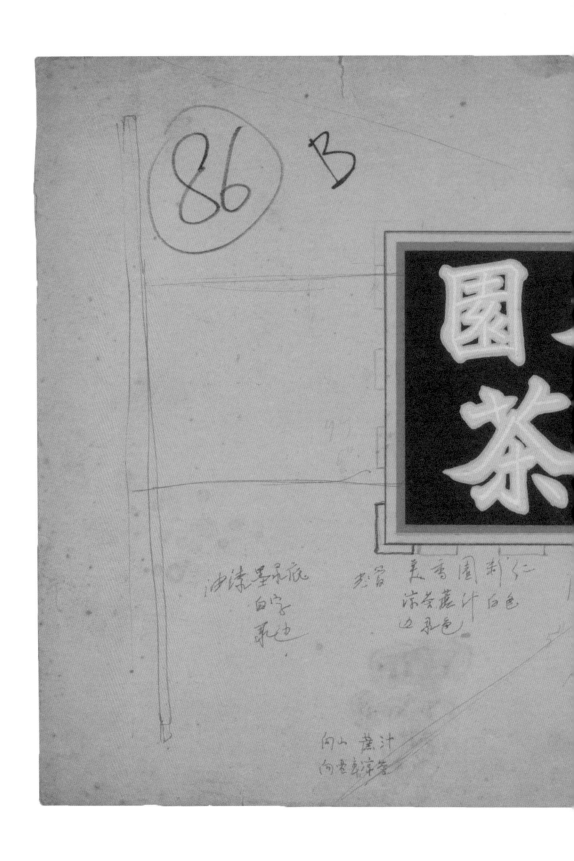

美香園涼茶 Mei Heung Yuen Herbal Tea
⊖ | 465 mm (w) × 290 mm (h)

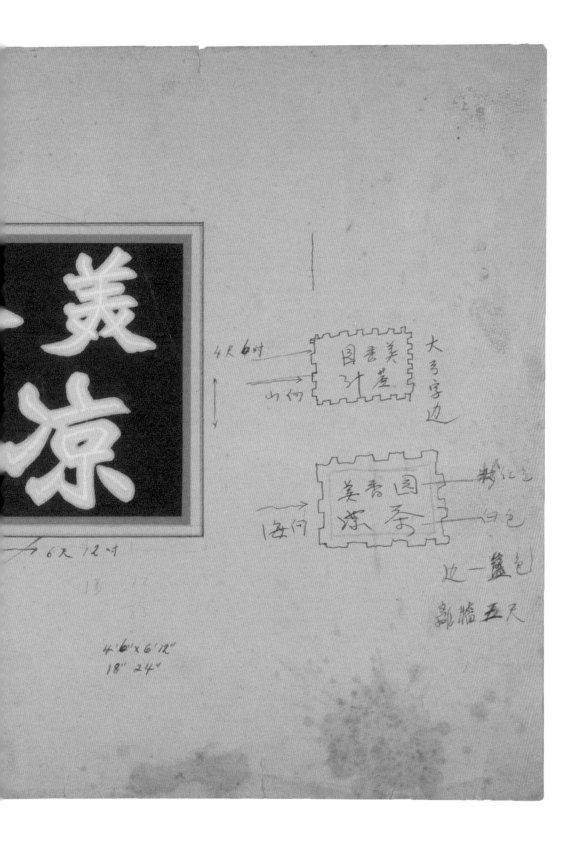

參考資料　REFERENCES

Chapter ❷

吳昊，2001，《飲食香江》，《南華早報》。

鄭寶鴻，2003，《香江知味：香港的早期飲食場所》，香港：香港大學美術博物館。

梁廣福，2018，《再會茶樓歲月》（增訂版），中華書局（香港）有限公司。

蕭欣浩，2019，《解構滋味：香港飲食文學與文化研究論集》，香港：初文出版社有限公司。

Hong Kong Statistics 1947–1967 (1969). Census & Statistics Department, Hong Kong Special Administrative Region. Retrieved from https://www.statistics.gov.hk/pub/hist/1961_1970/B10100031967AN67E0100.pdf

Back To The Future: Herbal Tea Shops in Hong Kong. Cheng, S. L. (1997). In Evans, G. & Tam, M. (Ed.), *Hong Kong: The Anthropology of a Chinese Metropolis* (pp. 51–73). University of Hawai'i Press.

Average rate of wages for labour. *Hong Kong Blue Book* (1928). Retrieved from http://sunzi.lib.hku.hk/hkgro/view/b1928/51928028.pdf

The Rise of a Refugee God: Hong Kong's Wong Tai Sin. Lang, R. & Ragvald, L. (1993). Oxford University Press.

Chapter ❸

Island Paint, Kin Kwok Lacquer and HK Paint Products – The Three Forgotten Players of the HK Paint Industry. Lo, Y. (2017). The Industrial History Hong Kong Group. Available at: https://industrialhistoryhk. org/35379-2/

The Disappearance of Hong Kong in Comics, Advertising and Graphic Design (East Asian Popular Culture). Wong, W. (2018). Cham: Springer International Publishing.

Made in Hong Kong: A History of Export Design in Hong Kong 1900-1960 (1st ed.). Turner, M. (1988). Hong Kong: Urban Council.

結語　AFTERWORD

本書旨在闡述本研究團隊在研究二百一十八張食肆霓虹招牌手稿過程中，有關本地視覺美學與設計的發現。二百多張手稿雖不足以呈現整個本地的視覺文化版圖及其歷史進程，但這些珍貴的手稿也在為本地設計、視覺美學、傳統工藝、色彩學、消費文化，以至五十至八十年代的社會、民生和經濟等狀況，提供了寶貴的線索和參考。

這次研究團隊已力求盡善盡美，將整理霓虹招牌手稿後的初步分析及研究發現細心記錄及展示，若資料有任何偏差或遺漏，懇請各位多多包涵，也希望各位前輩和讀者多多指教。另外，如果你對本研究項目有興趣，或能提供更多有關霓虹招牌的資料，可聯絡我們，使我們的研究成果更豐碩。

This book aims to introduce the findings of our research team on local visual aesthetics and design from our analysis of the 218 restaurant neon signboard sketches. While these artworks cannot represent the entire picture of local visual culture and its history, the precious collection can certainly provide clues about and references for understanding local design, visual aesthetics, traditional craftsmanship, colour theories, consumer culture as well as the livelihood and economic conditions of Hong Kong from the 1950s to the 1980s.

Our team has put our best effort and strived for accuracy and perfection to record and display our preliminary analysis and research findings from organizing the neon signboard artworks. We sincerely ask for your understanding for any deviations or omissions and welcome advices from seniors and readers. If you are interested in this research project, or if you can provide us with more information about neon signboards, please get in touch with us to make our study more fruitful.

信息設計研究室
infodesignlab.org

鳴謝 ACKNOWLEDGEMENTS

衷心感謝南華霓虹燈電器廠有限公司及譚華正博士贈予霓虹手稿作相關研究和教育用途。

We would like to present our gratitude to Nam Wah Neonlight & Electrical Manufactory Limited and Dr. Tam Wah-ching for their donation of the neon signboard artworks for research and educational purposes.

在此特別鳴謝以下人士及機構（排名不分先後）
Credits go to the following supporters and organizations
(listed in no particular order)

蘭芳園	Lan Fong Yuen
醉瓊樓	Tsui King Lau
長康酒樓	Cheung Hong Restaurant
信興酒樓	Shun Hing Restaurant
太平館餐廳	Tai Ping Koon Restaurant
春和堂單眼佬涼茶	Chun Wo Tong Dan Yan Lo Herbal Tea
梁榮光師傅	Master Leung Wing-gwong
香港理工大學設計學院	School of Design, The Hong Kong Polytechnic University
信息設計研究室	Information Design Lab
長春社文化古蹟資源中心	The Conservancy Association Centre for Heritage (CACHe)
衛奕信勳爵文物信託	The Lord Wilson Heritage Trust
高添強先生	Ko Tim-keung
李毓琪小姐	Li Yuk-ki

〈香港飲茶文化〉撰文｜郭斯恆、邱穎琛
Hong Kong Tea Culture written by Brian Kwok Sze-hang and Kiki Yau

作者簡介

郭斯恆，香港理工大學設計學院副教授，喜愛街道觀察及視覺文化。曾出版《我是街道觀察員——花園街的文化地景》、《霓虹黯色——香港街道視覺文化記錄》、《字型城市——香港造字匠》及《香港造字匠 2 ——香港字體設計師》。

About the Author

Brian Kwok Sze-hang is an Associate Professor of the School of Design, The Hong Kong Polytechnic University and an enthusiast about street observation and visual culture. His publications include *I am a Street Ethnologist: Street Culture in Fa Yuen Street*, *Fading of Hong Kong Neon Lights – The Archive of Hong Kong Visual Culture*, *City of Scripts – The Craftsmanship of Vernacular Lettering in Hong Kong* and *City of Scripts 2 – Hong Kong Type Designers*.

霓虹艷色
餐飲招牌手稿視覺記錄

NEON HUES
The Visual Documentation of Restaurant Neon Artworks

[作者]	郭斯恆	[Aurthor]	Brian Kwok Sze-hang
[責任編輯]	李宇汶	[Chinese Editor]	Yuki Li Yuk-ki
[英文編輯]	崔佩賢	[English Editor]	Pamela Tsui Pui-yin
[翻譯]	黃章翹	[Translators]	Sherrie Wong
	陳泳暉		Alex Chan
	郭斯恆		Brian Kwok Sze-hang
[書籍設計]	姚國豪	[Book Design]	Vincent Yiu Kwok-ho
[資料蒐集]	邱穎琛	[Researcher]	Kiki Yau
[插圖]	邱穎琛	[Illustrator]	Kiki Yau
[霓虹手稿拍攝]	邱穎琛	[Neon Artworks Photography]	Kiki Yau
	張洛爾		Cheung Lok-yi
	蔡悅心		Choi Yuet-sum
	曾昫晴		Tsang Hui-ching
	黃志妍		Wong Chi-yin
	麥意婷		Mak Yi-ting

[出版]　三聯書店（香港）有限公司
　　　　香港北角英皇道四九九號北角工業大廈二十樓

[香港發行]　香港聯合書刊物流有限公司
　　　　　　香港新界荃灣德士古道二二○至
　　　　　　二四八號十六樓

[印刷]　美雅印刷製本有限公司
　　　　香港九龍觀塘榮業街六號海濱工業大廈四樓A室

[版次]　二○二四年七月香港第一版第一次印刷
[規格]　大十六開（216 mm × 280 mm）四○八面
[國際書號]　ISBN 978-962-04-5465-3

[Publisher]　Joint Publishing (H.K.) Co., Limited
　　　　　　20/F., North Point Industrial Building,
　　　　　　499 King's Road, North Point, Hong Kong

[Distributor]　Sup Publishing Logistics (H.K.) Limited
　　　　　　　16/F., Tsuen Wan Industrial Centre,
　　　　　　　220-248 Texaco Road,
　　　　　　　Tsuen Wan, New Territories, Hong Kong

[Printing]　Elegance Printing and Book Binding Co., Ltd.
　　　　　　Block A, 4/F., Hoi Bun Industrial Building,
　　　　　　6 Wing Yip Street, Kwun Tong,
　　　　　　Kowloon, Hong Kong

[Edition]　July 2024, First Edition
[Specification]　216 mm × 280 mm, 408 pages
[ISBN]　978-962-04-5465-3

三聯書店
http://jointpublishing.com

JPBooks.Plus
http://jpbooks.plus